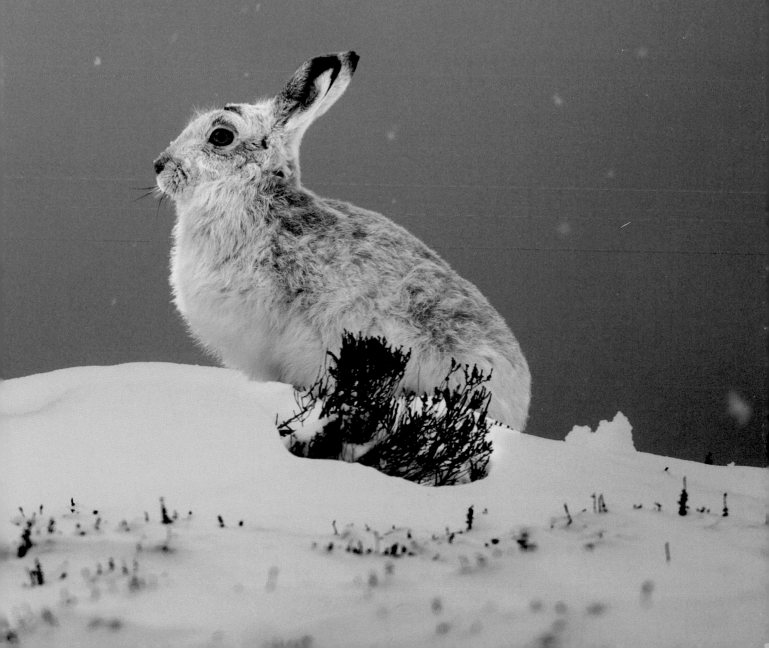

First published 2013 by
Ammonite Press
an imprint of AE Publications Ltd
166 High Street, Lewes,
East Sussex, BN7 1XU

Text and photographs © Ross Hoddinott and Ben Hall, 2013
Copyright in the Work © AE Publications Ltd, 2013

ISBN 978-1-90770-857-2

Publisher **Jonathan Bailey**
Production Manager **Jim Bulley**
Managing Editor **Gerrie Purcell**
Senior Project Editor **Virginia Brehaut**
Copy Editor **Tom Mugridge**
Managing Art Editor **Gilda Pacitti**
Design **Simon Goggin**

Set in Frutiger
Colour origination by GMC Reprographics
Printed and bound in China

PHOTO CREDITS

Ben Hall: pages 2–3, 4 (right), 5 (right), 12 (top), 23, 39 (bottom), 42–45,
47, 49 (bottom), 50–52, 58–73, 90–95, 97 (bottom), 99–113, 117–121,
138–155 and 159–167. © 2020VISION/Ben Hall pages 67, 90–91, 92,
104, 138–139, 143, 145 and 147.
Ross Hoddinott: pages 4 (left and middle), 5 (left and middle), 7, 9,
10–11, 14–15, 16 (top right), 26–37, 39 (top), 41, 46, 49 (top), 53–57,
74–78, 81–89, 115, 122–137, 157 and 168–169. © 2020VISION/Ross
Hoddinott pages 29, 33, 41, 74–75, 81, 84, 85 and 122–123.
Additional images by: f-stop gear: page 22 (top); Giottos: page 19
(top right), 25 (top left); Manfrotto: page 18; Nikon: pages 12 (bottom
left),16, 20, 79; Olympus: page 12 (bottom right); Pelican: page 22
(bottom); Visible Dust: page 24; Wildlife Watching Supplies: page 19
(lower right), 25 (top right), 97 (top right); Wimberley: page 19 (top left)
and Robert Wright page 97 (top left).

CONTENTS

INTRODUCTION

WORKSHOP *(Noun)*

A meeting of people to discuss and/or perform practical work. Training in a subject, skill or activity.

It is an exciting time to be a nature photographer. Digital technology has revolutionized picture-taking, promoting creativity and spontaneity. The speed, high ISO performance and accuracy of modern autofocus systems are ideally suited to photographing wildlife, and pixel and optical quality have never been higher. Not only is high-quality photography more affordable and more accessible than ever before, but the opportunities to travel and get closer to nature have never been greater. It is no wonder, then, that the standard of nature photography is reaching new heights – though there is always room for improvement.

Whether you are a newcomer to nature photography or an experienced professional, the aim is exactly the same: to improve. It is human nature to strive to do better and to learn, and this is why photographic workshops are so popular. Flick through the back pages of any photography magazine, or search online, and you will discover numerous courses aimed at expanding your knowledge and ability, and offering the opportunity to learn directly from practising professionals. Arguably, no subject is more popular or addictive than wildlife photography, which is why there is no shortage of workshops and photographic tours, all around the world, aimed at natural-history enthusiasts. This book isn't intended as a substitute for attending an on-location workshop – there is no better way to learn than by going out and doing it. However, it is not always possible to retain all the information you learn during a workshop or tutorial day; not everything will sink in. Also, workshops aren't cheap; not everyone can afford one, or justify the time away from work or family life. These are among the reasons that led us to put together this 'workshop' in book form. It is designed to provide a useful, practical resource, covering all the essential tools and techniques you need to take better nature photographs.

The book reflects the way we run our own workshops and tutorial days, explaining the subject in approachable, informal and jargon-free language, without intimidating beginners or patronizing the more experienced. We begin by briefing you about the foundations of photography – equipment, exposure, composition and lighting – and how they relate specifically to nature photography. For newcomers in particular, this is essential reading. Next, it is time to go out 'on location', where we will focus on different types of subjects and the techniques best suited to capturing them. This is where we will share our hands-on knowledge, skills and fieldcraft, showing you how to photograph insects, birds, mammals and plant life. Practical advice and tips will help to accelerate your learning and maximize your chances of success.

Once you've captured your nature images, you will need to process them. The penultimate chapter discusses workflow and outlines the essential post-processing skills you will need. And finally, we set you a number of Creative Assignments – a range of projects that simulate some of the challenges our workshop participants face in the field. While the assignments are, of course, optional, they are designed to challenge you and introduce good discipline.

The book is illustrated throughout with our own wildlife images, all captured using the skills and techniques we are sharing with you now. Put simply, this is a wildlife photography workshop in book form. We hope you enjoy it.

ROBIN *(ERITHACUS RUBECULA)*
Successful nature images require a combination of good technique, fieldcraft, an understanding of the subject, hard work, timing, a creative eye and a good deal of patience. Nature is unpredictable, so you'll often need a stroke of luck too. However, you will find that the harder you work, the luckier you get!
Nikon D300, 120–400mm (at 400mm), ISO 400, 1/500 sec. at f/5.6, handheld

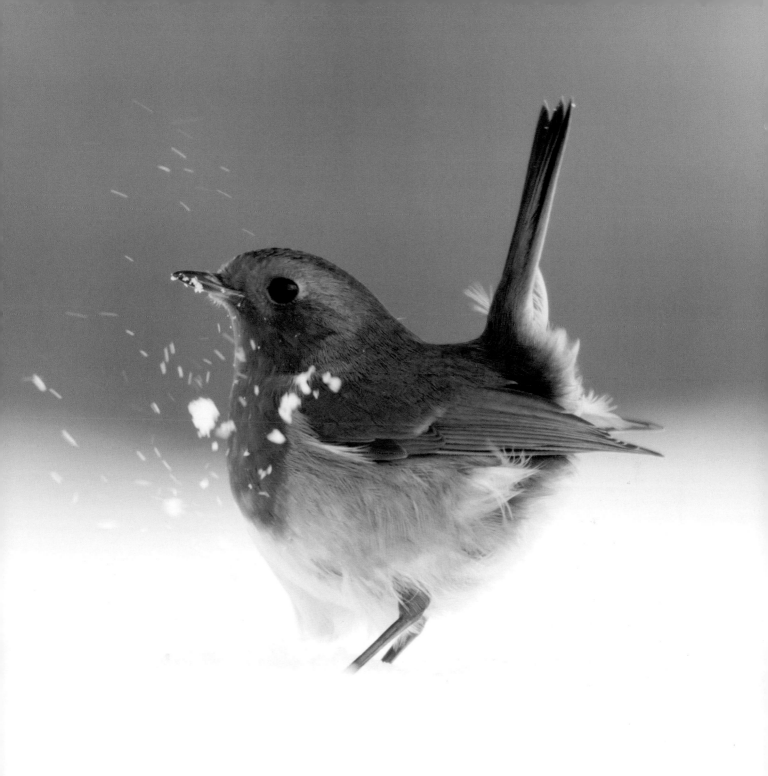

ETHICS

Intimate and extraordinary images of nature have the power to convey a subject's beauty and importance. A captivating image may even encourage the viewer to take an active interest in nature and conservation. However, first and foremost, wildlife photographers have a responsibility to their subjects. Every plant and animal, rare or common, is unique and its welfare is always more important than a photograph.

Wildlife isn't like other photographic subjects. If you wish to capture great images of nature, you need to have a deep passion, understanding and appreciation of the subject. Disturbance should always be kept to an absolute minimum and at no time should your subject be placed at risk. If the subject shows any signs of distress, you should retreat quickly and quietly. Breeding animals are particularly vulnerable. Avoid photographing birds at the nest or getting too close to animals with young – there is a risk of adults abandoning their young if you do so. Do not place yourself between adults and young – not only will this distress the subject, but with larger animals, you may also place your own safety at risk.

Smaller animals, such as insects and reptiles, are equally important. Hatching, or cold, torpid insects are particularly vulnerable – a careless foot can prove fatal. Do not touch or knock your subjects, and don't attempt to pick up or move small animals unless you are experienced at handling wildlife. Also be considerate to plant life. While a small degree of 'gardening' (see page 125) is normally acceptable, it is not ethical to bend, break, remove or damage plants or fungi just to improve the aesthetics or balance of a photograph.

Wildlife photographers have a legal obligation to protect their subjects. Many animals and plants are rare or endangered, and are protected by law. It is your responsibility to investigate the laws in regard to nature photography, wherever you intend to shoot – or you may face the consequences.

ETHICAL GUIDELINES FOR WILDLIFE PHOTOGRAPHERS

- Photography should not be undertaken at the risk of disturbing, damaging or distressing subjects; or consequential predation or reduced reproductive success.
- Photographers should always be familiar with their intended subject. The more complex the life form, or the rarer the subject, the greater the photographer's knowledge must be.
- Photography of nesting birds should only be considered if you have a good knowledge of bird breeding behaviour.
- If an animal displays signs of stress, immediately move further away and use a longer focal length.
- Do not erect a hide if it is likely to attract the attention of the public or predators.
- Where they exist, stay on trails and paths; otherwise, keep habitat disturbance to a minimum.
- When baiting wildlife, make sure you keep dispensers, water and food clean.
- Chilling invertebrates in order to reduce their activity for photography is unacceptable.
- When photographing captive animals, always declare that you have done so – do not try to pass off images as having been taken in the wild.
- Always be familiar with the laws of the country where you are taking photographs.

BLUE-TAILED DAMSELFLY
(ISCHNURA ELEGANS)

Photographers have a responsibility to ensure the welfare and safety of their subjects – large or small, plant or animal. Never assume your photograph is more important than the subject or its habitat. With our images, we have the power to highlight the beauty, fragility and significance of natural subjects.

Nikon D300, 150mm, ISO 200, 1/30 sec. at f/11, tripod

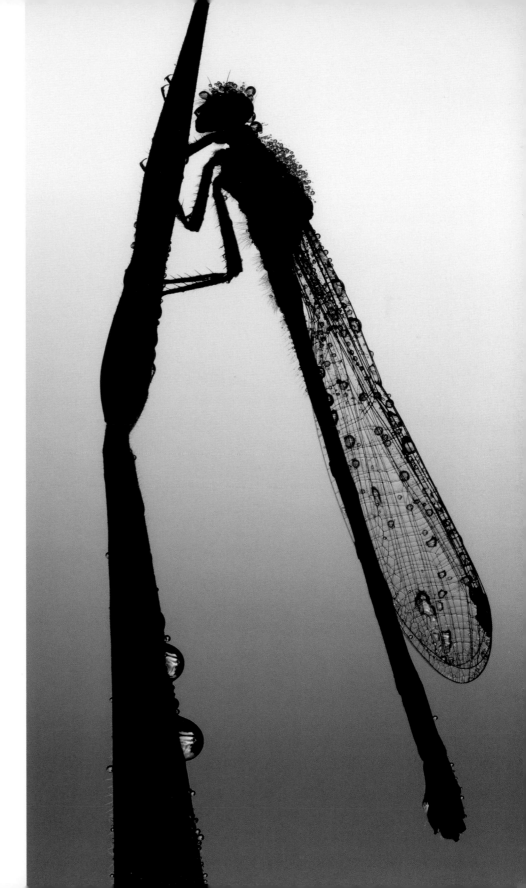

► CHAPTER ONE > **EQUIPMENT**

One of the biggest considerations when attending a workshop is, 'What equipment do I need?' After all, the gear you use can mean the difference between success and failure, and you don't want to be unprepared. Getting close to wildlife is rarely easy, which is why nature photography is generally perceived as a highly challenging subject, requiring specialist kit and long, pricey optics. To some extent this is true. However, great nature images are within your grasp regardless of your budget and the equipment you own, provided you can develop good technique and a creative eye. This chapter will introduce you to the equipment we have found most effective for nature photography – not just cameras and lenses, but the most useful accessories too. It is intended as a guide, not as a shopping list. Inevitably, your choice of equipment will depend on your preferred subjects – macro photography has very different requirements from bird photography, for example – and your budget. We hope that this chapter will not only aid your preparation, but also help you to avoid buying the wrong things or from making costly errors.

COMMON FROG (*RANA TEMPORARIA*)
It is easy to assume that, to capture great nature images, you need to invest heavily in specialist equipment. This isn't necessarily the case. In many situations, you can take excellent shots using relatively inexpensive or everyday kit – for example, the long end of a 70–300mm zoom for garden birds; or a close-up attachment to shoot macro. In this example, a +4 close-up filter (see page 21) was attached to a standard lens to capture this frame-filling frog portrait.
Nikon D300, 50mm, ISO 200, 1/250 sec. at f/5, +4 close-up filter, handheld

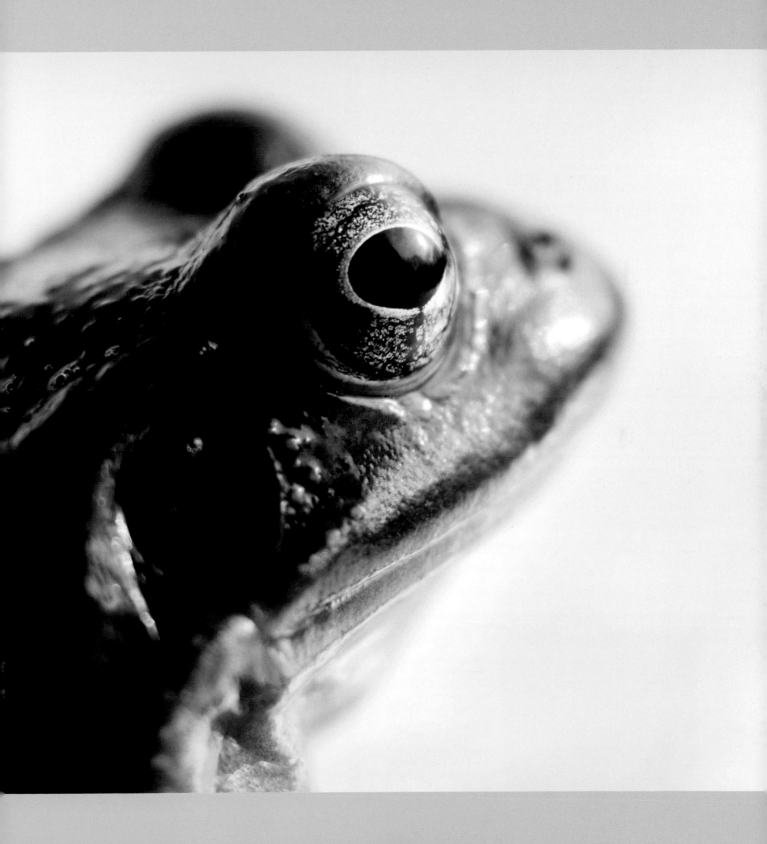

DIGITAL SLRs

It's possible to take successful wildlife images with almost any type of camera. Compacts and bridge cameras, for example, have impressive close-focusing ability, and can be used to capture frame-filling shots – although you will need to get close to the subject to do so. In public parks, where animals are used to humans, you may get so close that even your mobile phone camera will be sufficient. However, if you're serious, you will find that wildlife photography is fairly limited using anything but an SLR. The versatility, speed, quality and level of control afforded by a digital SLR system make it the logical choice for nature photographers – beginner, enthusiast and professional alike.

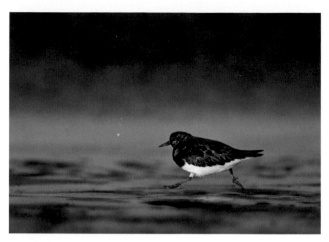

TURNSTONE *(ARENARIA INTERPRES)*
If you wish to capture rapid action in your nature photographs – as in this picture of a turnstone running – opt for a camera with a frame rate of at least 5fps.
Canon EOS-1D Mk II, 500mm, ISO 160, 1/100 sec. at f/5.6, handheld

WHAT IS A DIGITAL SLR?

When you peer through the viewfinder of a digital Single Lens Reflex camera (or digital SLR), you are looking through the actual taking lens. It employs a mechanical mirror and pentaprism system to direct light from the lens to the optical viewfinder at the rear of the camera. When a picture is taken, the mirror assembly swings upward; the aperture narrows – if set smaller than wide open – and the shutter opens to allow the lens to project light onto the digital sensor behind it. This process usually occurs in a fraction of a second: some top-end models are capable of capturing images at a staggeringly fast 11 frames per second (fps) – ideal for capturing action or flight. The digital SLR also offers high image quality; an unrivalled level of control; good high-ISO performance; fast, responsive autofocus (see page 94); excellent build quality; superb ergonomics, and a large, bright viewfinder, which aids focusing and composition. Entry-level and consumer models have never been more affordable. Digital SLRs are also compatible with a vast range of interchangeable lenses, accessories and flash systems. As a result, the capabilities and potential of an SLR system are almost limitless.

NIKON D4
When buying a digital SLR specifically for nature photography, the key points to consider are build quality, high ISO performance, autofocus and speed. Opt for a model that is weather-sealed and of a robust, magnesium alloy construction.

OLYMPUS E3
Light entering a digital SLR lens strikes a mirror in the body at a 45° angle, deflecting it into the viewfinder pentaprism. When a shot is taken, the mirror flips up, the shutter opens and the sensor is exposed to the light.

SENSOR TYPES

Each time you press the shutter, your camera makes millions of calculations in order to capture, filter, interpolate, compress, store, transfer and display the image. At the hub of every digital camera is its sensor, or digital chip. The two most common designs are Charge-Coupled Device (CCD) and Complementary Metal-Oxide Semiconductor (CMOS). The sensor determines the camera's resolution and its image quality. Most digital SLRs take very high-resolution images, often exceeding 16 megapixels (MP). Not all sensors are the same size: the three sizes commonly used in digital SLRs are known as full frame, APS-C, and Four Thirds.

FULL FRAME

The 35mm film format has remained relatively unchanged since the late nineteenth century, and is the standard we still refer to. Full-frame digital SLRs employ a sensor equivalent to a traditional 35mm negative – 36mm x 24mm. Full-frame chips are larger and more expensive to manufacture than APS-C sensors, and are typically only found in high-specification models such as Nikon's range of FX format digital SLRs. A full-frame SLR has no 'multiplication factor' (see APS-C, below), which means that the lens attached will produce the same field of view as it would on a 35mm film camera, retaining the characteristics of that particular focal length.

Full-frame sensors have larger photosites (the light-sensitive points on the chip). As a result, they capture more light with less noise, resulting in smoother, more detailed images. Full-frame models boast superior high-ISO performance than models with a smaller chip. This is of particular appeal to nature photographers who regularly need a shutter speed fast enough to freeze subject movement.

APS-C

The majority of consumer-level digital SLRs have an APS-C size chip, equivalent in size to Advanced Photo System images, which measure 25.1 x 16.7mm. However, sensor size can vary from 20.7 x 13.8mm to 28.7 x 19.1mm, depending on the manufacturer. Being smaller than the 35mm standard, this format is often regarded as being 'cropped'. Digital SLRs that incorporate a cropped-type sensor appear to multiply the focal length of the lens attached – this is known as the multiplication factor, or focal length multiplier. The degree of multiplication depends on the exact size of the sensor, but is typically 1.5x. Therefore, a 200mm telephoto lens will effectively be 300mm (200 x 1.5) when it is attached to a cropped-sensor camera with a multiplication factor of 1.5x. For nature photography, a camera's multiplication factor will often prove advantageous, effectively extending the power and reach of the lens. As a result, photographers can employ shorter focal lengths, or work from longer distances, than would be possible with a full-frame model.

FOUR THIRDS

A Four Thirds sensor measures 18 x 13.5mm (22.5mm diagonal). It is 30–40 per cent smaller than an APS-C chip, with an aspect ratio of 4:3. This is squarer than a conventional frame, which typically has an aspect ratio of 3:2. The diameter of its lens mount is almost twice as big as the image circle, allowing more light to strike the sensor from straight ahead. This is designed to ensure sharp detail and accurate colour, even at the periphery of the frame. The smaller sensor effectively multiplies the focal length by a factor of 2x, enabling manufacturers to produce smaller and lighter lenses.

MIRRORLESS CAMERAS

Mirrorless Interchangeable-Lens Cameras (MILC) or Digital Single Lens Mirrorless (DSLM) models resemble a digital compact, but have an interchangeable lens mount. Unlike digital SLRs, they dispense with the bulky reflex mirror, replacing it with an electronic viewfinder. They combine many of the benefits of both styles of camera. Mirrorless cameras offer the versatility of an interchangeable lens system while boasting a larger chip than most compacts. Due to the absence of the mirror system, the lens can be positioned closer to the sensor. As a result, high-quality optics can be made smaller, cheaper and lighter. At present, they are not a genuine alternative to digital SLRs for serious nature photography.

LENSES

One of the key reasons why a digital SLR system is the only real choice for wildlife photographers is its compatibility with a huge range of interchangeable lenses. You can customize your system by investing in the focal lengths that suit the subjects you wish to capture – for example, longer 'telephoto' lengths for photographing birds and mammals from a distance. Lens choice is important, greatly dictating the look, feel and impact of your nature shots.

FOCAL LENGTH

The focal length of a lens determines its angle of view and the extent to which the subject will be magnified. It also helps to determine perspective (see page 52). The focal length is represented in millimetres, with a low number indicating a short focal length (large angle of view) and a high number representing a long focal length (small angle of view). Optics range greatly in design and strength: from circular fisheyes, which offer an ultra-wide, distorted perspective, to powerful telephotos exceeding 1000mm. Human eyesight is roughly equivalent to 50mm, so a lens of this range is considered to be 'standard'. Anything smaller than 50mm is typically referred to as being 'wide angle', while anything longer is considered 'telephoto'.

A longer focal length gives a greater magnification of the subject than a shorter lens from the same distance. The relationship is geometric: assuming the same subject-to-camera distance, doubling or halving the focal length will also double or halve the size of the subject in the frame. As we've seen, many consumer digital SLR cameras have a sensor smaller than the 35mm or full-frame standard (see page 13) and this effectively increases the focal length of the lens. As a result, a shorter lens is required to achieve an equivalent angle of view. It is for this reason that digital SLR/lens combinations are often stated in terms of their 35mm-equivalent focal length.

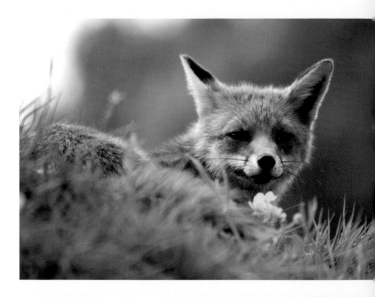

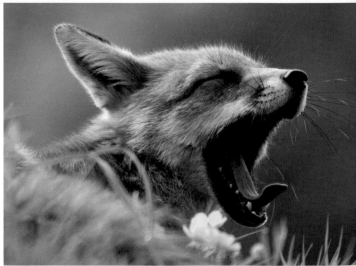

FOX (*VULPES VULPES*)
You can completely alter the look, feel and emphasis of a shot simply by adjusting the focal length. In this instance, I first photographed the (captive) fox using a focal length of 200mm. Then I zoomed in further, using the long end of my 120–400mm zoom lens to isolate the animal's head, capturing a frame-filling portrait. My position remained the same, but the two images look very different.
Nikon D300, 120–400mm, ISO 320, 1/640 sec. at f/5.6, handheld

MALLARD DUCK *(ANAS PLATYRHYNCHOS)*
Here, the light was poor, but I couldn't use a support. Without image stabilization, camera shake would have been inevitable, but with OIS switched on, I was able to capture a pin-sharp result.
Nikon D200, 80–400mm (at 400mm), ISO 200, 1/80 sec. at f/5.6, handheld

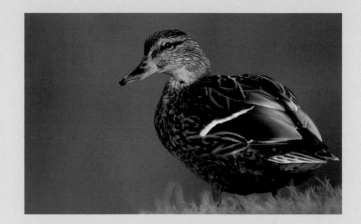

IMAGE STABILIZATION

Many modern lenses benefit from Optical Image Stabilization (OIS) technology, particularly longer focal lengths that are more difficult to handle and keep still due to their length and weight. OIS is designed to compensate for the photographer's natural movement, minimizing or eliminating the effect of 'camera shake'. 'Shake' shifts the angle of incoming light relative to the optical axis during exposure, resulting in image blur. OIS technology can allow photographers to shoot up to three or four stops slower than would otherwise be possible. Using internal motion sensors, or gyroscopes, it works in inverse relation to the movement of the lens, maintaining the position of the incoming light rays on the sensor.

Lens brands have different names for this technology but the principle is the same. Some manufacturers employ shake-reduction technology in the camera itself, rather than the lens. The advantage of this is that all attached lenses benefit.

OIS technology is a boon for nature photographers, who often have to work handheld. Long, heavy lenses naturally induce more movement, but stabilization helps to rectify the problem. Without OIS you may have to select a higher ISO sensitivity, in order to generate a shutter speed fast enough to eliminate movement – and this will affect image quality.

PRIME VERSUS ZOOM LENSES

There are two types of lens: prime and zoom. Prime, or 'fixed', lenses have a set focal length that cannot be altered. A zoom lens has an adjustable focal length, allowing you to choose from a range without having to change the lens.

Prime lenses are usually faster – for example, many prime optics have a maximum fixed aperture of f/2.8 or f/4. Faster lenses are beneficial when capturing action and when working in low light and they can be lighter and more compact. However, they can't match a zoom's versatility. Because zooms cover a range of focal lengths, you only need to carry a few lenses in total. You can remain in the same position and create different results just by zooming in and out, or react quickly to a changing situation. However, zooms designed for the consumer market tend to have a slower maximum aperture, which may not be fixed (growing progressively slower as the focal range is increased). Many have a fastest maximum aperture of just f/5.6 at the longest end.

A zoom range of 70–300mm is popular, and inexpensive. If your budget allows, avoid the most cheaply constructed zooms as they are more prone to aberrations, flare and diffraction. The best-quality zooms can now rival the image quality and speed of prime lenses, but they are costly.

LENS TYPES FOR NATURE PHOTOGRAPHY

One of the questions asked most often by participants prior to attending a workshop is, 'Which lenses should I bring?' There is no easy answer – subjects vary so much in size and type, and your choice of focal length will also be dictated by how close you can get to your subject. Typically, telephotos of 300mm or longer are most useful for bird and mammal photography, while a macro lens is best for close-up photography. However, depending on the subject, its environment and the result you wish to achieve, any focal length can be used to shoot great nature images.

TELEPHOTO

A lens with a focal length of more than 50mm is generally regarded as a 'telephoto' lens. Telephoto lenses have a narrower angle of view than the human eye, so a scene or subject appears magnified in the frame. Telephotos are available in a wide range of strengths, up to and exceeding 1000mm. They can be divided into three categories, depending on focal length: short, medium and long.

TELEPHOTO LENS
For bird and mammal photography, a focal length of at least 300mm is required. Fast, prime telephotos like this Nikkor 400mm f/2.8 are quite pricey, but there are many more affordable options available.

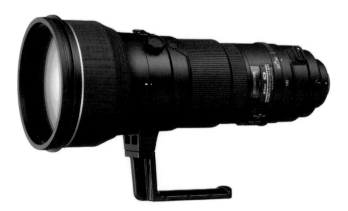

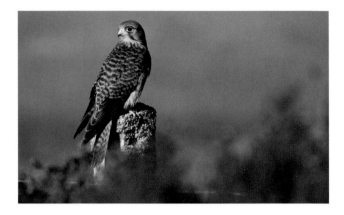

KESTREL (*FALCO TINNUNCULUS*)
Depth of field becomes progressively shallower at longer focal lengths and higher magnifications. However, as long as focusing is precise, this can help you to isolate your subject from its environment, throwing surrounding vegetation pleasantly out of focus.
Nikon D300, 120–400mm (at 400mm), ISO 200, 1/400 sec. at f/5.6, handheld

A focal length of 50–135mm is considered a 'short' telephoto. For most subjects – certainly timid ones – this focal range is fairly limited, and will not give you the reach you require. However, it is a useful range for shooting wider views of subjects, perhaps in order to show them in context with their surroundings; and also for using in combination with close-up attachments. A lens in the region of 50–100mm is ideal for use with an extension tube (see page 20).

'Medium' telephotos, typically in the region of 135–300mm, and 'long' telephotos, of 300mm or more, are most suited to wildlife photography. Their higher magnification makes them well suited to shooting animals – photographing birds from a hide, or large mammals from further away, for example. These lenses not only magnify the subject, allowing you to capture intimate images of subjects that would run or fly away if you tried to approach them, but they also foreshorten perspective. This means that elements within the frame appear closer to each other than they really are,

which can be particularly effective when you want a background subject to impose itself on the foreground.

Depth of field is inherently shallower with longer focal lengths, and front-to-back sharpness is limited even at smaller apertures. While this means that you must focus with pinpoint accuracy when using long focal lengths, a telephoto's narrow depth of field can also be a useful creative tool, helping you to isolate your subject from its surroundings. For photographing birds and mammals, a 300mm lens – prime or zoom – is generally considered a minimum, 'must-have' requirement.

PRO TIP: A focal length in the region of 50mm – roughly equivalent to our own eyesight – is considered a 'standard' lens. Standard lenses display minimal distortion and provide a natural-looking perspective. They are not generally considered the most useful lenses for nature photography, but the high-quality optics of a good, prime 50mm lens make them ideal for 'reversing' in order to shoot close-ups.

WIDE-ANGLE

A lens with a focal length shorter than 50mm is deemed 'wide-angle'. While they are often considered the preserve of the landscape photographer, wide-angle lenses, used appropriately, can produce stunning wildlife images. Their wide angle of view is ideal for shooting environmental portraits of approachable subjects or static subjects such as wild flowers. By getting close to your subject and using a short focal length, you can capture images that show your subject in context with its natural habitat – the results can convey far more about the subject and its environment than a frame-filling portrait.

One of the key characteristics of short focal lengths is the way they appear to stretch the relationship between near and far, exaggerating the scale of foreground objects. Nature photographers can use this to create images with terrific depth, dynamism and impact. Wide-angles can also create eye-catching or distorted perspectives. While it is not always possible to get close enough to your subject to shoot in this way, it is worth investing in a wide-angle – or wide-angle zoom – in the region of 17–35mm to allow you to do so when the opportunity arises. Wide-angles will give you extensive depth of field, and also usually boast a fast maximum aperture.

More extreme results can be obtained using a fisheye lens. Offering a field of view of 180 degrees or more, fisheyes typically have a focal length of 8–15mm. Two types are available: circular and full-frame. Circular fisheyes create a circular image surrounded by black edges, while full-frame fisheyes completely fill the frame. Both types create a significant degree of distortion, producing extraordinary-looking results when photographing nearby subjects.

MACRO

Macro lenses are optimized for close focusing, and are designed for photographing smaller subjects such as insects and plants. Their optics perform best at high magnifications, and they don't require any supplementary attachments to achieve a reproduction ratio of 1:1 life-size. They are typically produced in prime lengths, ranging from 40mm to 200mm. Shorter focal lengths – from 40mm to 90mm – tend to be compact and lightweight, making them portable and suitable for handheld use. Telephoto lengths – from 100mm to 200mm – offer a larger, more practical camera-to-subject distance. This makes them more suitable for shooting timid subjects such as butterflies, increasing your chances of capturing the shot without disturbing the subject.

Macro lenses are fast, normally boasting a maximum aperture of f/2.8 or faster. Such a large aperture not only helps provide a bright viewfinder image, but the shallow depth of field produced at its maximum f-stop throws background detail attractively out of focus. The disadvantage of macro lenses with longer focal lengths is that their increased size and weight make them difficult to use handheld.

If you're more interested in shooting larger subjects such as birds and mammals, a macro lens is an unnecessary investment. However, for close-up enthusiasts, a dedicated macro lens is the best choice. While it's more costly than using close-up attachments, the convenience and image quality of a macro lens is unrivalled.

CAMERA SUPPORTS

You've probably read, or been told, that you should always use a tripod to assist composition and avoid camera shake. In theory, this is sound advice. However, using a camera support is rarely practical when you're stalking wildlife, as it may stifle your ability to react quickly to the subject's behaviour. Nature photographers often have no option but to work without a support. Image-stabilization technology (see page 15) is a great aid when working handheld, and you can further maximize stability by keeping your elbows tight to your chest and holding the camera firmly to your face. Better still, lay prone on the ground, using your elbows to support your camera. But if you're photographing static subjects such as wild plants, or you're working from a hide, heed the traditional advice: always use a support.

TRIPODS

For stability, nothing can rival a tripod. While it can be heavy and inconvenient to carry, a sturdy tripod will all but eliminate camera shake and guarantee consistently sharp results – and it's a necessity when you're using long, heavy telephoto lenses. Aside from stability, tripods can help your photography in other ways too. When you're shooting static subjects, they can help to slow down the picture-taking process, giving you time to let your eye wander around the frame and fine-tune the composition.

If you don't own a tripod, or you wish to upgrade, your choice will depend on your budget, the subjects you wish to shoot, and the weight you can comfortably carry. There are numerous designs on the market, from leading brands including Benbo, Giottos, Gitzo, Manfrotto, Slik and Velbon. Avoid buying a one-piece model – not only do they tend to be lightweight, but buying the legs and head separately allows you to combine the components that best suit your individual requirements. Opt for legs that are solid and well-constructed with a good maximum load capacity, capable of supporting long, weighty telephotos. A tripod that seems sturdy in the shop may not prove to be up to the job when shooting on rough

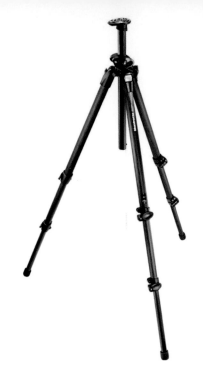

TRIPOD LEGS
The weight, versatility and affordable price tag of Manfrotto's 055 legs make them a popular choice for outdoor photographers.

ground in windy conditions, so always err on the heavy side when choosing legs – the added stability they provide will make the extra effort of carrying them around worthwhile. Opt for a design that lets you work from a low shooting angle. Select a design that will allow the legs to be splayed wide – almost to ground level – and with a centre column that can either be removed or positioned horizontally. This is important for low-level photography of animals and plants.

If your budget allows, carbon-fibre legs are a good option, as they are lighter in construction but still offer excellent stability. Due to the wide choice of designs, weights, heights and materials available, always try before buying.

TRIPOD HEADS

The benefit of buying the legs and head separately is that you can select the type of tripod head that you find easiest to work with. The range of designs may seem daunting at first, but most are a variation on either a traditional pan-and-tilt head or a ball-and-socket design. Ball-and-socket heads allow you to smoothly rotate the camera around a sphere and then lock it into position. They are quick to adjust, making them popular for nature photography, but they can be fiddly and difficult to level. A pan-and-tilt design offers three separate axes of movement – left-right tilt, forward-

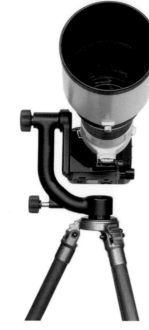

TRIPOD HEAD
Which tripod head you should buy depends on your personal preference, budget and the subjects you're likely to photograph. A geared or ball-and-socket head is ideal for close-up work, while a three-way pan-and-tilt or bracket design is traditionally better for long-lens and hide photography.

OTHER CAMERA SUPPORTS

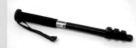

MONOPOD
A monopod is a simple camera support with a single leg. You attach the camera either via a head or directly to a screw thread. Monopods normally have two or three sections that can be adjusted to the height you require. While they can't offer the same level of stability as a tripod, their design, simplicity and excellent manoeuvrability make them well-suited to nature photography – particularly when you're stalking wildlife and using lenses without image stabilization.

BEANBAG
A beanbag offers surprisingly good support for your camera set-up when rested on a stable surface like a wall or car roof, or placed on the ground. The bag's filling naturally moulds itself around the camera and lens, absorbing movement. Beanbags are a favourite among nature photographers, because they are cheap, simple to use and, in the right situation, extremely useful. The Grippa Bag is designed in an 'H' shape, which allows it to grip onto a car door (with the window down) without sagging. This is perfect if you're using your car as a hide for photographing animals or birds.

back tilt and horizontal panning. They have three separate handles for locking the various movements and are well suited to use with heavier kit. Geared versions are also available, which – although more costly – allow you to make very precise adjustments, making them well suited to close-up work.

Another option is to use a bracket design. Due to their weight and bulk, long telephotos can be difficult to support and position when using general ball-and-socket or three-way pan-and-tilt designs. Custom brackets provide better balance for panning and tilting when using long optics. Gimbal heads such as those made by Benro, Custom Brackets, Jobu and Really Right Stuff are particularly popular. These are balanced around the central point of rotation; with camera and lens balanced at their natural centre of gravity, they seem almost weightless and are far easier to manoeuvre – perfect for tracking movement. They tend to be costly, but are a good long-term investment for users of long, fast, weighty telephotos. Most gimbal heads require use of an Arca-Swiss Type C lens plate to mount the lens to the head.

Again, test a variety of different designs before making your decision. If budget allows, you may want to buy different heads to suit different subjects. Most importantly, only buy a model that you personally find quick and comfortable to use.

PRO TIP: The majority of tripod heads are designed with a quick-release plate. This plate secures directly to the camera – via its screw thread/tripod bush and snaps on and off the tripod head to allow you to quickly attach and detach your set-up. They are not universal – the size and design of the plate varies from head to head.

USEFUL ACCESSORIES

While camera and lenses represent the biggest investment nature photographers will need to make, there are a number of key accessories that you will find useful when shooting wildlife. Here, we look at a handful of the most useful accessories that we recommend you have before going out on location.

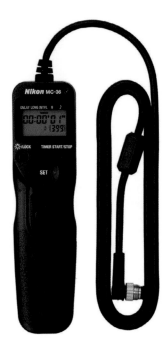

REMOTE DEVICE
When photographing static scenes, a remote cord will help you eliminate the risk of camera movement, thus maximizing image sharpness.

REMOTE CORD

This is a must for close-up photographers in particular. Even when a camera is tripod-mounted, pressing the shutter-release button can generate a small amount of vibration. Although the movement may only be slight, it can be enough to soften the image noticeably when it is enlarged or printed. To prevent this, trigger the shutter remotely using either a remote cord or a wireless device. Remote cords consist of a wire with a trigger button at the end, and attach to a digital SLR via its remote terminal. Cords vary greatly in size and design – basic models are designed with a simple trigger, while more sophisticated devices may be equipped with an electric speaker, interval timer, backlit control panel and timer. Infrared devices are useful if you wish to trigger the shutter remotely.

AUTO EXTENSION TUBES

Extension tubes are hollow rings that fit between camera and lens to extend the lens further away from the sensor plane. By doing so, they reduce the lens's minimum focusing distance. They are available in different camera-mount fittings and are constructed without any optical elements – as a result, they do not degrade image quality. They do, however, reduce the amount of light entering the camera. The higher the magnification, the more light is lost, although the camera's TTL metering will automatically compensate for this. Auto extension tubes are compact, light and retain all the camera's functions. Combined with a good-quality lens, they are capable of producing excellent results – comparable to that of a macro lens. Tubes can be bought individually, or in a set. The most common lengths are 12mm, 25mm and 36mm – the wider the tube, the

larger the reproduction ratio. They can also be combined to generate higher levels of magnification, equal to or exceeding 1:1 life-size. Avoid non-automatic versions – although cheap, they disable the camera's key automatic functions, such as metering and focusing. Not only are they useful for macro photography, but they can also reduce the minimum focusing distance of long telephoto lenses.

LENS HOOD

Lens hoods usually attach to the front of the lens via a bayonet fitting. They are designed to help prevent flare and a reduction in contrast caused by non-image-forming light. They come in a variety of shapes and sizes, designed for various focal lengths. The majority of new lenses come supplied with a dedicated hood. The most common are slightly flared, conical-shaped hoods. However, short focal lengths require a 'petal'-shaped hood, to reduce the enhanced risk of vignetting. For nature photography, a lens hood can also offer some physical protection to the front of the lens – shielding it from rain or snow, and preventing it from being scratched. Camouflage sleeves are available, which slip over the hood to help disguise the lens when it's poking out of a hide.

VERTICAL BATTERY GRIP
For bird and mammal photographers in particular, a vertical grip can be a worthwhile investment, increasing the camera's frame rate and battery life, and improving handling.

BATTERY GRIP

A vertical battery grip (or motor drive) is designed to increase the digital SLR's maximum frame rate – useful when shooting flight and rapid movement – and improve the camera's handling. Grips attach to the camera body via its battery compartment, and hold additional batteries in order to extend the battery life of the camera. Vertical grips are typically designed with an extra shutter-release button to aid shooting portrait-format images. Battery grips are normally designed to fit only one or a few specific camera models, as they must match the body's shape, connectors and power requirements.

ANGLE FINDER

An angle finder can be useful when taking pictures from a low viewpoint, as it enables you to compose images without having to contort your body to look through the viewfinder. However, with Live View now a standard function on many DSLRs, angle finders are becoming less of a necessity.

FILTERS

There are a few circular, screw-in type filters that can be useful to the nature photographer.

CLOSE-UP FILTERS

Close-up filters screw onto the front of a standard lens and act like a magnifying glass. By reducing the lens's minimum focusing distance, it is possible to capture images at higher magnifications. They are inexpensive, lightweight and available in various filter diameters. Most have a single-element construction and a range of strengths, usually +1, +2, +3 and +4. They do not affect normal camera functions or restrict the light entering the camera. They can degrade image quality though. Edge sharpness can suffer, and they are prone to 'ghosting' and spherical and chromatic aberration. However, you can maximize image quality by selecting an aperture no smaller than f/8 and combining them with better-quality optics – for example, short prime lenses, in the region of 50–135mm.

POLARIZING FILTER

The ability to reduce glare and restore natural colour saturation makes polarizers useful for nature photography. You can alter polarization by rotating the filter in its mount. You will see reflections come and go and the intensity of colours strengthen and fade. A polarizer is useful for shooting plant life, eliminating reflections and glare. They have a filter factor of up to 2 stops, so be aware that using one will lengthen exposure time.

UV/SKYLIGHT FILTER

UV and skylight filters are designed to absorb UV light, which can create a reduction in contrast. Being clear and inexpensive, they are also well suited to protecting the front element. It is far safer to clean a filter than a lens, and they are cheap to replace.

STORAGE

As a wildlife photographer, you will require two very different types of storage – bags and cases to safely house and protect your gear while walking, stalking or travelling; and digital storage on which to capture, and then back up, your valuable photographs.

Nature photographers regularly have to walk long distances to locate wildlife, possibly trekking up steep hills and mountains, over moorland or along rough paths to find the subject. It is essential to buy a camera bag that is comfortable, robust and large enough for your system. When you're photographing wildlife – particularly action – you might need to shoot numerous images in order to achieve the desired result. It is also important to own sufficient digital memory, together with the capacity to back up your images, to prevent data being lost due to a damaged, lost or corrupted card.

CAMERA BAGS

Your kit may well include one or two camera bodies, a range of focal lenses, and an array of accessories. The most comfortable type of storage for a system of this size is a backpack. Camera backpacks

F-STOP GEAR BACKPACK
A camera backpack evenly distributes the weight of your equipment, making long treks to locate subjects more comfortable.

are designed to distribute the weight of your gear across your shoulders and back. Admittedly, it is quicker to access equipment from a shoulder bag, but such bags are far less practical for the outdoor photographer. Crumpler, F-Stop Gear, Kata, Lowepro, Tamrac and ThinkTank are among the leading manufacturers of camera backpacks, and they all produce a range of sizes and designs. If you are looking to buy a new backpack, consider the following: comfort, capacity, features, build quality and price. Comfort is vital. If you are carrying a lot of weight, look for a

TRAVELLING ABROAD

Wildlife photographers often want to travel abroad to find interesting subjects. To provide the best protection and security during transit, a hard case is a good option. Peli are among the brands that manufacture hard storage designed for photographers. Their cases are indestructible, watertight and airtight. Locking panels adjust to fit any configuration, while the dividers hug equipment to protect against impact, vibration and thermal shock. This type of case enables you to securely protect, and easily carry, valuable kit – including laptops and portable storage devices – when travelling.

PELICAN 1510
The Pelican 1510 is the biggest airline-legal carry-on case available. Complete with side and front handles, and a convenient extension handle, it is an ideal, rolling travel companion, perfect for when you're shooting wildlife overseas.

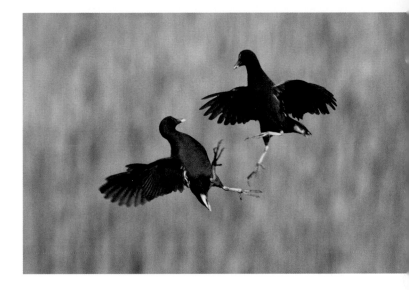

MOORHEN *(GALLINULA CHLOROPUS)*
To capture fast action, such as these fighting moorhens, you'll often need to shoot many frames in rapid sequence. Make sure your memory cards have a large enough capacity and are capable of writing data quickly.
Canon EOS-1D Mk II, 500mm, ISO 100, 1/800sec. at f/7.1

model with wide, well-padded straps so that they don't dig into your shoulders. Waist straps are also important, relieving tension from the lumbar region and helping to keep your back straight and your posture good. Capacity is a crucial consideration. How much equipment do you plan to carry, and what is the length of your longest telephoto? Most bags have adjustable internal compartments, which allow you to tailor the bag to your equipment. Opt for a bag that is slightly bigger than you presently require, so there is growing room if you buy more equipment.

Weatherproofing is important for wildlife photographers, so invest in a bag that is weather-resistant or has an internal all-weather covering. Look for accessory clips, which enable you to attach a tripod directly to the bag, rather than carrying it by hand. Has the bag got enough pockets and compartments for all your accessories? Look at the layout and try to envisage how exactly you would arrange your kit. If you need to carry a laptop, buy a model with a dedicated laptop compartment. Build quality is also important. A padded bag gives your kit plenty of protection from knocks and bumps. The fabric, zips and stitching need to withstand regular use in the outdoors. Finally, consider price. A backpack is an important investment – don't simply opt for the cheapest model. Identify the bag that satisfies your own personal demands before investing.

MEMORY CARDS

Memory cards are small but invaluable devices that are used to store your pictures. CompactFlash and SD are the two most popular forms of storage media for digital SLRs. Large-capacity cards (up to a staggering 256GB) are now relatively affordable, and are capable of storing thousands of digital files. It is best not to rely on just one

large-capacity card. Instead, opt for multiple lower-capacity cards – in the region of 16GB or 32GB – to ensure that not all your images are stored on a single card, should it get lost, or become corrupted. Always carry a number of empty, formatted cards in your camera bag so you are never short of space when out in the field and can swap cards quickly. Most cards have a fast write speed of up to 1000x (1x equates to a transfer speed of 150 Kilobytes (KB) per second). A fast write speed allows the camera to store the image on the card more quickly, so you can capture large bursts of images. Download speeds from the camera are very quick too. Ideally, opt for cards with a write speed of 133x (20MB per second) or more.

PORTABLE STORAGE DEVICES

A Portable Storage Device (PSD), photo viewer, or portable external hard drive will ensure you can keep your images backed up. PSDs are palm-sized external hard drives, capable of storing images while in the field. Most are designed with an LCD monitor to view and manage images. Small and lightweight, they can slip into a camera bag and are better suited to this type of storage than a laptop. Full cards can be transferred, allowing them to be quickly reused – although, ideally, data should be duplicated again before formatting. The capacity of portable devices varies depending on the model.

CAMERA CARE

Your camera equipment represents a significant investment, so you'll want to care for, and protect, your equipment. By keeping your kit clean and well maintained, you will ensure optimum performance and long life, maximizing its resale value.

DRY CLEANING
One of the best dry cleaning solutions on the market is the Arctic Butterfly, by Visible Dust. Its negatively charged microfibres collect dust particles from the sensor.

CAMERA CARE

Wildlife photographers tend to be quite hard on their equipment – we're always working outdoors, in all types of weather, climate and terrain. Thankfully, digital SLRs are well constructed, have decent weather sealing, and are relatively robust. That said, whenever possible, it is wise to keep them protected from dirt, sand and moisture. If your camera gets wet, wipe over the body using a soft cloth. Remove dust from the eyepiece using a blower brush, and if your camera is exposed to salt water and spray, wipe the body over with a well-wrung damp cloth to protect against corrosion. It is worthwhile keeping a small sachet of silica gel in your camera bag to absorb any moisture and prevent condensation.

SENSOR CLEANING

The electromagnetic properties of imaging sensors mean they attract dust and dirt. Dirt settling on the sensor – or its protective low-pass filter – is unavoidable, but keeping the body cap on whenever the camera isn't being used, and changing lenses efficiently, will minimize this. Most digital SLRs are designed with sensor-cleaning systems, which reduce the amount of dust settling on the sensor. However, with regular use, you will inevitably notice black specks and marks appearing on your images due to dust. At first, it is quick and easy enough to remove them using the Clone Tool or Healing Brush in post-processing. However, if you're working on large numbers of images, this soon becomes time-consuming – which means it's time to clean your image sensor.

PRO TIP: When caring for your equipment, don't overlook your tripod. If your tripod has corrosive parts, bathe the legs in warm water to loosen any sea salt, then brush. Rinse the legs before applying a small amount of oil to nuts and bolts.

Most camera retailers will have an approved technician who can do it for you, but this can prove both inconvenient and costly. Therefore, many photographers prefer to do it themselves. It is important to remember that the sensor and low-pass filter are delicate components and should be treated with great care. Cleaning is a delicate operation. Before beginning, consult your camera's manual. Most digital SLRs have a sensor-cleaning mode. This varies from model to model, but the basic principle is the same – turn the camera on, lock up the mirror and open the shutter curtain to reveal the sensor for cleaning. It is essential that the camera remains switched on, so use a freshly charged battery. With the sensor exposed for cleaning, begin by using a rocket blower to remove any particles of grit, which could potentially scratch the sensor's surface during cleaning. Always use a mechanical blower – do not use compressed air on the sensor. Now you can begin cleaning.

There are a variety of different sensor-cleaning solutions on the market. The Arctic Butterfly, made by Visible Dust, is one of the best dry cleaning methods. Its microfibres are negatively charged so, as the brush passes, it collects any particles from the sensor. For more stubborn marks, a wet clean will be required. Typically, this involves using paddle-shaped microfibre swabs, together with a dedicated, non-alcoholic, non-toxic, non-corrosive cleaning fluid. Swabs are available in different sizes, depending on sensor size. Whatever cleaning product you use, follow the instructions carefully. Place the swab at one side of the

BLOWER
A blower, such as the Giottos Rocket-Air shown here, is a useful gadget for camera maintenance. It gives a strong blast of air, perfect for removing dust from cameras and optics.

DUST COVER
Rain sleeves and dust covers will help protect your equipment from dirt and the elements. Covers that are green, or designed with a camouflage pattern, are useful when you're stalking wildlife, as they also help to disguise the camera's outline.

sensor and gently wipe across in one smooth motion. Try to get into the corners and cover the full surface of the sensor. Ensure you use a fresh, clean side of the swab for each stroke across the surface and throw it away afterwards.

LENS CARE

The lens is the 'eye' of the camera, so if it gets dirty, marked or scratched, image quality will be degraded. Attaching a lens hood will help shield the front element from rain or snow, and there are many waterproof covers on the market. However, you can't prevent dust and dirt settling on the lens. While it is best not to clean optics more than is required, it is important to keep front elements free of dirt in order to maximize image quality and reduce the risk of flare. First, use an air blower or dedicated soft brush to remove loose particles of dust and dirt. Fail to do so, and you can inadvertently rub tiny, hard particles across the lens, which may result in fine scratches. To remove smears, dirt, fingerprints or spray, use a dedicated microfibre lens cloth, using gentle, circular motions to clean the lens. Photographic wipes and lint-free 'tissues' are also available. For stubborn marks, you may require a cleaning fluid. Only buy solutions intended for photographic lenses and – unless the instructions state otherwise – apply it to the cleaning cloth, not the lens itself. Obviously, don't ever attempt to clean using ammonia or other household cleaning solutions. Don't overlook the rear of the lens – dust on the rear element can fall into the camera body and settle on the sensor. Finally, remember to keep the rear and front caps on whenever the lens isn't in use, as they protect against dust, dirt and damage.

INSURANCE

Don't forget to properly insure your valuable equipment. Never assume your kit is covered on your household policy, unless you have it in writing that your insurers are fully aware of the equipment you own and its value. Some insurers will consider a photographer 'professional' if they have sold just one or two images, or if they actively market their images on a website. This can invalidate some household policies, so clarify this with your insurance company. The combined value of your equipment can often amount to several thousand pounds. List all items with a value exceeding £1,000 and supply your insurers with serial numbers, make, model and replacement cost. Don't under-insure – it is always best to err on the side of overvaluation. Keep a list of all the equipment you own and update it regularly. This will help if you need to make a claim. For serious enthusiasts, we recommend using an insurance company that specializes in insuring photographers. It may prove money well spent.

▶ CHAPTER TWO > **EXPOSURE**

Exposure is at the very heart of photography. Before you attempt to locate and photograph wildlife, a good understanding of the mechanics of the discipline is absolutely vital. So, before we move on to the details of how to capture better nature shots, it is time for the 'workshop briefing' – a discussion of fundamental photographic technique. F-stops, shutter speed, ISO and histograms might not seem very interesting at first, but a good working knowledge of exposure will help ensure that, in the field, you are able to work quickly and creatively and can adapt to any situation. After all, when photographing wildlife, opportunities can be brief and unexpected – you have to be able to work efficiently and intuitively.

This chapter will explain exposure in a language that is understandable for beginners, but that will not patronize more experienced photographers. For newcomers, it is worth reading and reading again; and even if you are an accomplished enthusiast, it is always useful to refresh your knowledge – you may even learn something new.

MARBLED WHITE *(MELANARGIA GALATHEA)*
When shooting this image I had to apply 1-stop of negative exposure compensation to achieve a correct exposure of this marbled white butterfly against a deep black background.
Nikon D800, 150mm, ISO 100, 1/100 sec. at f/7.1, tripod

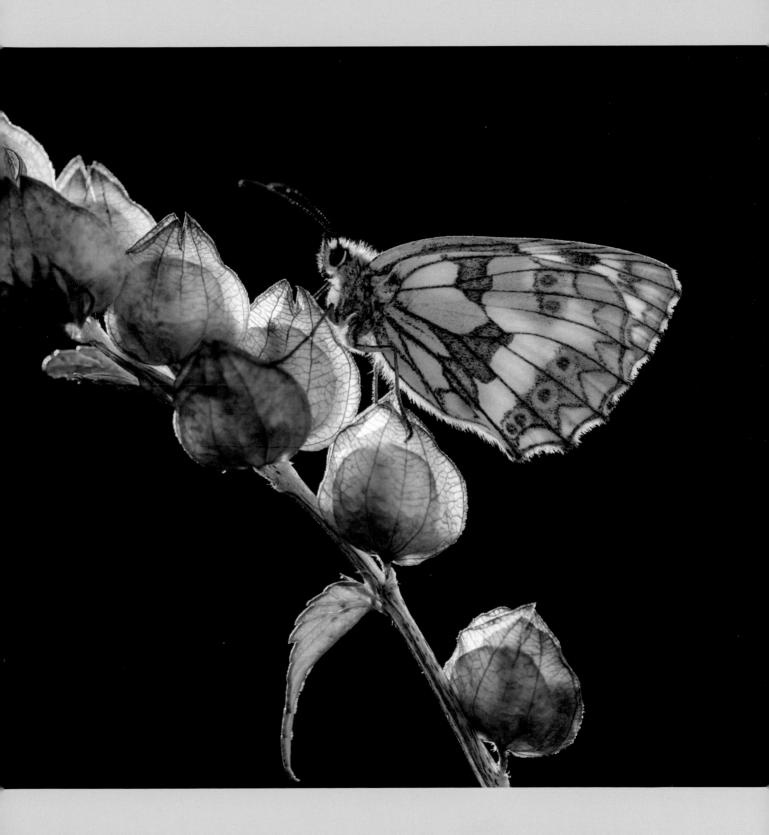

EXPOSURE

Exposure is the process of light striking a photo-sensitive material – for example, a digital sensor. While camera technology may have changed dramatically from the days when French lithographer, Nicéphore Niépce, captured the first permanent photograph around 200 years ago, the three key parameters controlling exposure remain unchanged – lens aperture, shutter speed, and the photographic material's sensitivity to light.

UNDERSTANDING EXPOSURE

How do you define a 'correct' exposure? Well, quite simply it is the exposure that achieves the result the photographer intended. If the picture is too light, it is overexposed; if it is too dark, it is underexposed. Achieving the right exposure is aided by the sophistication and accuracy of modern Through-The-Lens (TTL) metering systems. These systems are reliable under most lighting conditions, allowing wildlife photographers to work quickly and confidently when the subject is moving or the opportunity is brief. Metering systems are not infallible, though, and your camera is unable to predict the effect you are trying to achieve. Therefore, a good understanding of exposure remains vital, allowing you to efficiently correct errors and remain creative.

While it is true that digital images have a reasonable tolerance to error – particularly if you are shooting Raw format (see page 140) – it remains important to achieve the correct exposure in-camera, even in the digital age. A degree of exposure error can be corrected during post-processing using tools like Photoshop's Levels (see page 143). However, image quality is often degraded if the original is poorly exposed – for example, if a photograph is overexposed, detail can be irretrievably lost in the highlights; while brightening an underexposed image will introduce noise (see page 150), obscuring detail and sharpness. Therefore, despite the technology at your fingertips, don't become dependent on it – achieving the right exposure is just as important today as it ever has been.

EXPOSURE MODES

Digital SLRs offer a choice of exposure modes. Many models have pre-programmed 'Picture' or 'Subject' modes, tailored to that particular subject, but they offer limited control and are best avoided. Instead, rely on the 'Core Four' modes:

PROGRAMMED AUTO (P)

This is a fully automatic mode: the camera selects the most suitable combination of aperture and shutter speed. While often reliable, the camera is in complete control of the settings.

SHUTTER-PRIORITY (S OR TV)

This is a semi-automatic mode: the photographer sets the shutter speed, and the camera selects the corresponding f-stop. This mode is useful for determining the appearance of motion. It is a popular choice among bird and mammal photographers, when shutter speed is a key consideration.

APERTURE-PRIORITY (A OR AV)

This mode works in the opposite way to Shutter-priority mode: the photographer selects the f-stop, and the camera sets the shutter speed. This is designed to give control over depth of field, for example in close-up photography.

MANUAL (M)

In Manual mode, the camera's automatic settings are overridden and the photographer sets the value for both aperture and shutter speed. Select the aperture then semi-depress the shutter-release button to take a meter reading. You can apply the recommended settings by aligning the indicator with the (0) in the metering information display in the viewfinder (and/or LCD control panel). To make the image darker, move the indicator in the direction of the (–) symbol. To lighten the image, move it in the direction of the (+) sign.

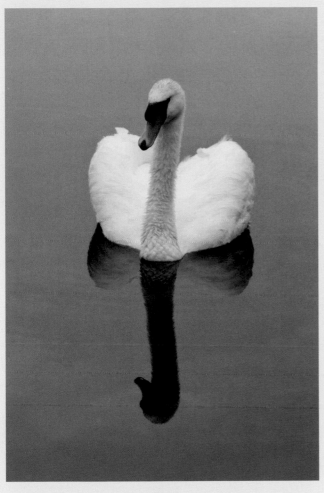

0 EV

−2 EV

−1 EV

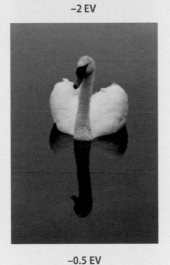

−0.5 EV

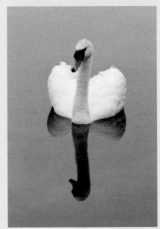

+0.5 EV

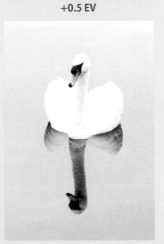

+1 EV

+2 EV

MUTE SWAN *(CYGNUS OLOR)*

A good understanding of the three exposure variables – and their relationship to each other – is essential. Underexposure (when an image is too dark), can be remedied by selecting a larger aperture, a slower shutter speed, or by increasing ISO sensitivity. Overexposure (when the photo is too light) can be corrected by making the lens aperture smaller, increasing the shutter speed, or reducing the sensor's sensitivity to light. When you have selected an appropriate combination of lens aperture and shutter speed – for a given ISO sensitivity – a change in one will require an equal and opposite change in the other. It is these three variables that control exposure.

Nikon D300, 70–200mm (at 200mm), ISO 400, 1/30 sec. at f/5.6, handheld

APERTURE

F-stops are often the cause of confusion among photographers – and not just beginners. In fact, they are actually quite easy to understand. It is essential to have a good knowledge of aperture and how it works. The aperture is the common term for the iris diaphragm of a lens, which consists of a number of thin blades that adjust inward or outward to alter the size of the near-circular hole they form (the aperture), through which light can pass. By altering the size of the iris, photographers can determine the amount of picture-forming light that is allowed to enter the lens and strike the sensor. The aperture controls the depth of field – the amount of an image that appears acceptably sharp.

UNDERSTANDING F-STOPS

It can be helpful to compare the aperture to the pupil of an eye. Pupils widen and contract to control the amount of light entering the retina. Aperture works in a similar way. Altering the size of the aperture adjusts the speed at which light can pass through the lens to expose the camera's sensor. If a large aperture is selected, light can enter quickly – so a faster corresponding shutter speed is necessary to produce a correct exposure. If a small aperture is selected, it takes longer for the light to enter the lens and expose the sensor, so a slower shutter speed is needed. Apertures are stated in numbers, known as f-stops. The aperture range varies depending on the speed

of the lens, with some optics having more or fewer settings. The typical standards for aperture are shown in the diagram below: f/2.8, f/4, f/5.6, f/8, f/11, f/16, f/22. The f-numbers relate to whole-stop adjustments. However, most modern cameras allow you to alter the aperture in 1/2- and 1/3-stop increments, for even greater control.

Confusion often arises because large apertures are represented by low numbers (f/2.8 or f/4, for example), while smaller apertures are represented by higher numbers (like f/22 or f/32). To help you remember which value is bigger or smaller, it is useful to think of f-stops as being fractions – for example, ⅛ (f/8) is smaller than ¼ (f/4). F-numbers correspond to a fraction of the focal length. For example, f/2 indicates that the diameter of the aperture is half the focal length; f/4 is a quarter; f/8 is an eighth; and so on. With a 50mm lens, the diameter at f/2 would be 25mm; at f/4 it is 12.5mm.

A lens is often referred to by its settings – maximum and minimum. Its maximum – or fastest – aperture relates to the widest setting; closing it down to its smallest setting – which allows the least amount of light through – is said to be the lens's minimum aperture.

Until fairly recently, many optics were constructed with an aperture ring, which the photographer adjusted to select the f-stop required. Today, however, few lenses are designed with an adjustable ring – instead, aperture is quickly and conveniently adjusted via the camera itself, often using a command dial or wheel.

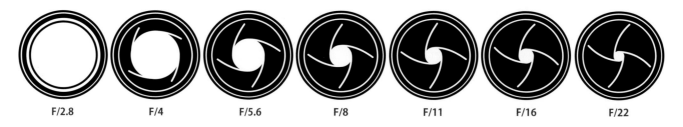

| F/2.8 | F/4 | F/5.6 | F/8 | F/11 | F/16 | F/22 |

LENS APERTURE
This graphic helps illustrate how the size of the aperture varies at different f-stops.

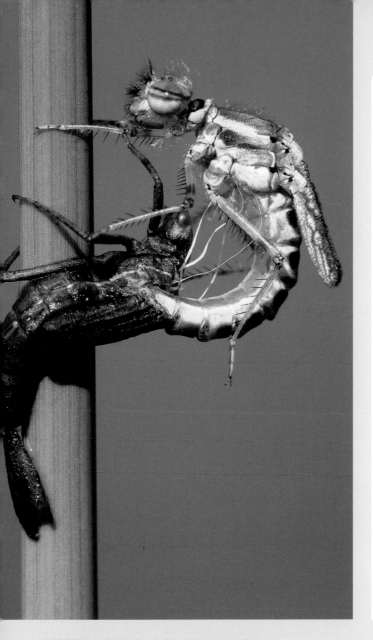

LARGE RED DAMSELFLY *(PYRRHOSOMA NYMPHULA)*
The aperture you select will have a huge effect on the look of your image. A larger aperture will help generate a faster shutter speed, but depth of field will be shallow; a smaller aperture will create more front-to-back sharpness, but the corresponding shutter speed will be slower. The aperture you choose will be dictated by a combination of available light, your environment, and the effect you desire. In this instance, as the subject was static, I could opt for a relatively large aperture of f/13 to render this hatching damselfly pin-sharp throughout.
Nikon D70, 150mm, ISO 200, 1/30 sec. at f/13, tripod

DEPTH OF FIELD

Adjusting aperture size not only alters the speed at which sufficient light can pass through the lens to expose the sensor, but it has a visual effect too – determining the area in your image that is recorded in sharp focus. This zone is known as depth of field.

Depth of field is a crucial creative tool. At large apertures, like f/2.8 or f/4, depth of field is narrow. This will throw background and foreground detail quickly out of focus, reducing the impact of any distracting elements within the frame and helping to place emphasis on your subject or point of focus. In contrast, select a small aperture, like f/16 or f/22, and depth of field will be extensive, helping capture good, acceptable sharpness throughout your wildlife shots.

While the aperture is the overriding control dictating depth of field, it is also affected by the focal length of the lens and the subject-to-camera distance. For example, longer focal length lenses produce a more restricted depth of field than those with a shorter range. The distance between the camera and the object being photographed also has a bearing on depth of field – the closer you are to the subject, the less depth of field you will obtain in the final image. This is one of the reasons why it can be so challenging to achieve sufficient focus when shooting at high magnifications.

PRO TIP: Lens aperture has a reciprocal relationship with shutter speed (see page 32) – a change in one requires an equal and opposite adjustment in the other to achieve the same level of exposure.

SHUTTER SPEED

The shutter speed determines the length of time the camera's mechanical shutter stays open during exposure, and hence the amount of light that enters the camera. If this length of time is too short, insufficient light will reach the sensor and the image will be too dark (underexposed). If the shutter is open too long, too much light will strike the sensor and the resulting image will be too bright (overexposed). Shutter speed has a reciprocal relationship with lens aperture (see pages 30–1).

SHUTTER SPEED

At the time of writing, the fastest shutter speed available on any digital SLR is 1/8000 sec.; the slowest is typically 30 seconds. Shutter speeds longer than this can be selected using the camera's Bulb setting, which can be useful in very low light. The exact length of the shutter speed required depends on the available light, aperture and ISO selected, and the result you desire.

Shutter speed has a pivotal role in how an image is formed. Although designed to ensure that the right amount of light reaches the sensor to achieve a 'correct' exposure, photographers can alter the way the subject is recorded by varying the shutter speed/aperture equation. By adjusting the shutter speed you can control how subject motion is recorded. A fast shutter will freeze the subject, while a slow speed will normally blur subject movement – useful for creating the impression of motion (see pages 50–1). For example, if you wish to freeze the motion of a bird in flight, you would prioritize a fast shutter – ideally, 1/1000 sec. or faster. If you wished to be creative, you might opt for a speed of 1/30 sec. or slower to generate motion blur, to help create an impression of subject movement. Wildlife is rarely static – even plants and flowers move in windy weather. Deciding how you wish to capture motion is an important decision. The shutter speed you select will greatly affect the look and feel of the final image, so it can be an important creative tool.

Changes in shutter speed – and aperture – values are referred to in terms of 'stops'. A stop is a halving or doubling of the amount of light reaching the sensor. For example, altering shutter time from 1/500 sec. to 1/250 sec. will double the length of time the shutter is open; adjusting it to 1/1000 sec. will halve exposure time. Almost all modern cameras allow exposure to be adjusted in stop, 1/2-stop and 1/3-stop increments, for optimum control.

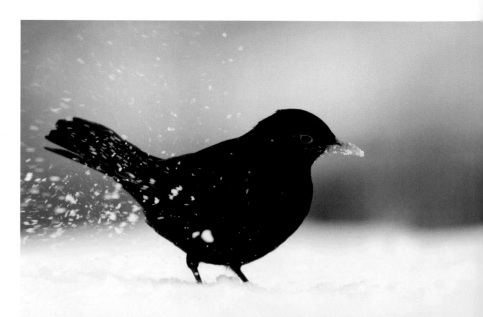

BLACKBIRD *(TURDUS MERULA)*
Subject movement is recorded very differently at different shutter speeds. You can create the impression of motion by selecting a slow exposure, or suspend movement by choosing a fast shutter speed. In this instance, a relatively quick speed of 1/800 sec. froze this blackbird's movement – and the disturbed snow – as it searched for food.
Nikon D300, 120–400mm (at 400mm), ISO 400, 1/800 sec. at f/5.6, handheld

PRO TIP: If you're not using a
camera support or image-stabilization
technology (see page 15), it is important
to select a shutter speed fast enough
to eliminate 'camera shake'. A good
general rule is to select a speed that
is equivalent to or exceeds the focal
length of the lens. For example, if you're
using the long end of a 70–300mm tele
zoom, opt for a shutter speed of 1/300
sec. or faster. Doing so will help avoid
blurred images.

ISO SENSITIVITY

ISO (International Standards Organization) equivalency refers to a sensor's sensitivity
to light. It is a term adopted from film photography, when film was rated depending
on the way it reacted to light. A low ISO rating – or ISO number – is less sensitive to
light, meaning it requires more exposure. A high ISO rating is more sensitive to light,
so it requires less exposure. Every doubling of the ISO speed halves the brightness of
the light (or the length of time required) to produce the correct exposure, or vice versa.

The sensitivity of a DSLR's image sensor is measured in much the same
way as film. For example, an ISO equivalency of 200 would react to light in an
almost identical way to a roll of film with the same rating. Digital cameras allow
photographers the luxury to alter ISO sensitivity quickly and easily from one frame
to the next if required. However, at higher ISO ratings, the amount of signal 'noise'
(see page 150) will increase. Noise degrades image quality, so it is always best to
select the lowest practical ISO rating. Therefore, if your camera is designed with an
Auto ISO feature, ensure it is disabled and select the ISO sensitivity manually.

While a low ISO will produce the highest-quality result, the high ISO performance
of the latest generation of digital SLRs is so good – particularly on the full-frame
models – that photographers can confidently use ISO speeds of 1600 or higher, and
achieve perfectly usable results. These improvements in sensor technology are of
particular benefit to wildlife photographers, who often wish to shoot movement in
limited light. Being able to shoot at high ISO creates new opportunities and allows
photographers to capture images of nature that were not possible before.

SOUTHERN HAWKER DRAGONFLY
(AESHNA CYANEA)
*The excellent high-ISO performance of
the most recent digital SLRs creates new
opportunities for nature photographers.
For example, to freeze the rapid movement
of this dragonfly in flight, I required a fast
shutter. The light was insufficient to generate
the speed I required, and the image was
only possible because I was able to 'up'
the ISO sensitivity.*
*Nikon D300, 70–200mm (at 200mm) TC-20E III,
ISO 1000, 1/1250 sec. at f/5.6, handheld*

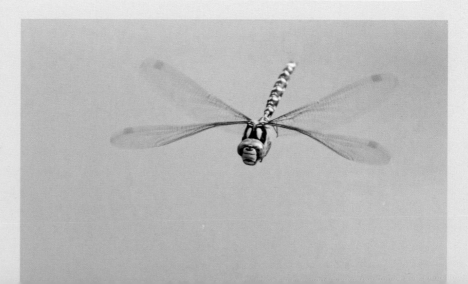

HISTOGRAMS

While the principles of exposure remain largely unaltered since the days of the first, pioneering photographers, digital technology has given us a far greater degree of creative control. Of all the new tools available, the histogram is the most useful. A histogram is essentially a graph that represents the range of tones contained in an image. Interpreted correctly, it can help ensure that you achieve a correct exposure every time.

USING THE HISTOGRAM

When you replay an image on your camera's LCD monitor, you can scroll through several pages of picture information. Of these, the most useful is the histogram screen, which provides a graphic illustration of how the tones are distributed in that particular image. A histogram typically resembles a range of mountain peaks. The horizontal axis represents the picture's range from pure black (0, far left) to pure white (255, far right); the vertical axis shows how many pixels have that particular value.

When a histogram displays a large number of pixels grouped at either edge, it is often an indication of poor exposure. For example, a large peak to the left of the graph can indicate underexposure, while a sharp peak on the right side of the graph usually means the shot is overexposed, with detail lost in the highlights – this is also referred to as 'clipping'. A graph with a narrow peak in the middle – with no black or white pixels – represents a photograph that lacks contrast. With practice, reading histograms becomes second nature. Although photographers often strive to achieve a 'perfect' histogram – one that shows a good range of tones across the horizontal axis, with the majority of pixels positioned around the middle (128, the mid-point) – in reality, there is no such thing as a 'good' or 'bad' histogram. A histogram simply tells you how an image is exposed, allowing you to decide whether – and how – to adjust the exposure settings. The look of the histogram varies depending on the subject matter and the result you want. When assessing exposure using the histogram, consider the subject's brightness. For example, if you're photographing against a snowy background, expect the graph to be skewed to the right. In contrast, a silhouetted subject will produce a graph biased to the left. Therefore, while an even spread of pixels throughout the greyscale is considered desirable, you need to use your own discretion.

By regularly reviewing histograms, you will quickly learn to identify exposure errors. You can rectify these problems using exposure compensation, and then reshoot.

EXPOSURE COMPENSATION

Metering systems are not infallible. Light meters work on the assumption that the subject being photographed is a mid-tone. This will produce correct results in most situations, but high-contrast scenes, back-lit subjects, and predominantly dark and light subjects may 'fool' your camera. Thankfully, many of the errors your metering system is likely to make are predictable with experience. Exposure error is relatively straightforward to correct using exposure compensation. If an image is too light, shorten exposure by applying negative (–) compensation. If it is too dark, dial in positive (+) compensation to lighten the shot. Use the image's histogram to guide you as to how much compensation is required. Most digital SLRs have a dedicated exposure compensation button – simply enter the level of compensation you require by pressing the button while simultaneously rotating the command dial or wheel. Most allow exposure compensation to be applied in 1/3-stop increments.

INTERPRETING HISTOGRAMS

*Ideally, a histogram should show a good
spread of tones, covering at least two-thirds
of the graph. However, very light or very
dark subjects – for example, a frame-filling
shot of the white plumage of a swan or the
dark fur of a black bear – will naturally
produce histograms weighted to one side
of the graph. The histogram isn't indicating
poor exposure – the graph is simply
representative of the subject. The two images
shown here are both correctly exposed, but
have very different-looking histograms due
to the subject matter and backgrounds.*

MEADOW PIPIT *(ANTHUS PRATENSIS)*
*Nikon D300, 120–400mm (at 360mm), ISO 320,
1/1000 sec. at f/5.6, handheld*

MARBLED WHITE *(MELANARGIA GALATHEA)*
*Nikon D300, 150mm, ISO 100, 1/30 sec. at f/7.1,
tripod*

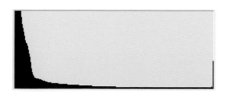

PRO TIP: Most digital SLRs also
have a Highlights warning screen
among their playback functions.
If the highlights in an image exceed
the sensor's dynamic range, they
will be seen to flash or blink, providing
a quick exposure warning.

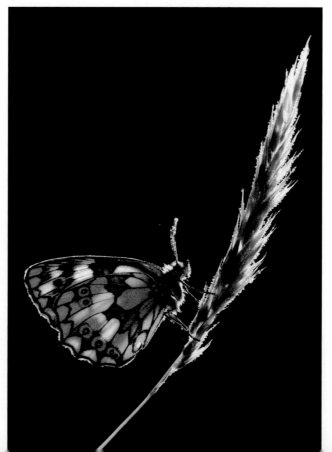

35

WHITE BALANCE

White balance is a camera function designed to neutralize colour casts produced by different colour temperatures. Our eyes are so sophisticated that they naturally adjust for the light's temperature, natural or artificial, enabling us to always see it as white or neutral. A digital chip isn't quite so clever, though, which is why it needs a helping hand in the form of white balance.

PRO TIP: If you shoot in Raw (see page 140) you can easily adjust white balance during processing. Raw conversion software allows you to fine-tune a photo's colour temperature, or even change it completely. However, if you shoot JPEGs, it is important to set the correct white balance in-camera.

COLOUR TEMPERATURE

Every light source contains varying amounts of the three primary colours: red, green and blue (RGB). Lower temperatures have a greater percentage of red wavelengths, so appear warmer; higher temperatures have a greater proportion of blue wavelengths and appear cooler. The temperature of light is measured in degrees of Kelvin (°K). For example, the warm light of a candle has a low value of around 1,800°K, while shade under a cool blue sky is equivalent to around 7,500°K. Light is considered neutral at circa 5,500°K (roughly equivalent to the RGB wavelengths of white light).

To capture colour authentically, photographers need to match the colour temperature of the light falling on the subject with the appropriate white balance value. To help, digital SLRs have an Auto White Balance function, whereby the camera looks at the overall colour and sets the white balance using a 'best guess' algorithm. This setting can be relied upon to produce natural-looking results in most types of light. Cameras are also programmed with a variety of white-balance presets, designed to mimic a range of common lighting conditions – for example, Daylight, Cloudy, and Shade. By setting the white balance to a specific colour temperature, the photographer is actually informing the camera that the light is that colour, so that the camera can bias settings in the opposite direction. Although the pre-programmed values do not guarantee exact colour reproduction, they help you get close to it.

It is also possible to customize white balance by selecting a specific colour-temperature value. However, it would be unusual for a nature photographer to have the opportunity to be this accurate. It is the light's colour, quality and warmth that often helps 'make' the image. Most nature photographers rely on either Auto White Balance or the camera's Daylight setting for ease and speed, and fine-tune colour temperature later. While intended for correction, white balance can also be employed creatively. By mismatching white balance, it is possible to create colour casts. For example, if in daylight you select the camera's Incandescent or Fluorescent preset, you create a cool blue hue. Wildlife photographers usually record subjects naturally, but it is worth knowing that the most pleasing result will not always be created by choosing the technically correct colour temperature.

COLOUR TEMPERATURE CHART

The chart below shows the colour temperatures (in degrees Kelvin) of various light sources.

1,800–2,000°K	Candle flame
2,500°K	Torch bulb
2,800°K	Domestic tungsten bulb
3,000°K	Sunrise/sunset
3,400°K	Tungsten light
3,500°K	Early morning/late afternoon
5,200–5,500°K	Midday/direct sunlight
5,500°K	Electronic flash
6,000–6,500°K	Cloudy sky
7,000–8,000°K	Shade

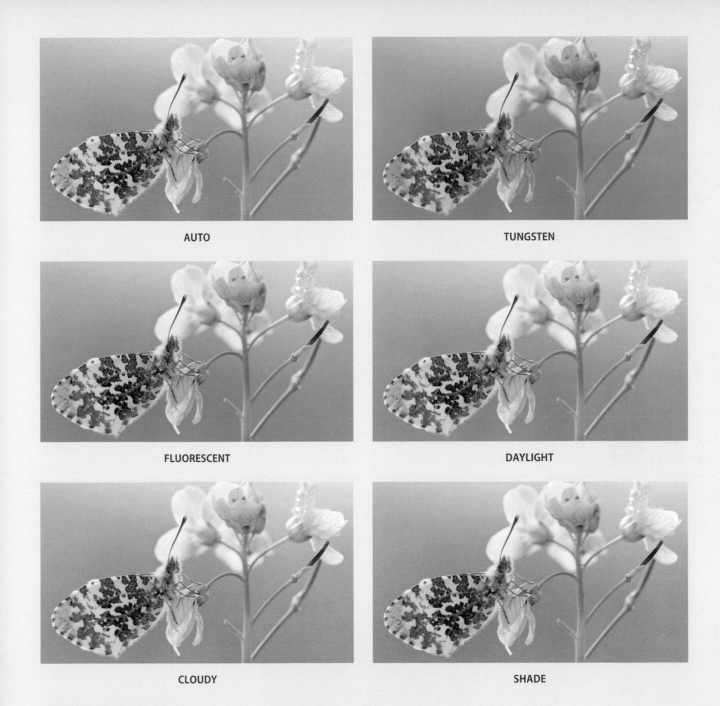

AUTO

TUNGSTEN

FLUORESCENT

DAYLIGHT

CLOUDY

SHADE

WHITE BALANCE COMPARISON
ORANGE TIP *(ANTHOCHARIS CARDAMINES)*
The series of images above help to illustrate the effect of different white balance settings. Presets such as Tungsten
and Fluorescent, which are designed to correct a low colour temperature, will cool down an image. Settings such as
Cloudy and Shade, designed to balance a high colour temperature, will produce a warm cast. More often than not,
wildlife photographers will wish to select the correct white balance setting in order to record their subject authentically.
In the examples above, the Daylight setting, equivalent to 5,500°K, produces the best, most natural result.
Nikon D300, 150mm, ISO 250, 1/320 sec. at f/5.6, tripod

HIGH-KEY AND LOW-KEY PHOTOGRAPHY

High-key and low-key are terms that describe an exposure that is predominantly light or dark. A high-key image is bright and dominated by light, white tones – a mountain hare, in winter coat, against a snowy backdrop, for example. A low-key image is dark with minimal lighting and the majority of the tones occurring in the shadows. Judging by this description alone, you might expect high- and low-key images to lack impact and contrast. In fact, both styles can produce evocative nature images.

HIGH-KEY AND LOW-KEY IMAGES

High-key is a popular photographic style among product and portrait photographers – it is generally considered to flatter subjects and convey a positive, upbeat mood. However, high-key photography can prove equally well-suited to natural-history subjects, helping to create clean, simple images that highlight beauty, shape and form. While commercial photographers can carefully light their subject in a studio environment to create high-key results, nature photographers generally don't have this level of control. Unless you're using a field studio – where you introduce a white backdrop and employ multiple flashguns to create high-key images of small subjects – high-key images are usually only possible in certain conditions or environments – snow, ice, mist and sky are the type of natural backdrops that will give high-key results. They work particularly well when combined with light-coloured subjects, the resulting photo being predominantly white or brightly lit, with little mid-range tonality – for example, a gull, avocet or egret in flight against a plain white sky. For more extreme, artistic results, push the level of exposure to the point where the subject's

brighter surroundings are close to overexposure, but the subject itself isn't washed out – you can do this either in-camera, or during processing. Doing so will help create a simple, bleached backdrop devoid of colour or detail.

Low-key images have a high percentage of dark tones, with few highlights. The controlling colour is black and a subject's shape and form is usually highlighted by a degree of back- or side-lighting. By positioning yourself carefully, you can often affect the look of a subject's background. For example, it is possible to create low-key results by aligning yourself so that an area of shade forms the subject's background, creating a clean, inky-black backdrop.

High- and low-key styles employ intense contrast to convey mood. High-key images are light, bright and positive; low-key shots are often dramatic and striking. Capturing such images presents a few exposure challenges. TTL (Through-The-Lens) metering systems are calibrated to always give a reading for a mid-tone – or 18% grey. While this is normally reliable and accurate, errors are far more likely to occur when photographing subjects predominantly lighter or darker than this mid-tone. The camera's metering will still attempt to set a mid-tone value – but you want subjects that are lighter or darker than mid-tone to appear so. Typically, TTL metering will automatically render high-key subjects too dark, and low-key scenes too bright. Therefore, a degree of positive (+) exposure compensation will normally be required when shooting high-key subjects, and negative (–) exposure compensation for low-key images.

PRO TIP: Histograms representing high-key images will typically show peaks to the right of the graph; in low-key shots, the majority of pixels will be grouped left of centre. In such cases, the histogram is reflecting the picture style, rather than indicating poor exposure.

METERING MODES

The way your camera calculates exposure is determined by the metering pattern used to measure the light reaching the metering sensor. Digital SLRs offer a choice of metering patterns – typically multi-segment (or evaluative), centre-weighted and spot.

MULTI-SEGMENT

Multi-segment metering is the best choice for wildlife photographers in most situations. Typically the camera's default setting, it works by taking multiple, independent light readings from various parts of the frame, before calculating the overall exposure. Multi-segment metering is most effective when the subject is predominantly mid-tone – only high-contrast and back-lit subjects are likely to deceive it.

CENTRE-WEIGHTED

This is the oldest form of TTL metering, but is still found on the majority of digital SLRs. The system works by averaging the light reading over the entire scene, but with the reading – typically 75% – biased to the central portion of the frame. Centre-weighted metering works on the assumption that the main subject will be central in the frame. While the system still has its uses, it has been greatly superseded by the sophistication of multi-segment metering.

SPOT

Spot is the most precise form of TTL metering, calculating exposure based on just a small portion of the frame. As a result, it is not influenced by light or darkness in other regions. Typically, spot metering employs a reading from a central circle covering just 1–4% of the frame. Spot metering gives optimum control over exposure. By overlaying the metering spot – or sensor – on the subject area you wish to meter from, you can achieve precise readings for small, specific regions.

MUTE SWAN *(CYGNUS OLOR)*
High-key images are bright and dominated by light, white tones. Shooting a subject against a bright backdrop can help create simple, clean portraits or atmospheric, arty-looking results. In this instance, mist formed the backdrop for a mute swan, gliding over the water. I dialled in an exposure value of +2EV to create this high-key effect – a value that pushed the exposure as far as possible without clipping the highlights.
Nikon D300, 70–200mm (at 200mm), ISO 200, 1/200 sec. at f/7.1, handheld

PUFFIN *(FRATERCULA ARCTICA)*
High- and low-key images can be striking, but subjects will often fool metering systems because they are dominated by either light or dark tones. For images like this, careful metering is often required. A spot meter reading was taken from the puffin's head to help ensure correct exposure.
Canon EOS 1D Mk II, 500mm, ISO 200, 1/2000 sec. at f/4.5, handheld

EXPOSING TO THE RIGHT (ETTR)

Histograms (see pages 34–5) have made it easier than ever before to achieve the right exposure. A quick glance at a picture's histogram will tell us all we need to know, helping to avoid errors such as blown-out highlights. However, if you shoot in Raw (see page 140) – the format we recommend – there is a technique known as exposing to the right (ETTR), which will enable you to generate larger, higher-quality Raw files. While it is worth underlining that this technique is not always practical for nature photography – particularly if you're shooting active subjects – it is good practice to always expose to the right when the situation allows.

MAXIMIZING IMAGE QUALITY

While ETTR is generally considered an advanced technique, the principle is easy to understand. That said, applying it precisely does require care. ETTR requires the photographer to expose a picture so that the histogram is pushed as far to the right of the graph as possible, without the highlights becoming clipped. Push the exposure by applying positive (+) exposure compensation. Doing so will produce Raw files that contain more tonal information and that suffer less from the image-degrading effects of noise. This is a result of the way that digital sensors work.

Typically, CCD and CMOS chips have a dynamic range (i.e. the range of tones the chip can record, from brightest to darkest) of around six stops. Most digital SLRs can capture a 12-bit image file, capable of recording 4,096 tonal levels (the higher the number of tonal levels, the smoother the transition between the tones in an image). However, an image's tones are not spread evenly throughout the sensor's brightness range. While you might assume that each stop in the sensor's six-stop range would contain an equal number of tones, this isn't so. This is because sensors are linear devices, and each stop records half the light of the previous one. For example, half the tonal levels are found in the brightest stop (2,048); half the remainder (1,024) is devoted to the next stop, and so on. As a result, the last and darkest of the six-stop range contains only 64 brightness levels. You may be wondering why this is relevant. Well, if an image is underexposed, and you try to brighten the image during processing, the tonal transitions will not be as smooth, because you are working with fewer tonal levels and the risk of posterization – abrupt changes in tone and shading – is high. However, if you record more data in the sensor's brighter stops, you will capture far more tonal information. The difference in file quality is easy to illustrate by simply taking two images – one exposed normally and the other exposed to the right. Compare the file size and you will notice that the ETTR image is larger. This is because the file contains more valuable data – the difference can be as much as several megabytes. Don't just trust us; try it for yourself.

At first glance, ETTR images look poorly exposed. They appear bright, washed-out and lacking in contrast. In fact, they can look awful when reviewed on the camera's monitor. Don't let this put you off, though – trust the technique. As long as you push exposure carefully, regularly reviewing the histogram to ensure that the highlights don't actually clip, you won't go wrong. The technique requires good post-processing skills. Using your Raw converter software, adjust the exposure, brightness and contrast sliders to restore the natural look of the subject, and achieve a 'technically' correct-looking result. Admittedly, ETTR images require you to invest more time, thought and effort, but the final image will contain more tonal information and display smoother tonal transitions, and will therefore withstand larger reproduction without noticeable loss in picture quality.

Another benefit of ETTR is that it produces far cleaner, less noisy images. Noise is present to some degree in all digital images, even those shot at low ISOs. However, it is most prevalent in the shadow areas, so by biasing exposures towards the highlights, noise is kept to a minimum.

The ETTR technique involves using longer exposures than would otherwise be required. For wildlife photography, this isn't always practical. When you're photographing action, such as flight

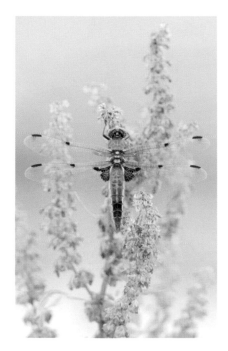

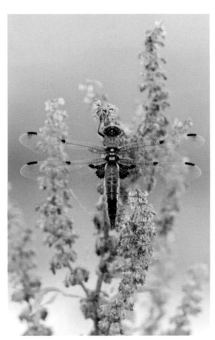

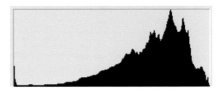

FOUR-SPOTTED CHASER DRAGONFLY (LIBELLULA QUADRIMACULATA)
At first glance, the image on the left looks washed out and overexposed. However, by pushing exposure as far to the right of the histogram as possible – without clipping the highlights – you record more data and generate a cleaner file. In your Raw converter, adjust the exposure, brightness and contrast to achieve a 'technically' correct-looking exposure (see right-hand image). Expose to the right whenever the subject or situation allows.
Nikon D300, 150mm, ISO 200, 1/60 sec. at f/4, tripod

or an animal running, a fast, workable shutter speed is the priority. After all, there is no point exposing to the right to achieve a better file if, as a result of the length of the exposure used, the subject is blurred. Like most things in photography, you have to compromise – assess the situation and prioritize accordingly. However, when a subject is static, ETTR is a technique we encourage, to help ensure you capture the best-quality images possible.

NOISE

Image noise shows as brightly coloured pixels that appear all over the image. Some degree of noise is present in any electronic device that transmits or receives a signal. While noise is almost invisible at a camera's lowest ISO rating, if you increase the sensor's sensitivity to light, noise is amplified. This is like turning up the volume of a radio with bad reception. It amplifies the (desired) music, and the (undesired) interference.

There are different types of noise, for example, 'random' or 'fixed pattern' noise. Noise is also affected by longer exposures. For this reason, many digital SLR cameras have a long-exposure noise-reduction (NR) facility. This works by taking a dark frame and subtracting the background noise from the final image. In reality, it is rare for nature photographers to employ exposures of this length, so the function is best switched off. Advances in sensor technology have vastly reduced the effects of noise, to the point that even at relatively high ISO ratings, ISO 3200 or higher, image quality remains good. However, it is still advisable to select the lowest ISO possible in any given situation.

The effects of noise can be reduced using noise-reduction software during post-processing.

CHAPTER THREE > **COMPOSITION**

Composition is the age-old art of arranging the elements within the frame into the most visually pleasing, stimulating order. It is key to successfully communicating your ideas, vision and message. The two biggest compositional challenges are how to balance the elements within the picture, and how to represent three dimensions in a two-dimensional medium. Nature photographers have colour, space, balance, symmetry, perspective, scale, motion, depth and lighting at their disposal to help bring their compositions alive. However, as nature rarely stays still for long, wildlife photographers often have to make decisions quickly. In time, you will start to do this intuitively. However, at first, there are a number of useful compositional 'rules', tips and techniques designed to help you capture striking, well-balanced images every time.

GREAT CRESTED GREBES *(PODICEPS CRISTATUS)*
This image combines two of the most effective 'rules' of composition. First, the grebes are placed nicely on a dividing third (see page 44); second, negative space (see page 48) is employed to create scale, context and atmosphere. The picture also illustrates the fact that simplicity is often key to a strong composition.
Canon EOS-1D Mk II, 100–400mm (at 130mm), ISO 100, 1/400 sec. at f/5.6, tripod

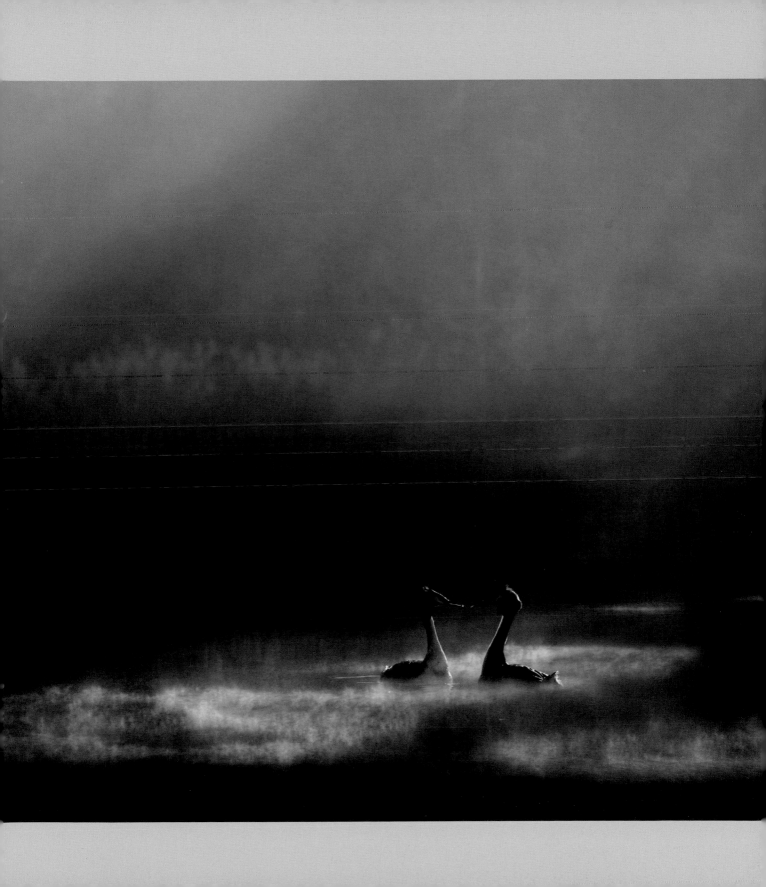

THE RULE OF THIRDS

The goal for any photographer is to achieve consistently strong compositions, with a good balance between the key elements in the frame. There are many different ways to achieve this, but the most reliable and effective approach is to use the rule of thirds. First developed by painters centuries ago, the technique remains just as relevant and useful to visual artists today. It is no coincidence that the vast majority of successful nature images conform to this rule.

APPLYING THE RULE OF THIRDS

To apply the rule of thirds, imagine two horizontal and two vertical lines splitting the viewfinder image into a grid of nine equal parts. The intersecting lines create four 'power points'. According to the rule, placing your subject – or a key element of it – on, or near, one of the points produces a more balanced, spatially interesting composition. It is often considered a rule most applicable to landscape photography, but it applies to just about any subject – and particularly wildlife. For example, if you're photographing a frame-filling animal portrait, you might position the subject's eyes on an intersecting third; or, if you're shooting a wide-angle environmental shot, you would avoid placing the horizon centrally. Some photographers argue that the rule of thirds is a cliché, or that it is too restrictive. However, in reality, the majority of successful images will conform to the theory in one respect or another. The rule is a simplified version of a tried and tested proportion known as the Golden Ratio – or the Golden Section, when applied to a rectangle. The rule encourages you to avoid placing the subject centrally in the frame, which can produce static-looking results. Naturally, there are always exceptions to the rule. For example, you might want to place the subject centrally to emphasize symmetry (see page 56). However, more often, placing key points of interest off-centre tends to encourage the viewer's eye to explore the image. If you study your own – or other photographers' – images, you will quickly notice that in the majority of them, the subject, or a strong point of interest, is situated on or near a power point. The rule of thirds is a simple compositional guideline – apply it to your nature images, and they will have greater energy, interest and impact.

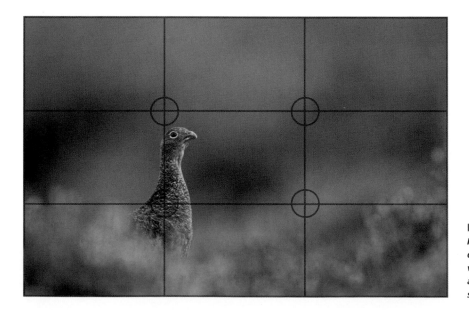

RED GROUSE *(LAGOPUS LAGOPUS SCOTICA)*
Imagine a grid overlaying your viewfinder, dividing it into thirds horizontally and vertically. The points where the lines intersect are particularly powerful points to place your subject, or key elements of interest.

ARCTIC TERN *(STERNA PARADISAEA)*
The rule of thirds is relatively simple to apply,
but can dramatically improve composition.
Compare the following shots – one with the
bird placed in the centre of frame; the other
with the tern placed on an intersecting third.
Most would agree that the image that is
composed according to the rule of thirds is
far more dynamic and visually interesting.
Canon EOS-1D Mk II, 100–400mm (at 275mm),
ISO 50, 1/80 sec. at f/5.6, handheld

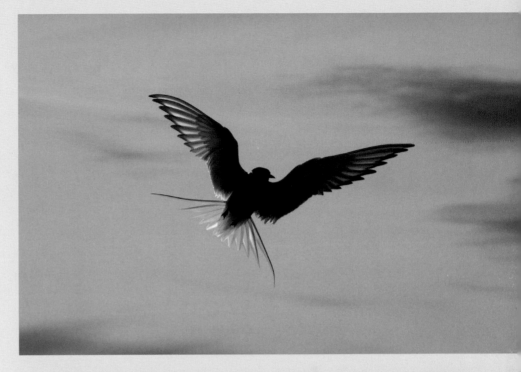

PRO TIP: Some digital SLRs allow
you to overlay a rule of thirds grid in
the viewfinder – or during Live View
operation – to aid composition. The
function is normally accessed via a
menu setting. Consult your camera
manual to find out whether your
camera has this facility.

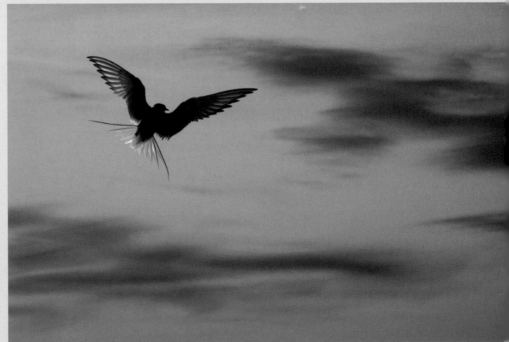

45

THE RULE OF ODDS

Although the rule of odds isn't discussed as often as the rule of thirds, it is a useful and effective guideline in relevant situations. It is also remarkably simple: odd numbers within a composition tend to create more aesthetically pleasing results than photographs that contain an even number of subjects. Nature photographers typically have little or no control over their subject, but if you apply the rule when you can, you will find that it results in stronger compositions.

AN ODD RULE?

The rule of odds states that an odd number in an image is more interesting and, therefore, more pleasing to the eye. The rule is particularly relevant to wildlife photographers who regularly photograph small numbers of animals in family or social groups. There are various arguments as to why this works. The most logical answer is that an odd number creates a natural frame – there will always be a central subject. Our eye naturally searches for the centre of the group, so if there is an even number, there is a risk that the viewer's eye will settle in the negative space between the animals. The rule is relevant when you are trying to achieve a visually pleasing composition of small groups of animals; three is a particularly strong number, as a line or triangle will be formed – both of which are interesting and desirable within a composition.

However, the rule doesn't apply to larger groups of animals. As soon as numbers enter double figures, the number simply translates to our brains as 'many' – for example, it isn't of any real significance whether there are 21 or 22 wading birds feeding together! As with any compositional rule, there will always be exceptions. For example, you will only include two subjects when photographing, say, courting grebes or stags fighting. However, intentionally including a third key element within the composition will bring a sense of harmony.

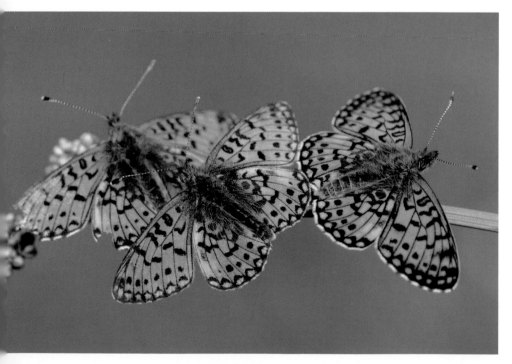

SMALL PEARL-BORDERED FRITILLARY BUTTERFLIES (*BOLORIA SELENE*)
The rule of odds is easy to understand: an odd number of subjects is more visually interesting than an even number. Three and five are particularly strong numbers, creating a frame for the central subject. This rule is not always easy or possible to apply, but when the opportunity allows, your compositions will benefit.
Nikon D300, 150mm, ISO 200, 1/60 sec. at f/9, tripod

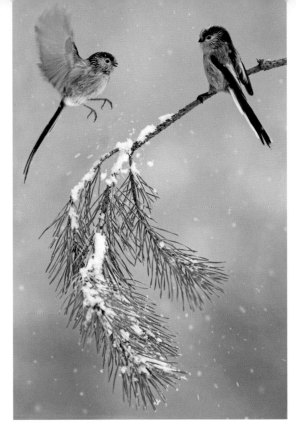

LONG-TAILED TITS
(AEGITHALOS CAUDATUS)
Birds and mammals are often found in pairs, making it difficult to apply the rule of odds. However, try including another key element in the frame to produce a similar effect. In this example, the pine needles provide the third point of interest. Together with the two birds, the branch forms an implied triangle, creating a strong composition.
Canon EOS-1D Mk II, 100–400mm (at 260mm), ISO 100, 1/320 sec. at f/5.6, tripod

GANNETS *(MORUS BASSANA)*
When photographing wildlife, almost anything can create a frame for your subject. In this instance, the two gannets in the foreground form an ideal frame for the bird in the centre – drawing your eye into the shot. This image also conforms to the rule of odds – three is a particularly strong number of subjects to include in the frame.
Canon EOS-1D Mk II, 500mm, ISO 160, 1/640 sec. at f/9, handheld

USING A NATURAL FRAME

Natural frames are another excellent compositional tool. A 'frame within a frame' will keep compositions tight and help to focus attention on your main subject. All manner of objects can be used as a frame — trees, overhanging branches, crops, flowers, buildings and other animals, for example. Out-of-focus grass or foliage, created by a low viewpoint, a long focal length or narrow depth of field, can also create subtle but effective natural borders. By framing the subject in this way, the viewer's eye is immediately drawn inwards towards the main subject. It may also keep the eye there longer, as the frame forms a barrier between the subject and the outside of the shot. An in-focus frame helps to place the subject in context, add scale, and create a greater impression of depth; an out-of-focus frame can add mood or even intrigue to your images.

Be aware that including a frame will not automatically improve your compositions. In fact, a poorly selected frame can add clutter or make a composition look awkward or cramped. Before shooting, always be sure that the frame will actually enhance your subject and not detract from it.

NEGATIVE SPACE

It is easy to assume that, in order to achieve maximum impact, the subject should fill the frame. While this approach can certainly create bold, eye-catching nature photographs, it rarely produces the strongest, most stimulating compositions. By including a degree of negative space around your subject, you can capture a far more compelling, harmonious image – one that conveys more about the subject and its environment.

WHAT IS NEGATIVE SPACE?

Put simply, negative space is the area of the image that is not occupied by the subject. When photographing wildlife, it is tempting to focus attention solely on the subject, overlooking the importance of the empty space around it. However, used correctly, negative space can create far more aesthetically pleasing compositions, helping to create a feeling of context, scale, or even isolation.

Regardless of whether you are photographing a large mammal, a bird, a wild plant or a tiny insect, the principle remains the same – including a degree of negative space will give your composition balance. Positive space – the area that is occupied by your subject – will completely overwhelm the frame if there is no breathing space around it, and the image may look cramped, static and unimaginative as a result.

Creating negative space is easy – use a wider focal length, or move further away from the subject so that it is less dominant in the frame. However, it is not possible to define exactly how much space you should include around your subject – it will depend on the situation, the environment and the effect you wish to achieve. Composition is subjective, after all – how much space you include is a matter of taste. Don't be afraid to be bold, though. Minimalist compositions, in which the subject is small in the frame, can be striking, creating an exaggerated impression of solitude.

The best results are often achieved when the space around the subject is a constant, contrasting colour, free of distraction – for example, sky, snow, shadow, or out-of-focus grass or foliage.

This kind of simple, clean backdrop will accentuate the subject, focusing the eye and allowing the viewer to appreciate the animal without distraction. If you want your subject to stand out boldly against its background, prioritize a shallow depth of field (see page 31).

Using negative space works well in combination with other compositional guidelines, particularly the rule of thirds (see page 44). For example, try placing the subject in one third of the frame, leaving the other two thirds completely empty. The key to using negative space is to experiment with subject placement and the amount of space you include. You will soon be able to recognize how the empty areas can help to direct the eye and highlight your chosen subject. Used correctly, negative space is capable of transforming a good nature shot into a truly captivating one.

PRO TIP: When including negative space, the best results are often achieved by leaving space in front of the subject, rather than behind it. Doing so generates space for the subject to 'look' or 'move' into. Generally, this looks more natural and visually pleasing.

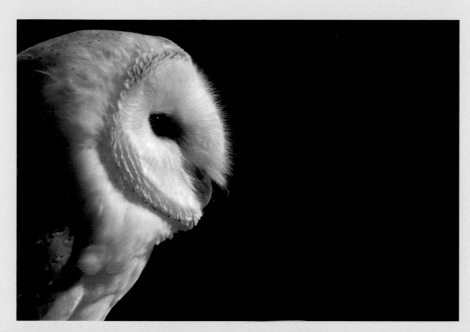

BARN OWL *(TYTO ALBA)*
Although the majority of this photo consists of black, empty space, the image is far stronger than it would have been without it. I placed this captive owl's eye near an intersecting third, and the viewer naturally follows the bird's gaze into the negative space in front of it.
Nikon D200, 200mm, ISO 100, 1/1000 sec. at f/5, tripod

MOUNTAIN HARE *(LEPUS TIMIDUS)*
In this image, negative space helps to tell a story – illustrating the cold, harsh, inhospitable conditions and remote environment. A closer, frame-filling approach would not have produced the same atmosphere.
Canon EOS-1D Mk II, 500mm, ISO 200, 1/2 sec. at f/5.6

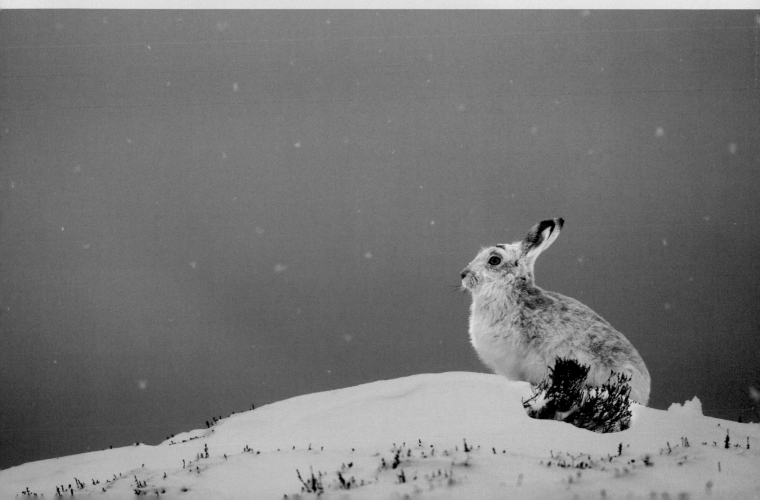

MOTION

By its very nature, a still photograph can't capture movement – or can it? While only a movie can truly record time and motion, it is certainly possible to convey the impression of movement in a still photograph. There are two ways to do this – either by suspending movement using a fast shutter speed; or with implied motion, created by intentionally blurring subject movement. The impression of motion is a powerful visual tool that can help you avoid static-looking compositions.

A SENSE OF MOTION

The way you capture subject movement will have a significant effect on the look and feel of your photographs. Motion is a key compositional tool, providing depth, energy and dynamism to your wildlife images. Essentially, photographers have two choices – either to suspend movement or blur it intentionally. If you do neither, movement will often look messy and accidental – you have to be decisive.

To freeze the movement of, say, a hovering bird or leaping deer, prioritize a rapid shutter speed (see page 32). Typically, you will require a speed of 1/1000 sec. or faster. Speed is relative, though – you will need to match the shutter speed to your subject. To generate a fast shutter speed, bright conditions are best, and you should usually opt for a large aperture and high ISO sensitivity (see page 33).

Achieving perfectly composed images of fast-moving subjects in-camera is challenging; it often requires time, practice and also an element of luck. Rather than trying to compose images too tightly through the viewfinder, it is often better to opt for a slightly wider focal length when tracking motion. By including a degree of 'spare room', you give yourself a margin for error. For example, if you inadvertently record a subject in the wrong place in the frame, you can crop the photo later to correct or strengthen the final composition (see page 142). This is useful when your subject's movement is fast or unpredictable and your first priority is simply to achieve pin-sharp focus.

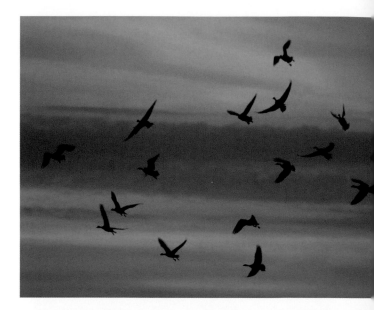

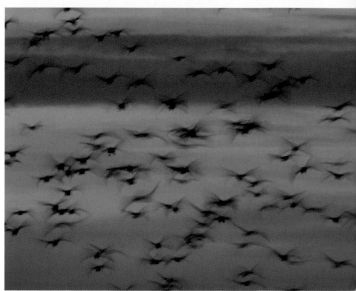

PINK-FOOTED GEESE (ANSER BRACHYRHYNCHUS)
Shutter speed is key to capturing movement. Before deciding which aperture and shutter speed combination to use, consider the effect that would best suit the subject or situation. In the top image, a shutter speed of 1/200 sec. sharply recorded the geese in flight; a slower shutter speed of 1/8 sec. gave a completely different, more impressionistic result in the image below.
Canon EOS-1D Mk II, 100–400mm (at 400mm), handheld

Suspended motion can look striking, highlighting every muscle, sinew and detail. However, motion blur is often a more powerful compositional tool, conveying the impression of movement, drama and journey. Don't confuse intentional subject blur with images that lack critical sharpness due to poor technique or camera shake (see page 15). Creatively blurring movement is a popular and effective technique among wildlife photographers – and in poor light, it may be the only practical option. It is able to convey a feeling of movement and energy that is otherwise difficult to produce in a still image. A relatively slow shutter speed – and a degree of trial and error – is required. The ideal speed will vary depending on the subject's motion and the effect you want – 1/15 sec. is a good starting point, but a speed of, or exceeding, one second may be required for more extreme results. In low light, exposure time will naturally be long; a low ISO, small aperture or neutral density (ND) filter are other ways to generate a sufficiently long speed. Any subject movement during the length of exposure will be recorded as a blur – for example, the beating wings of birds in flight, or a wave crashing over a seal sheltering on rocks. No two images will ever look quite the same, and the results can be interesting, intriguing or surreal.

If movement is perpendicular to the camera, panning (see page 95) with the camera can create the most striking results, but there are other ways to create an impression of motion in your nature images – for example, zooming the lens in or out during exposure, or intentionally moving the camera up, down or from side to side. Achieving just the right amount of blur comes with experience – too much, and the subject may be difficult to distinguish; too little, and the effect won't look deliberate. It's a fine line. While subject blur isn't to everyone's taste, it can bring a whole new dimension to still images. No other technique can imply motion as effectively. Motion blur has the ability to bring your compositions alive.

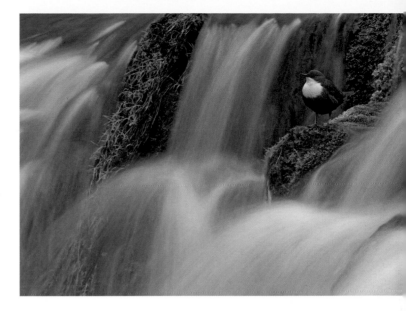

DIPPER (CINCLUS CINCLUS)
In certain situations, it is better to apply a sense of motion to the subject's environment, rather than the animal itself. You can add interest to a photo by intentionally blurring the movement of surrounding foliage, crops or moving water. This approach relies on your subject remaining still during exposure, but the results can be truly stunning.
Canon EOS 10D, 100–400mm (at 170mm), ISO 100, 1/5 sec. at f/22, tripod

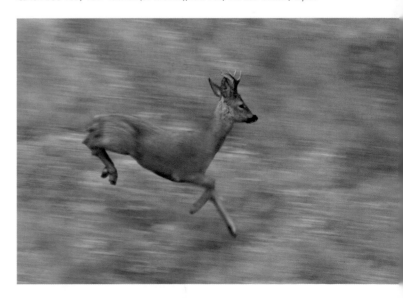

ROE DEER (CAPREOLUS CAPREOLUS)
Subject motion can add energy and life to wildlife images. How you render movement can also affect the viewer's perception of the subject. In this image, the blur creates the impression that the roe deer is fleeing or being pursued.
Canon EOS-1D Mk II, 300mm, ISO 200, 1/30 sec. at f/22, handheld

PERSPECTIVE

When discussing compositional rules, the role of perspective in photography is often overlooked. However, it can be a valuable compositional tool and is often employed to good effect in successful nature images. In photography, perspective refers to the relationship between subjects – or their surroundings – within the image space. Their relative position to one another can help dictate how the viewer perceives size, depth and distance. Without perspective, compositions can lack scale or character.

A NEW PERSPECTIVE

Lens choice, depth of field and shooting angle can all have an impact on perspective. Wide-angle lenses (see page 17) appear to stretch perspective, making nearby subjects look more prominent while pushing distant subjects further away. Wide-angle compositions will appear to have greater depth, so it is easier to place subjects in context with their surroundings. In contrast, telephoto lenses (see page 16) compress perspective, making foreground and background subjects look much closer together. Perspective compression is common in wildlife photography, as nature photographers often have to rely on long focal lengths to get close to their subjects. This type of foreshortening means that

subjects at varying distances look artificially close to one another; it can also help background objects impose themselves on those in the foreground. This can prove particularly effective if you are including an animal's environment within the composition – for example, a hare against a mountain backdrop, or a fox in an urban setting. The background subject doesn't always need to be in sharp focus; it simply needs to be recognizable enough to create the desired perspective. Foreshortening can help to highlight the relationship between subjects and create a heightened sense of scale or context.

Shooting angle also has a bearing on perspective and the way in which the subject is perceived. When photographing nature, we are often advised to shoot from eye level. Doing so creates a natural eye-to-eye perspective, which is both engaging and intimate. Often, far more striking compositions can be created by choosing a different perspective – a low or overhead viewpoint, for example. When an animal is photographed from far above eye level, the subject immediately looks smaller and less imposing. When shot from a worm's-eye view, a subject looks larger and more imposing. The effect on perspective of lowering or raising the camera angle can be hugely significant. Don't be limited by the ease of shooting from eye level – a new perspective will bring interest and impact to your photographs.

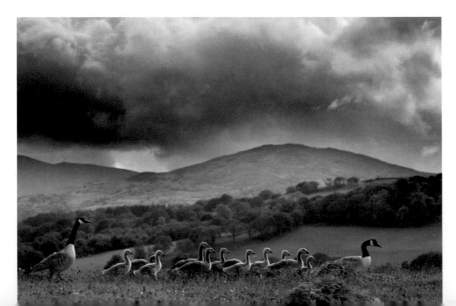

CANADA GEESE (*BRANTA CANADENSIS*)
It is important to understand how focal length can alter the appearance of perspective. In this image, a telephoto lens was used to foreshorten perspective. As a result, the hills in the background look closer to the subject, and more imposing – highlighting the relationship between the family of geese and their environment.
Canon EOS-1D Mk II, 100–400mm (at 115mm), ISO 160, 1/500 sec. at f/5.6, handheld

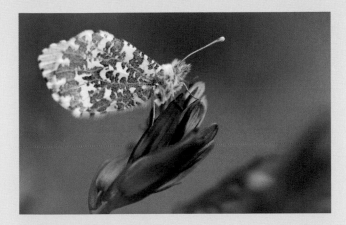

ORANGE TIP BUTTERFLY
(ANTHOCHARIS CARDAMINES)
Often an animal's shape, behaviour or environment will dictate the orientation of the camera. Don't be afraid to experiment, though, or employ the frame unconventionally. You can produce vastly different images of the same subject simply by switching format.
Nikon D300, 150mm, ISO 400, 1/60 sec. at f/2.8, tripod

PORTRAIT OR LANDSCAPE?

At our workshops, we are often asked which is best – a vertical (portrait) or horizontal (landscape) composition. Vertical compositions look bold, accentuate height, and can imply strength. A horizontal format will emphasize width and can give a greater feeling of balance and stability. However, as with all matters relating to composition, there are no hard-and-fast rules or easy answers.

Whether you opt for a portrait- or landscape-format composition will depend on your subject, situation and the effect you want to achieve. Composition is all about arranging the elements in the most logical, pleasing way, so often the subject – its shape, behaviour and environment – will make the decision for you. For example, long subjects like orchids, or narrow-bodied insects like damselflies, will usually suit a vertical composition, while birds in flight or a butterfly with its wings held open will often look best shot in a horizontal format. What you should avoid is shooting in one format or the other simply out of habit, or laziness. Newcomers to photography can forget to turn the camera on its side – maybe because we are so accustomed to viewing the world in a horizontal format. The orientation of your composition can make or break an image and affect the viewer's perception of the subject. However, while you should generally try to match the shape of the frame to that of the subject, dramatic, eye-catching results are possible by orienting the frame in an unexpected way. Don't be afraid to experiment and, if in doubt, photograph your subject using both vertical and horizontal formats.

COLOUR

Nature is colourful, so colour naturally plays a huge part in wildlife photography. Careful use of colour will give your images extra impact, and the way in which you use and combine hues can greatly determine the image's mood and affect its composition. It is important to understand the potential impact of different colours and the visual effect of different colour combinations.

COLOUR IMPACT

While we may not have any control over the colour of our subjects, we do have a choice over what we do and don't include in our compositions. Colour can help dictate the mood of your photographs and affect the viewer's emotional response. Images can be harmonious or contrasting, warm or cool, saturated or muted, or even calming or unsettling. The ways in which you place and combine colour can make or break your nature photographs.

To use colour successfully, you need to understand some basic colour theory. Different colours imply different moods and evoke different reactions. Red signifies danger, warmth or excitement;

blue is considered tranquil, calming or cool. Green is another calming shade, and often suggests freshness, vibrancy and vitality. Yellow is a powerful colour that demands attention – it is often considered uplifting and associated with happiness. Some colours stand out and carry more visual weight than others. Even a tiny splash of red can dominate an entire composition, creating a key point of interest, or directing the eye towards the subject. Red, yellow and orange are all 'advancing' colours that will shout out far louder than neighbouring shades. In contrast, green, blue and purple are regarded as 'receding' colours that will normally fall away into the background. A colour wheel helps us to understand the relationship between colours.

Colour in a composition can be subtle or striking. Red, yellow and blue – the three primary colours, which cannot be formed by any other combination of shades – typically demand the most attention. Simplicity is often the best option, and a single splash of primary colour against a backdrop of more subtle hues can be very effective. For example, the bright red bill of a wader will help

COLOUR WHEEL
Colours that lie opposite each other on the colour wheel are considered 'complementary'; those that sit next to each other are 'harmonious'. By using shades that are either opposite or similar – but not in between – you can create stronger and more pleasing results.

draw attention to the subject and provide a key focal point if the bird is set against a more subdued backdrop. Vibrant results can be achieved by combining primary and secondary colours. Secondary colours – green, orange and purple – are made by mixing two primary colours. Using complementary colours side by side in your compositions will make them look more vibrant and intense. Red and green work particularly well together, as do blue and orange. This is particularly important when selecting suitable backgrounds – natural or artificial – for your subjects. A red dragonfly will look particularly striking against a pleasantly diffused green backdrop of grass or foliage, for example. A mix of harmonious colours may not have the same sudden impact as contrasting shades, but they will generate a sense of balance and order, and look pleasing to the eye – autumnal colours are a good example of this.

Colour will often add impact to images and provide key points of interest – but there are always exceptions. In the right situation, removing colour – either altogether or almost completely – can produce the most dramatic result (see page 114).

THICK-LEGGED FLOWER BEETLE
(OEDEMERA NOBILIS) **ON CORN MARIGOLD**
(CHRYSANTHEMUM SEGETUM)
This composition couldn't be simpler: just two elements – the beetle and the flower – fill the frame. Yellow and green are harmonious shades and it is this combination of colours that makes this image successful.
Nikon D200, 150mm, ISO 200, 1/40 sec. at f/14, tripod

COMMON FROG *(RANA TEMPORARIA)*
For nature photographers, background colour is of particular importance, as subjects are often shot against an out-of-focus backdrop. Contrasting or harmonious backgrounds – natural or artificial – can give your photos much greater impact. In this example, a red bucket created an eye-catching backdrop.
Nikon D300, 150mm, ISO 200, 1/320 sec. at f/4, handheld

BREAKING THE RULES

While it is important to know and understand the compositional rules in this chapter, it is equally important to understand that they are only guidelines. Follow them slavishly and you run the risk of creating work that, while competent, is unimaginative and predictable. The trick is to understand the rules, apply them when appropriate, and ignore them when the opportunity to do so arises. Trust your own judgement and instincts when composing nature photographs – often, the best images will break every rule in the book.

RULES ARE MADE TO BE BROKEN

Compositional rules are a great starting point and will help you to logically organize the elements within the frame. But adhering to the rules won't always guarantee the best results. For example, the rule of thirds (see page 44) is a tried-and-tested method, designed to help create compositions full of balance and harmony. There are many instances, though, when placing the subject centrally in the frame will create a far stronger end result. Doing so emphasizes symmetry – particularly effective when shooting close-ups of wild flowers, or animals reflected in still water. While theory suggests that positioning the subject centrally creates static compositions, it can give additional impact to the subject, its behaviour or form.

In photographs that include the horizon, don't feel compelled to position it on a dividing third. Placing the horizon close to the bottom of the frame can prove equally effective, heightening the impression of isolation or emptiness – particularly in minimalist compositions where an animal is small in the frame, surrounded by a large amount of negative space (see page 48).

PRO TIP: The most important thing to remember when composing images is to keep it simple – cluttered, fussy and chaotic pictures are rarely successful. Composition is often as much about what you exclude from the frame as what you include.

While it is usually desirable to capture a subject facing the camera, or 'looking' or 'moving' into the space purposely left in front of it, there will be times when you should disregard this theory. Rather than lead the viewer's eye out of the frame, a subject looking or moving directly out of the picture – or away from the camera – can create a sense of intrigue and wonder.

It is often argued that, as we instinctively view things from left to right, photographic compositions should mimic the direction of this natural flow – in other words, the subject should be placed to the left of centre, looking right, rather than the other way round. However, placing your subject to the right of frame, so that it leads the eye back into the picture – rather than allowing it to leave the composition – can produce equally strong results.

Don't feel constrained by preconceived ideas. It is often stated that, unless you are shooting a portrait, the entire animal should always be included in the frame. Again, it is simply not possible to make this type of generalization – after all, composition is subjective and dictated by the subject, situation and the result you want. Isolating detail, or just a small area of the subject – ears, tail, legs or plumage – can produce simple, striking compositions that convey far more about the subject, and its form and design, than a wider view.

Knowing when to apply and when to ignore the rules of composition takes experience. But digital SLRs give you the ability to instantly review your images and assess what is working and what isn't. This promotes creativity and spontaneity. Don't be afraid to experiment: be bold and imaginative, and don't allow the rules of composition to rule your composition.

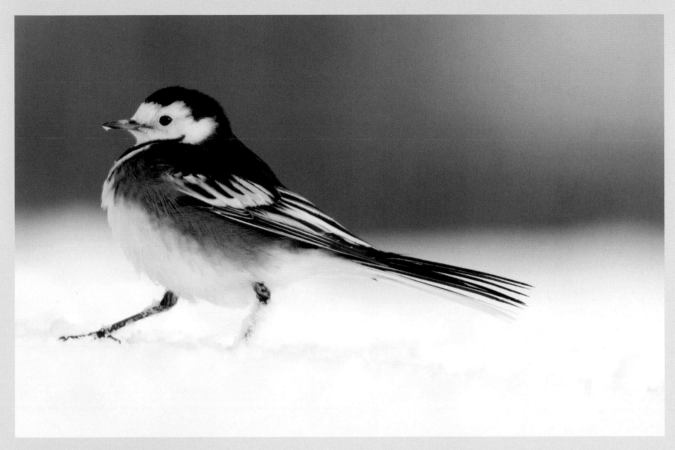

PIED WAGTAIL *(MOTACILLA ALBA)*
Compositionally, this image shouldn't work. The wagtail is walking directly out of the frame, moving from the right to the left of the image: it breaks the rules. While it may not be to everyone's taste, the image is unquestionably striking, unusual and memorable.
Nikon D300, 120–400mm (at 400mm), ISO 400, 1/1250 sec. at f/5.6, handheld

FOUR-SPOTTED CHASER DRAGONFLY
(LIBELLULA QUADRIMACULATA)
In theory, there are many things wrong with this shot. The reed is placed centrally, bisecting the image, while the dragonfly is positioned too low in the frame and part of its tail is cut off. However, these are the reasons why the composition actually works. It is bold, eye-catching and unconventional.
Nikon D300, 150mm, ISO 200, 1/8 sec. at f/11, tripod

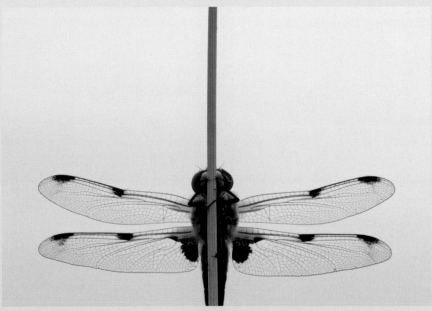

► CHAPTER FOUR > **LIGHTING**

Light is the photographer's best friend – in fact, the word 'photography' derives from the Greek and means, literally, 'writing with light'. In almost all aspects of photography, light is critical. It is the photographer's chief resource, and one that must be used to the full. An apparently dull subject can be transformed into something magical under appropriate lighting conditions. If photography depends on light, an understanding of what light is, how it behaves and how you can exploit it is essential to creating great images.

GREATER KUDU (*TRAGELAPHUS STREPSICEROS*)
During a trip to the Karoo National Park in South Africa, we endured ferocious electrical storms each night and I was keen to make the most of the atmospheric light. One evening, as the sun was setting, ominous storm clouds started brewing overhead. I noticed a lone kudu bull walking across a ridge some distance away. I waited for what seemed an eternity before the animal paused and looked straight towards me, its seemingly tiny body dwarfed by the huge, dramatic sky.
Canon EOS 1D Mark IV, 100–400mm L IS (at 330mm), ISO 250, 1/320 sec. at f/6.3, handheld

DIRECTION OF LIGHT

Natural sunlight is the most commonly used light source for nature photography, but several factors must be weighed up to ensure the best possible outcome for each image. First, before attempting to photograph your subject, carefully consider the direction of the light and the effect it will have on your images.

FRONT-LIGHTING

Direct front-lighting provides even illumination, helping to reveal detail in your subject. For the best results, shoot when the sun is low in the sky. The red and yellow hues present at dawn and dusk will adorn your shots with warmth, adding mood and atmosphere. Depending on your subject, front-lighting is the most forgiving in terms of exposure, with adjustments needed only if your subject is very pale or dark in colour, or if a large part of the image is comprised of water or sky. Typically, you should avoid shooting when the sun is high in the sky – the light at these times will be harsh and will rarely compliment your subject. If you do find yourself in this situation, keeping the sun directly behind you is your only option, as this will minimize shadows and help you to capture the most detail.

BACK-LIGHTING

Back-lighting is often used to capture atmospheric and evocative images of wildlife. Due to the intensity of sunlight, it is only possible to back-light your subject when the sun is very close to the horizon, unless there is mist present, which helps to cut down contrast. Shooting directly towards the sun at dawn and dusk will create a halo of light around your subject, known as 'rim lighting'. Mammals with fur, such as rabbits, hares and deer are perfect candidates for this technique, but care must be taken with exposure, to avoid burning out the highlights and to retain detail in the shadow areas.

Following a clear but cold night, large – or sometimes even small – bodies of water are often covered in a layer of rising mist; these conditions can create dramatic and ethereal results. Such mornings are perfect for back-lighting as the mist will diffuse the glare of the sun, allowing you to shoot for longer than would normally be possible. Dark backgrounds work especially well, so look for areas of shadow to include as the background. In the right conditions, the surroundings will be bathed in golden light and the mist should be clearly visible. When the sun is diffused in this way, contrast levels will be much lower; this will help you to retain detail in both the shadows and highlights and make it easier to determine the correct exposure. Each situation is different, however, so check the histogram regularly to make sure you are not losing highlight or shadow detail (see page 34).

SIDE-LIGHTING

As a general rule, side-lighting is more suited to landscape photography and rarely lends itself to wildlife photography. Often the contrast you encounter will be substantial, resulting in the sunny side of the subject being overexposed and the shadow side underexposed, with little detail. But, as always, there are exceptions to the rule. Side-lighting enhances texture, so mammals with furry coats or birds with highly textured plumage can benefit from the long shadows created when the sun illuminates them from one side. Exposure can be difficult in these high-contrast conditions, so keep a close eye on the histogram to make sure you are capturing plenty of detail.

OVERCAST LIGHTING

Overcast weather is no excuse to stay indoors! You can take great images under apparently bland conditions. When the light is soft, you can capture plenty of detail without fear of under- or overexposing – and you don't need to worry about the angle you are shooting at, as there will be no harsh shadows to spoil your images. This gives you complete freedom when it comes to composition, so you can concentrate on your surroundings. High-key images often work well in overcast light.

RED GROUSE *(LAGOPUS LAGOPUS SCOTICA)*
In this image of a red grouse, side-lighting has brought out the wonderful texture in the feathers, which is enhanced further by the low angle of the sun.
Canon EOS-1Ds Mk III, 100–400mm L IS (at 400mm), ISO 200, 1/200 sec. at f/5.6, tripod

Great images of wildlife can be taken under a wide variety of lighting conditions, each evoking a different mood. The common denominator in all of these is the need to venture out as early or as late as possible, and capture the subject during the first or last two hours of sunlight. Even when the light is overcast, an early start increases the chances of success as wildlife is always more active at these times of day. There are no hard-and-fast rules in creative photography, so experiment with exposure to achieve different effects; but remember, the quality of the light is the most important aspect of all.

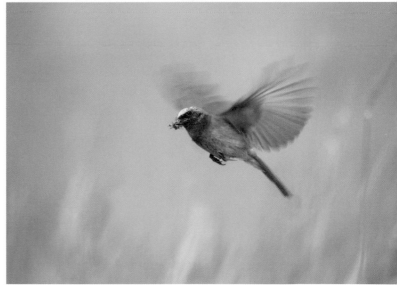

REDSTART *(PHOENICURUS PHOENICURUS)*
I took this image on a bright but overcast day. I made sure the direction of light was coming from behind me to enable a fast enough shutter speed to freeze the head and body of the bird.
Canon EOS 1D Mk II, 100–400mm L IS (at 375mm), ISO 250, 1/250 sec. at F/5.6, hide and tripod

DAWN AND DUSK

The quality of daylight varies because its temperature is seldom constant. In this context, temperature has nothing to do with the sensation of heat or cold – it refers to the different wavelengths of light, which give us the colours of the rainbow and create different photographic effects. For photographers, yellow and red light are usually referred to as 'warm' and blue light is 'cold'.

THE GOLDEN HOUR

The temperature of light is measured in degrees Kelvin ($^{\circ}$K, see page 36). During the first and last hours of daylight, when the sun is close to the horizon, the temperature of the light will measure in the region of 3,000°K. This is why these times of day are often referred to as the 'golden hour'. The wavelengths of the light are longer, which gives the light its warm tones, perfect for back-lighting your subject and creating rim-lighting effects. Rim-lighting is a term used to describe the halo of light that appears around the outline of a subject and that only occurs when shooting into the sun. This technique can be used for any subjects, but it is particularly effective when photographing mammals with fur coats.

The other advantage of shooting at dawn and dusk is that most bird and animal species are more visible at these times. Photographing coastal birds, for instance, is far more productive at dawn and dusk, when large flocks of geese and waders congregate to feed and roost. Similarly, dawn is the best time to photograph songbirds, especially in spring, when individuals perch out in the open and sing to proclaim their territory. As dusk approaches, nocturnal mammals such as badgers and foxes start to become active and can sometimes be captured in natural light without the need for flash. Although most species of owls are nocturnal, some also venture out to hunt before last light. Both short-eared owls and barn owls usually start to hunt in the late afternoon – which, in winter months, often coincides with the best light for photography.

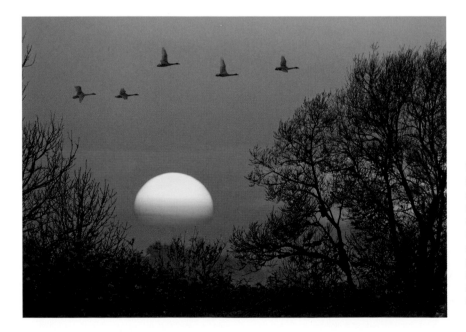

WHOOPER SWANS *(CYGNUS CYGNUS)*
I took this image on a beautifully crisp winter day. As the sun began to sink, an intense pink colour flooded the sky. In the foreground, just out of shot, was a large lake that had completely frozen over. The ice, coupled with the surrounding snow, gave me plenty of cold hues. This contrast between warm and cold colour created a magical effect.
Canon EOS-1D Mk IV, 500mm L IS, ISO 400, 1/400 sec. at f/5.6, beanbag, hide

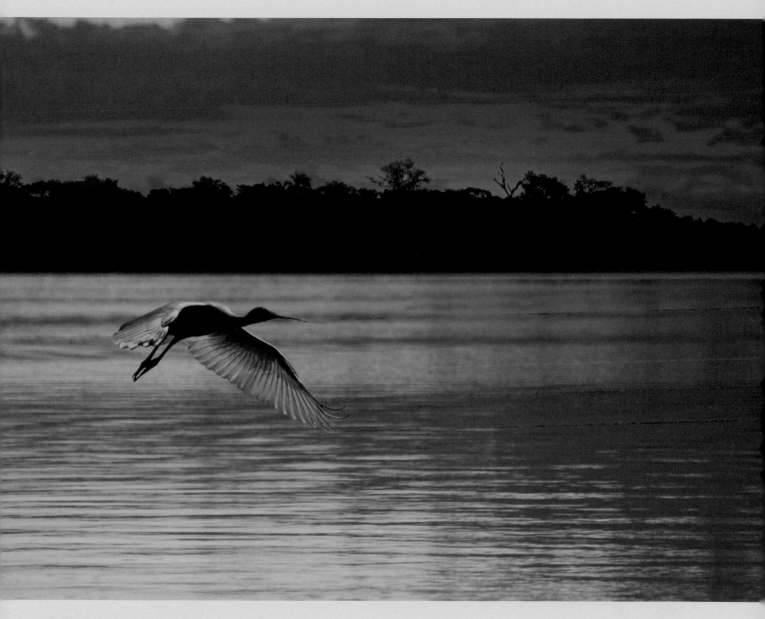

SPOONBILL *(PLATALEA LEUCORODIA)*
This spoonbill was just taking off from the water. The warm dusk light shone through its wings and bathed the bird and the surrounding water in golden light.
Canon EOS-1D Mk II, 100–400mm L IS (at 115mm), ISO 400, 1/250 sec. at f/11, tripod

WEATHER

Weather conditions can have a dramatic impact on your nature images, and knowing how to exploit different conditions can transform an otherwise humdrum image into a work of art. Stormy skies can produce particularly spectacular results. When clouds part, even for just a brief moment, shafts of light can be cast onto the land or sea – with magical results.

SNOW AND RAIN

During the winter, snow may transform the landscape. It creates an atmosphere that is impossible to replicate and can be used to convey a sense of wildness and extremity. A mountain hare, for instance, hunkered down in a deep snowdrift, immediately tells a story. It demonstrates the hardiness of the animal and the harsh environment that it has to face. Exposure is critical under these circumstances. The brilliant white of the snow causes the camera to underexpose, so you will need to increase the exposure by up to 2 stops, depending on the amount of snow and the colours and tones of your subject. Start by making an adjustment of +1 stop and check your histogram to make sure detail is retained in both the shadows and highlights.

Falling snowflakes can give your images a painterly look, and different shutter speeds will create very different effects. Fast shutter speeds will freeze the snowflakes, while slower speeds will render them as long streaks. A bird flying through a flurry of snow can look especially effective, but take care to ensure it is captured in pin-sharp detail. Autofocus can become useless when trying to focus through heavy snowfall, so switch to manual focus and pre-focus on a fixed point in front of the bird. As the bird approaches the focal plane, fire a burst of frames. At least one of the image sequence should be sharp.

Rain can also be used to good effect in your wildlife images. It, too, adds atmosphere and helps to provide a sense of the subject's environment. As with falling snow, shutter speed will have a dramatic effect on the end result. Slow shutter speeds will render raindrops as long streaks, while a faster shutter speed will freeze the droplets in mid-air. Consider the subject carefully and decide for yourself which will be the most effective. Rain will appear more prominent against a dark background, so pay attention to your surroundings and, if necessary, adjust your position so that you are shooting towards an area of deep shadow. Rain can confuse even the best autofocus systems and the light will usually lack contrast in such conditions, so you may find that focusing manually yields a more consistent result.

WHOOPER SWAN *(CYGNUS CYGNUS)*
This close-up portrait of a whooper swan was captured during a flurry of snow. The tight composition highlights the elegant shape of its neck.
Canon EOS-1D Mk II, 500mm f/4 L IS, ISO 250, 1/200 sec. at f/4.5, beanbag, hide

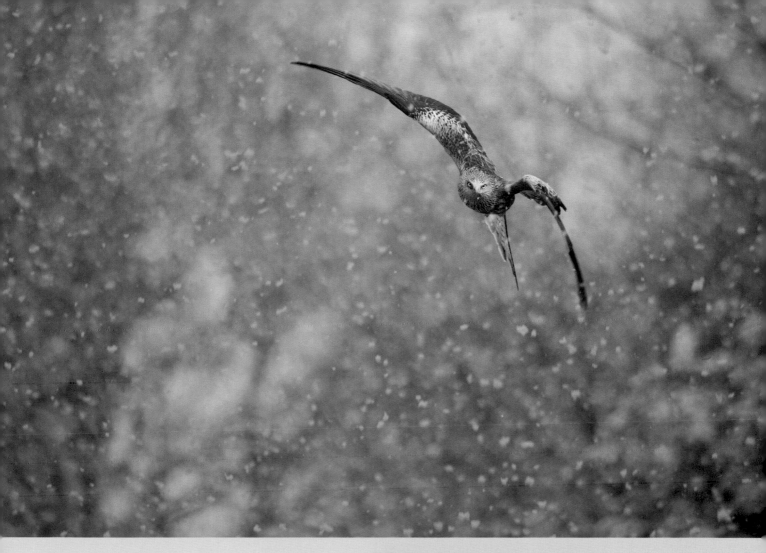

RED KITE (MILVUS MILVUS)

On the day I took this picture it had been snowing hard for several hours. The flurry of falling snowflakes made it impossible to use autofocus, so I switched to manual and pre-focused on a spot in front of the bird. As it approached the plane of focus I fired a burst of shots. Luckily, this one was rendered sharp. The pose of the bird – its intense stare captured among the falling flakes – gives the shot additional impact.
Canon EOS-1D Mk II, 100–400mm L IS (at 400mm), ISO 400, 1/250 sec. at f/5.6, tripod

PUFFIN (FRATERCULA ARCTICA)

When rain starts to fall, most people put away their cameras and run for cover. I always persevere. Just like snow, rain adds atmosphere and gives the viewer a sense of the subject's environment. I took this shot on Skomer Island in Wales; it had started drizzling hard and I shifted position until I was shooting towards a distant cliff face shrouded in shadow. The dark background helps to show up the droplets of rain.
Canon EOS-1D Mk II, 100–400mm L IS (at 400mm), ISO 320, 1/1000 sec. at f/5.6, beanbag

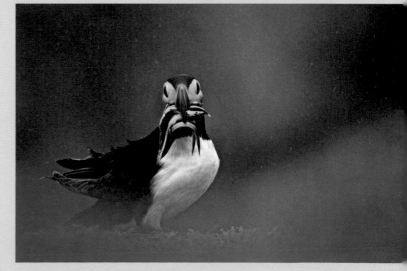

SILHOUETTES

Silhouettes occur when you're shooting directly towards the sun. Executed with care, they can produce very striking and graphic images. Usually, the main element in a silhouette – besides the subject, of course – is colour. Every sunrise and sunset provides a unique palette of colours to work with, so even photographing the same subject in the same location can produce results that vary dramatically from one day to the next.

CREATING SILHOUETTES

For a silhouette to work successfully it is vital that the outline of the subject is clearly recognizable. Some subjects will work well, others less so. A deer, for instance, standing proud against a dramatic sky can evoke emotion and become more than just a picture of a wild animal – it has a conceptual quality. If the sky is clear, the sun's intensity will be too great for photography, so you will need to wait until it is almost on the horizon before taking pictures. It is also often possible to shoot for a short time after the sun has set. During the few minutes following sunset, the warm yellow and red hues fade from the light and are replaced with much cooler tones, made up predominantly of blues.

Large open spaces such as the coast, lakes, fields and moors, where the subject can be positioned in front of the rising or setting sun, yield the best results. By visiting the same locations frequently you can learn to predict the position of the sun in relation to your possible subjects, making it easier to achieve the desired results.

Silhouettes can also be taken near to water. At dawn and dusk, water provides a wonderful backdrop as it reflects the image of the brightly lit sky, adding drama and impact. To expose correctly for silhouettes and strongly back-lit subjects, take a meter reading from the brightest part of the scene and either use your exposure lock button, or dial in the exposure manually. This way, highlight detail will be retained and the subject will naturally fall into silhouette.

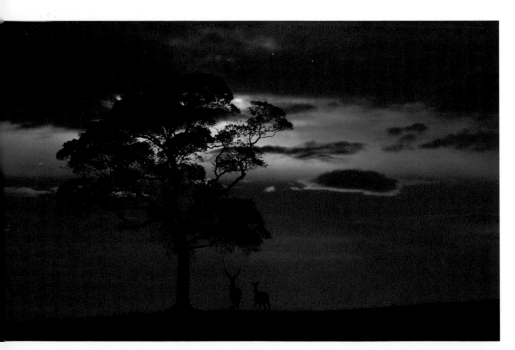

RED DEER *(CERVUS ELAPHUS)*
I had frequently visualized this image on previous visits to a local deer park. I returned each evening to the same spot until the deer were finally in the right position against a beautiful dusk sky. I metered from the brightest area of the sky and locked the exposure to prevent losing important highlight detail.
Canon EOS D60, 100–400mm L IS (at 100mm), ISO 100, 1/180 sec. at f/5.6, handheld

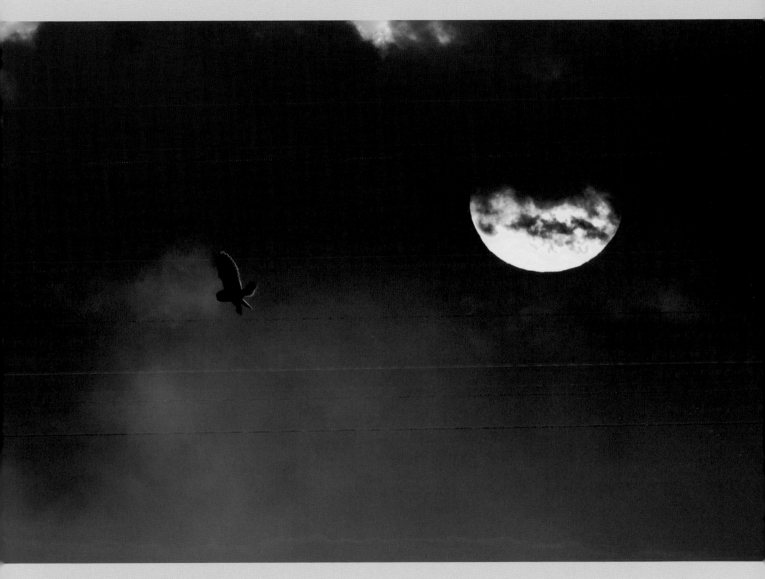

SHORT-EARED OWL *(ASIO FLAMMEUS)*
It was a stroke of luck: this short-eared
owl flew in front of the sun at just the
right moment, allowing me to capture its
silhouette against a blood-red sky. There
was just enough power in the sun to create
a halo of light around the wings, further
enhancing the shape of the bird.
Canon EOS-1D Mk IV, 500mm f/4 L IS, ISO 100,
1/500 sec. at f/5.6, tripod

SEASONS

SPRING AND SUMMER

Each season offers the wildlife photographer something unique. During spring, birds are preparing to breed and nest, and displays of courtship can be captured. Great crested grebes perform an incredibly elaborate display and can be found with relative ease, often on large lakes or gravel pits. The sound of birdsong fills the dawn air as passerines sing out in the open to establish and defend their territories. Garden birds also become more active as they gather up nesting material in preparation for the breeding season which is ahead.

Spring also offers plenty of opportunities for mammal photography. Young rabbits sit out in open fields, most often visible at dawn and dusk. They are shy animals, and as a result they are the perfect candidates for honing your fieldcraft skills.

Summer is perhaps the least productive season for wildlife photography. Dense foliage blocks out much-needed light, and on sunny days, the light is too harsh for most of the time, giving you just the first and last two hours of daylight in which to shoot. Birds and mammals become more elusive during the summer months, but there are still plenty of macro subjects to be found – butterflies and other insects are plentiful during the warmest months of the year.

There are two magical weeks in the height of summer when heather blooms and turns moorlands into a sea of pink. This offers the perfect backdrop for moorland-dwelling birds. By getting down as low as possible and shooting through the flowering heather, you can frame your subject among dazzling pink hues, creating images of intense colour and beauty.

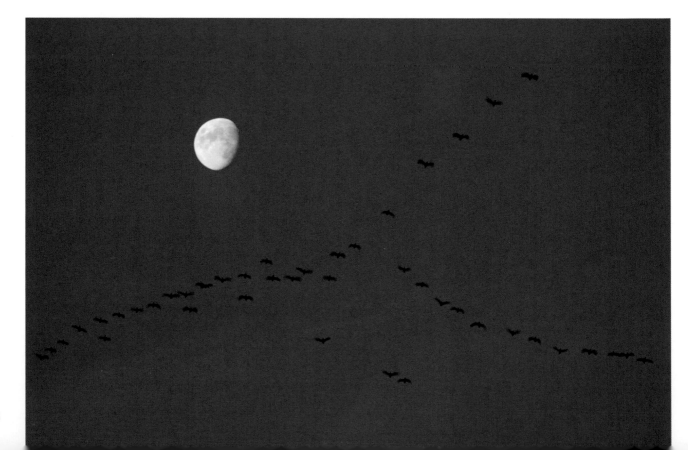

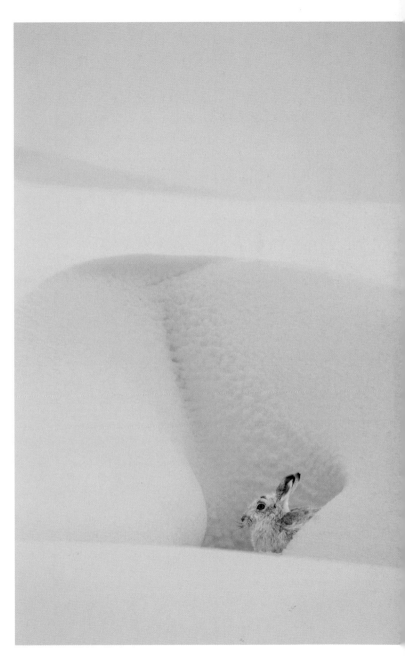

AUTUMN AND WINTER

As autumn approaches, the land takes on another change. Colour of a different type sweeps across the land, and the days shorten, offering warmer, richer, better-quality light. Lakes or ponds that are surrounded by trees are good places to explore, as autumn leaves reflected in water provide colourful backgrounds for birds swimming on water. During October, the annual deer rut gets underway, providing opportunities for action shots of stags roaring and fighting (see pages 106–107). Late autumn signals the return of migratory geese and swans.

As autumn progresses and turns into winter, we start to see another marked change in the light. The sky at dawn and dusk often results in a cacophony of colour, perfect for silhouetting birds in flight. Mammals such as squirrels, hares and foxes all take on a more photogenic appearance in winter, as their coats become thicker to protect them from the cold. As the weather worsens, their food sources become more scarce. This makes them bolder and they will often allow a closer approach. For all these reasons, winter is a favourite season for wildlife photography.

PINK-FOOTED GEESE
(ANSER BRACHYRHYNCHUS)
I had been photographing swans at a local wetland reserve when a group of pink-footed geese suddenly appeared on the horizon, their silhouettes unmistakable against the purple hues of the dusk sky. As they drew closer, I realized that I might have a chance of capturing their 'V' formation against the moonlit sky. Quickly scrabbling for position, I set my camera on a tripod, composed the image and waited for them to fly into frame. As they passed overhead, I fired a sequence of shots. The slow shutter speed necessary to expose for the dark sky rendered their wings a blur, giving them a ghost-like appearance.
Canon EOS-1D Mk II, 100–400mm L IS (at 250mm), ISO 200, 1/80 sec. at f/5.6, tripod

MOUNTAIN HARE *(LEPUS TIMIDUS)*
I love shooting in adverse weather conditions, and after an arduous approach I managed to capture this mountain hare crouched in a deep snowdrift. I kept the image high-key, increasing the exposure by two stops to keep the tones as light as possible. Shots like these tell the story of the harsh conditions that certain species have to face each year to survive.
Canon EOS-1D Mk II, 500mm f/4 L IS, ISO 50, 1/320 sec. at f/.6, beanbag

USING A REFLECTOR

A reflector is a very useful lighting accessory and should form an integral part of your kit. They are particularly suited to portrait, studio and close-up photography, but can be put to other uses too. Basically, a reflector is a large reflective disc that bounces light back onto the subject. You can control the reflector manually and angle it to direct light onto the area you require, throwing extra light onto your subject and filling in areas of harsh shadow. Reflectors can be so effective that in certain situations, they can even preclude the need for flash.

A SUBSTITUTE FOR FLASH

When light levels are low or limited, you may be tempted to use a burst of flash. However, a reflector can be an effective substitute that retains the natural feel of an image. It is easier to manipulate, and its subtlety can be its main advantage – particularly when photographing close-ups of plants or insects.

Reflectors are fairly inexpensive and available in different sizes and colours. The colour is important and has a dramatic effect on the result. White provides a soft, diffused light; silver is more efficient, but can look harsh; gold or 'sunfire' will add warmth. It's a good idea to buy a reflector that has a different colour on each side, as this gives you a choice depending on what you are shooting. Collapsible versions are available that can be stored away neatly when not required. They are available in sizes from 12in (30cm) up to 4ft (120cm) or more. The larger the reflector, the greater the area of reflected light – a small reflector is only suitable for small subjects.

A reflector enables you to alter the intensity, and therefore the quality, of the light, simply by moving it closer to or further away from the subject. However, avoid placing it too close, or you risk giving the image an 'artificial' look. You can buy reflector brackets, or clamps, but they are usually held in position by hand to achieve exactly the right type of illumination. Bear in mind that using a reflector adds extra light to the subject you are photographing, which in turn affects exposure. Remember to meter with the reflected light in place – fail to do so and you risk overexposure.

PRO TIP: You can make your own small reflector by securing a sheet of aluminium foil to a piece of stiff cardboard. You can then use it to angle light onto your subject.

LONG-FLOWERED CROCUS
(CROCUS LONGIFLORUS)
Although the crocus wasn't in direct sunlight, it was necessary to use a small reflector to bounce light upwards and fill in the shadow area on the underside of the flower.
Canon EOS 10D, 100–400mm L IS (at 400mm), ISO 200, 1/320 sec. at f/6.3, beanbag

ARTIFICIAL LIGHTING

Most wildlife photographers tend to avoid flash whenever possible. This is mainly because any kind of artificial light, if not used properly, will look just that – artificial. It is also cumbersome to use and can be technically challenging. There are certain situations, however, when flash is a necessity – and it can even add drama and impact.

NOCTURNAL ANIMALS

The most common situation that requires flash is when you are photographing nocturnal creatures. Badgers, for instance, are rarely seen in daylight hours. Depending on the location of the sett, you may get lucky and see the badgers emerge just before last light. More often than not, however, you will need to rely on flash to provide your main source of illumination. For the simplest set-up that will give you natural-looking light you will need two flashguns. One should be set around 6–8ft (1.8–2.4m) off the ground – mounting it onto a flash stand is the most effective method, as it allows easy repositioning. This will act as the main light source and should fall onto your subject from above to emulate the look of moonlight. The second flashgun should be positioned at least 4ft (1.2m) away and much closer to the ground – try 12in (30cm), or even less. Its job is to fill in any harsh shadows created by the main flash, and put a catchlight into your subject's eye.

FILL FLASH

There are also instances when a small amount of flash can be used to good effect in daylight. We have already discussed the merits of shooting during the 'golden hour', but during summer this period is brief – and it may only be practical for you to shoot during the middle of the day. On bright days, the sun will be shining from directly overhead for most of the day, casting harsh, unpleasant shadows across the face of your subject. In these circumstances, a touch of flash will fill in those unsightly shadows, helping to reduce contrast and preserve detail – this is called 'fill flash'. The key is learning how much flash to add. Each situation will be different, but there are several key factors to consider. How harsh is the sun? The more powerful the sun, the more flash you will need to eradicate the shadows. How far away is your subject? The further away, the more flash you will need.

Using the TTL (Through-The-Lens) function of the flash is the simplest way of determining the exposure. In this mode, the camera's meter measures the amount of flash reflecting from your subject and decides for itself how much flash is needed. You can then override this with the compensation dial if necessary. Start with –1 stop, check the image on the LCD display and then decrease or increase the amount depending on the results. Flash compensation works in the same way as exposure compensation. Most modern flashguns have a compensation dial that enables you to either reduce or increase the power of the flash. Most digital SLRs also allow you to do this in-camera, but you should read your flash instructions thoroughly. The last thing you want is to be presented with a once-in-a-lifetime photographic opportunity only to miss the shot while you're fiddling with the buttons on your flash!

If you choose to mount your flash on the camera's hotshoe, be aware of red eye. This is caused by the light reflecting from the retina in the eye, and can be avoided by moving the flash to one side and using a cable to connect it to the camera. Of course, most subjects will not allow a close approach. There are, however, flash extenders available that can increase the range of a flashgun. They work by concentrating the beam of light in much the same way as a magnifying glass would, and can prove useful for distant subjects.

It is important to note that currently, the flash-sync speed (the fastest shutter speed that you can use with flash) on most Digital SLRs is 1/250 sec., so you will need to keep a close eye on your shutter speed. If it exceeds this, you will need to activate the high-speed sync setting on your flashgun to prevent overexposure. When using fill flash on bright days, your shutter speed is likely to be high so this mode should be kept activated at all times.

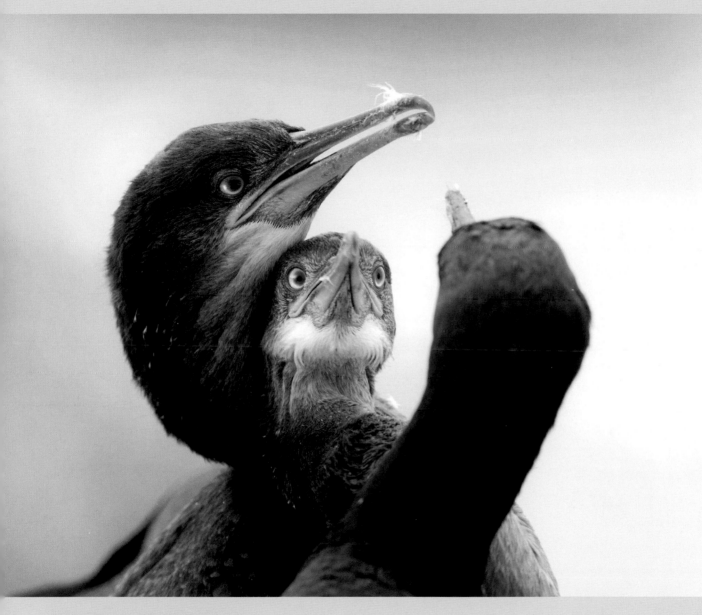

SHAGS *(PHALACROCORAX ANSTATELIS)*
I photographed this family of shags on the
Farne Islands off the Northumbrian coast, UK,
in the height of summer. The light was harsh
but as this was an organized boat trip I was
forced to shoot during the middle of the day.
By adding fill flash I was able to make the
most of the situation, eliminating the harsh
shadows created by the overhead light.
Canon EOS-1D Mk IV, 500mm f/4 L IS, ISO 400,
1/640 sec. at f/8, tripod

► CHAPTER FIVE >
CLOSE-UP PHOTOGRAPHY

Beneath our feet is a fascinating world of miniature subjects. Although insects, reptiles, amphibians and arachnids often have a bad public image, in frame-filling close-up, their beauty, colour, design and detail are revealed. Compared to feathered and furred creatures, such subjects are normally considered less appealing and glamorous, but they are just as photogenic. So-called 'mini-beasts' also tend to be more approachable and accessible than many other natural subjects. Some can be found as close to home as your own back garden, and although it can sometimes be challenging, it is possible to capture great close-up images without owning costly or specialist gear. Therefore, it is time to get down to ground level and search among the undergrowth, as you hone your close-up skills.

IN THE BAG: WHAT IS REQUIRED?

Budget
- 50mm, or standard zoom lens (for example, 28–70mm)
- Close-up filters or extension tubes
- Tripod
- Self-timer facility

Enthusiast
- Macro lens – ideally of 90mm or longer
- Ring/twin flash
- Tripod
- Remote cord
- Mirror lock-up facility

Useful accessories
- Polarizing filter
- Reflector
- Scissors
- Fully charged spare camera battery
- Wimberley Plamp
- Ground sheet
- Beanbag

COMMON BLUE DAMSELFLY
(ENALLAGMA CYATHIGERUM)
With a macro lens or close-up attachment, nature photographers can highlight the beauty and design of miniature subjects like this tiny damselfly. Intricate detail and colour are revealed in frame-filling close-up, giving the viewer a greater appreciation of the subject.
Nikon D300, 150mm, ISO 200, 1/8 sec. at f/8, tripod

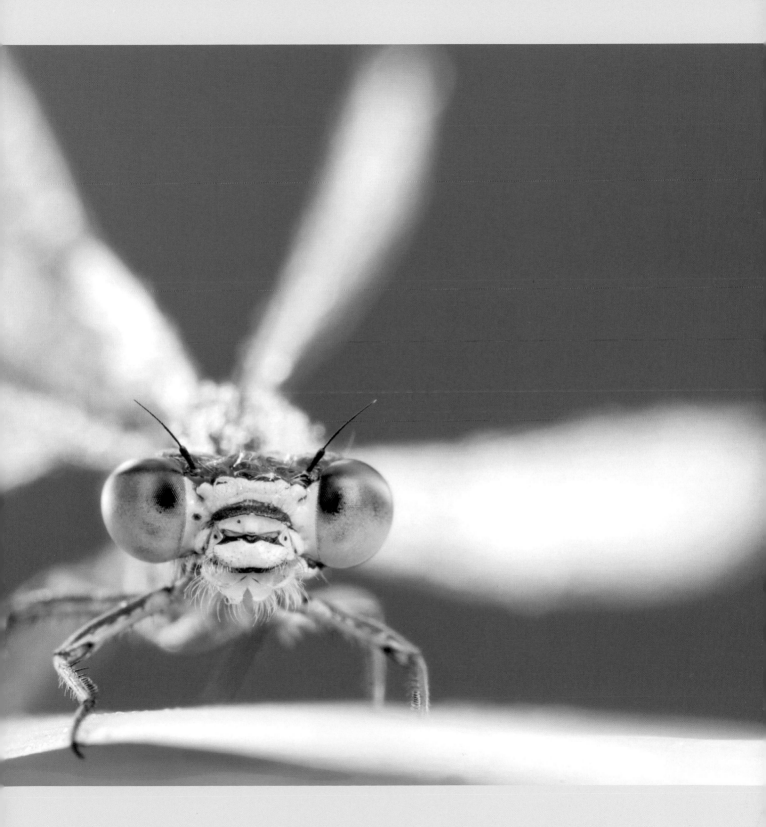

TECHNIQUE

There is a huge variety of miniature wildlife to photograph. Subjects can be fast or slow, brightly coloured or well camouflaged, relatively large and easy to spot, or tiny and difficult to find. Inevitably, the techniques you use – and the challenges you face – will alter depending on your subject. We can only look at a small selection of photographic subjects in detail in this chapter, but much of what we will cover can be applied to other close-up subjects too. Here, we will highlight a few useful, general points that will benefit your close-up photography, regardless of the subjects you choose.

BACKGROUNDS

It is easy to underestimate the importance of the background and the overall effect it has on your image. It may be a cliché, but what you exclude from the frame is often as important as what you include. Ugly background elements – partially out-of-focus highlights, distracting grasses and other bits of vegetation protruding undesirably into the frame – will quickly draw the viewer's eye away from your subject and weaken the image's impact. When you're working in close proximity to your subject, as in close-up photography, it's easier to control what appears in the background. Natural backdrops are best. When peering through the viewfinder, allow your eye to fully explore the subject's surroundings, looking for even the smallest detail that might be distracting in the final image. Distracting elements can often be excluded with relative ease, either by altering your viewpoint fractionally, or by using a larger aperture to create a shallower depth of field. If the subject is static or not easily disturbed, you may even be able to remove twigs or grasses by hand, or using scissors. It is useful to keep a pair of scissors in your camera bag for just this purpose.

When a subject's background is particularly messy, changing viewpoint, f-number, or selectively 'tidying up' the

PRO TIP: Under the scrutiny of a macro lens or close-up attachment, even the smallest imperfection or flaw is highlighted. Therefore, for the very best results, only select and photograph subjects that are in pristine condition.

backdrop is unlikely to be enough. Instead, the best option might be to introduce an artificial background. To create your own backdrops, try spraying coloured paints onto card to simulate out-of-focus backgrounds, or simply photograph foliage – with your lens de-focused – before printing the results at A3 or A4 size and attaching them to card to create an authentic-looking artificial background. Produce a variety of different backdrops that harmonize with different subjects. However, artificial backdrops are only practical for static subjects – a dew-covered dragonfly, for example. Active subjects won't tolerate a background being positioned behind them.

One final method for simplifying a subject's background is to use flash – the fall-off in light can create a pure black backdrop, as long as the surrounding vegetation is outside the range of the flash burst. While this can look unnatural, it will often be a more desirable option compared to shooting your subject against an ugly, distracting backdrop.

WEATHER

One of the biggest challenges close-up photographers face is the weather. Working so near to subjects allows close-up photographers to retain a good level of control over lighting – for example, natural light can be easily manipulated using fill-flash or a reflector (see pages 70–72). Overcast weather can actually be a very flattering light source, with clouds acting as giant diffusers. Many insects and reptiles are less active during cool, overcast conditions, so grey days can be a productive time for close-up photography. However, in poor light, exposure time is naturally longer, which can make shutter speeds impractically slow for freezing the subject's movement, or your own. Therefore, in overcast conditions, using flash may well be the only practical option.

Windy conditions are the worst for close-up photographers, causing subjects – or the vegetation they are resting on – to continually sway in the breeze. With depth of field being naturally shallow at high levels of magnification, wind movement makes it exceptionally difficult to accurately frame images and achieve sharp focus. Light, intermittent winds aren't generally such a big problem – simply wait until there is a brief pause in the wind, then quickly fine-tune the focus and trigger the shutter. However, in stronger winds, when there is little or no shelter, it can be impossible to work unless the subject is on the ground or resting on an object unaffected by wind. In some situations, it may be possible to use a Plamp (see page 98) to steady the stem of the plant the subject is resting on. However, realistically, in strong, persistent wind or rain, you are best advised to switch your attention to subjects less affected by the conditions – birds or mammals, for instance. Remember to check the weather forecast regularly. Still days – when the predicted wind speed is below 10mph (16km/h) – are best.

REPRODUCTION RATIO

The term 'reproduction ratio' is regularly used in macro photography, indicating the magnification of a subject. The reproduction ratio is the size of the subject in relation to the size it appears on the image sensor. For example, a reproduction ratio of 1:2 (magnification of 0.5x) is half life-size, meaning that the subject will appear half of its actual size on the sensor. A reproduction ratio of 2:1 (magnification of 2x) indicates that the camera will record the subject at twice its actual size. The terms 'close-up' and 'macro' photography are often used interchangeably, but in reality, only a reproduction ratio of 1:1 life-size (1x) or greater can be truly classed as macro; anything else is simply a close-up. However, the significance of what is and isn't 'macro' is fairly unimportant – it is the aesthetic quality of the final image that really counts.

A lens's maximum magnification is provided in its specification details. Some tele-zooms have an impressive reproduction ratio of 1:4 (quarter life-size) or even 1:2 (half life-size) and may boast the word 'macro' in their title. However, it is not a genuine macro lens unless it offers a magnification of 1x or greater.

COMMON GREEN GRASSHOPPER
(OMOCESTUS VIRIDULUS)
While it is only possible to discuss a small selection of subjects in any depth during this chapter, many of the techniques, tips and hints given are just as relevant to photographing other miniature subjects – for example, bees, wasps, flies, ladybirds, beetles, locusts, crickets and grasshoppers.
Nikon D300, 150mm, ISO 200, 1/200 sec. at f/2.8, tripod

MACRO FLASH

On our workshops, we encourage the use of natural light – but inevitably there are times when it will be insufficient. One of the greatest challenges of close-up photography is the limited light that results from working in such close proximity to the subject and shooting at high reproduction ratios. When natural light won't generate a fast enough shutter speed to eliminate camera or subject movement – or create the result you desire – flash is the answer. Normal Speedlights or built-in flash units have their uses (see page 72), but the flash burst from a camera-mounted flash can 'miss' or only partly illuminate nearby subjects due to its (relatively) high, fixed position. The best way for close-up enthusiasts to artificially illuminate miniature subjects is using a dedicated macro flash.

FLASH TYPES

In shooting situations where it will benefit your images, don't be afraid of using artificial light. Applied well, it has many advantages, and you can still produce natural-looking images of nature. For example, flash allows you to use a smaller aperture, providing a larger depth of field. It also highlights fine detail, helping to create sharper-looking results. It can provide photo opportunities that wouldn't have existed otherwise.

There are two main types of macro flash – ring/macro flash, and a twin flash unit. Unlike a conventional flashgun, a ring/macro flash is circular, attaching directly to the front of the lens via an adapter, while the control unit sits on the camera's hotshoe. This design enables the flash to effectively illuminate nearby subjects

LARGE RED DAMSELFLY
(PYRRHOSOMA NYMPHULA)
Unless the background is fairly close to the subject, flash fall-off from macro flash units can be quite apparent, creating dark, inky-black backgrounds. While this can look artificial, it can also create a striking and clean backdrop.
Nikon D300, 150mm, ISO 200, 1/200 sec. at f/16, Metz 15MS-1, tripod

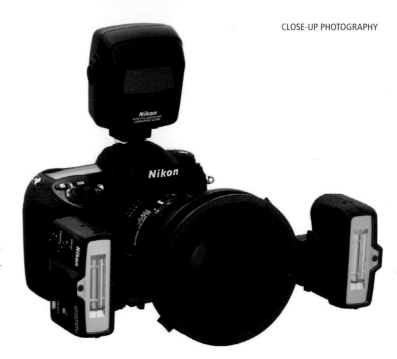

from all directions at once, providing even, shadowless light. However, in practice, the resulting light can look unnaturally flat. To help overcome this, the majority of modern ring/macro flash units boast more than one flash tube, which can be controlled independently. This allows photographers to vary the output ratio between them in order to create more natural, three-dimensional-looking results. Alternatively, you can improvise by using black tape to mask parts of the ring to vary the flash output.

Twin flash units work using a similar principle to a ring/macro flash. Instead of a ring, they consist of two individual flash heads that are mounted on an adapter ring attached to the front of the lens. The flash output can be varied between the heads to overcome the problem of the flat, even light commonly associated with macro flash. However, they can also be moved and positioned independently – or alternatively removed from the mounting ring altogether and used handheld or attached to, a tripod leg, for example. The heads can be fired together or individually, providing even greater flexibility and increased creative possibilities. They are relatively lightweight and compact, and are arguably the most versatile form of flash available to close-up photographers. However, they do produce twin catchlights, which can look unnatural, so it is worthwhile using some form of diffusion. Because macro flashes are intended to illuminate close-up subjects, they normally have a small GN (guide number) and are most effective within a range of 3.2ft (1m).

TWIN FLASH

For the close-up enthusiast, a twin flash system, such as Nikon's SB-R1C1, is a good investment. This wireless system is designed with two SB-R200 remote units. Exposure and triggering information is carried out using infrared wireless communication. By using two separate flash heads, it is possible to direct light precisely onto miniature subjects.

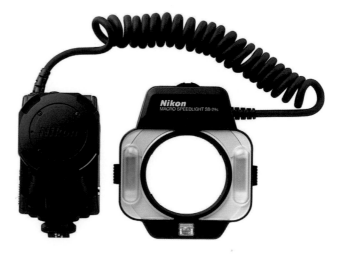

MACRO FLASH

Ring/macro flashes are designed to produce even, shadowless light to illuminate close-up subjects, but they can be quite costly.

BUTTERFLIES

If you are new to insect photography, begin by photographing butterflies. Not only are they appealing and photogenic, but they are also accessible, widespread and usually easy to locate. There is somewhere in the region of 20,000 species of butterfly worldwide, with swallowtails, blues, skippers, fritillaries and whites being among the best-known families. They inhabit almost every environment and can migrate in vast numbers over very long distances. Due to their colourful and varied markings, few nature photographers can resist photographing butterflies. However, insect photography presents a whole host of challenges – research, patience and good technique are key to achieving the results you crave.

PHOTOGRAPHING BUTTERFLIES

Throughout the next few 'on location' chapters, we will tell you repeatedly how important it is to research your subject. The message should be clear – whatever the subject, do your homework first. It is no different with insects. In order to know where and when to look for a certain variety of butterfly, learn all about it first. What type of habitat does it prefer – heath, forest or grassland? In which month of the year does the adult emerge? A butterfly's lifespan may only be a few weeks, so your window of opportunity can be small. Arm yourself with as much knowledge as possible before planning visits to suitable environments or nature reserves.

Typically, the best time to find butterflies on the wing is during the middle of the day, when they are busy flying, feeding and breeding. However, because this is when they are at their most active, it can make it difficult to get close enough to take good photographs. Stalking is one approach – following (not chasing) butterflies as they fly about, and then efficiently moving into position when they stop to feed on nectar-rich flowers, or bask in the sunshine. Although you have no control over where the insect lands – or the lighting and background – stalking can bring a good degree of success. The further away from the insect you stay, the less likely you are to disturb it. Therefore, to maximize your chances, use a macro upwards of 90mm, if possible, as this will provide a greater working distance from the subject. Always be aware of your shadow – if it is cast across the subject during your approach, it will almost certainly alarm the insect and frighten it away. Tread carefully, too; if you disturb nearby grasses, flowers or foliage, the insect will fly.

It's a good idea to manually pre-focus the lens beforehand and then – with the camera to your eye – move progressively closer to the subject until it is in sharp focus through the viewfinder. Doing so obviates the need to adjust the focusing ring, eliminating the chance of your hand movements alarming the subject. Autofocus is normally best avoided, as it can struggle to lock on to some close-up subjects.

Butterflies can be photographed in many different ways, for example, head-on for quirky-looking portraits; or from one side, to show the markings on their underwings. However, the most popular angle is from above, when the insect's wings are open and flat. Depth of field is shallow at this level of magnification, but you can maximize what little there is by keeping your camera parallel to the butterfly's wings. There is only one geometrical plane of complete sharpness and normally you will want to place as much of your subject in this plane as possible. To ensure your subject stands out against its surroundings, select an aperture no smaller than is necessary. In other words, an f-stop small enough to keep your subject sharp throughout, but large enough to throw background detail pleasantly out of focus. The optimum aperture will vary from one situation to the next, but f/8 is often a good starting point.

PRO TIP: Many of these techniques can be adapted to photographing moths. While photographing moths at night presents a whole new set of challenges, there are many varieties that fly during the day. Moths can often be found during the day sheltering among vegetation, resting on bark, or among grasses.

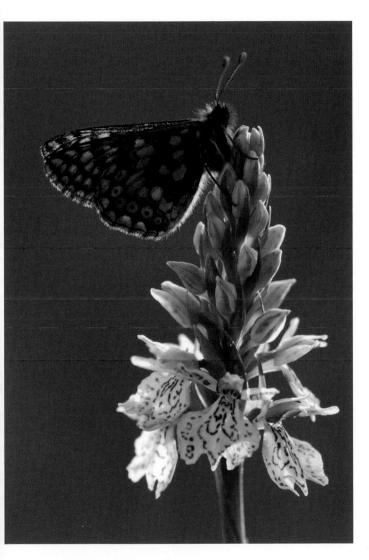

MARSH FRITILLARY BUTTERFLY
(EUPHYDRAYAS AURINIA)
Select your shooting angle carefully. A low,
parallel viewpoint often looks most natural, while
back-lighting suits the translucency of butterfly
wings and highlights shape and detail. You don't
have to fill the frame to capture great butterfly
images – if it is resting on an attractive flower,
a wider approach may work best.
Nikon D300, 150mm, ISO 200, 1/40 sec. at f/8, tripod

Many species like to bask with their wings at a 45° angle. However, not only can this result in the wings looking awkward in photos, but to keep them sharp throughout the frame demands an impractically large depth of field. Wait for the butterfly to open its wings fully, or close them completely, before taking the photo.

MORNINGS AND EVENINGS

Arguably a better, more controlled way to photograph butterflies is to shoot them in the early morning and late evening when they are less active. At this time of day, they can often be found roosting among foliage or tall grasses. Search carefully, always being cautious where you tread. Still days are best – even the slightest breeze will sway subjects around, making focusing and composition difficult. When you've located a subject, move into position slowly. On cool mornings, before the insect is warm enough to fly, it may be possible to use a tripod. This is hugely advantageous, aiding both pinpoint focusing and composition. Before releasing the shutter, search the background for any distracting elements, like grasses or out-of-focus highlights. These can often be excluded by simply adjusting your shooting position slightly, or selecting a larger aperture. Alternatively, if the insect is dormant, it may be possible to carefully remove distracting background vegetation using scissors, or gently flatten it by hand.

As with any wildlife image, lighting can make or break the shot. With butterflies, back-lighting can prove most effective, highlighting the shape of the wings and giving them an attractive glow and translucency. A small degree of fill flash can be useful in dull weather to lift ugly shadows; a reflector can be used if the insect is static.

Insect photography can be very frustrating, with your subjects flying away just as you are about to trigger the shutter and get the shot. However, prepare well and be patient, and you will soon capture great butterfly images.

DRAGONFLIES AND DAMSELFLIES

Dragonflies and damselflies are easily distinguishable. The wings of most dragonflies are held away from, and perpendicular to, their bodies when at rest; damselflies close their wings together above their bodies. Also, damselflies are typically smaller, more slender and fragile-looking, and their eyes are set apart – in most dragonflies, the eyes touch. Although the two types of insect are different, the technique and approach required to photograph them is the same.

PHOTOGRAPHING DRAGONFLIES AND DAMSELFLIES

Dragonflies and damselflies are most commonly found close to marshes, swamps, lakes, ponds and streams. Exotically coloured, they are powerful and accomplished predators. As with any natural subject, research your chosen one thoroughly. Visit suitable wetland locations and spend time observing their activity. Dragonflies are highly territorial and will often patrol the same stretch of water and visit the same place of rest again and again – for example, an overhanging branch, reeds or grasses. Identify resting places, and then stand nearby – camera at the ready – waiting for the time when the insect returns. Stealth is required, but by wearing drab clothing and waiting, you will maximize your opportunities.

Typically, dragonflies will begin flying at temperatures of 55–59°F (13–15°C), so during early morning and late evening, when temperatures are lower, they're far less active. This is a good time to visit wetland habitats and search for resting insects clinging to tall grasses or perched on branches – some damselfly and dragonfly types will even 'roost' close together. Morning is a particularly good time for dragonfly photography, as tiny droplets of dew will form on the insects' wings and body during cool, clear nights. Droplets will add interest and scale, and glisten like jewels in the morning light.

While insects are less active at the beginning and end of the day, take care not to disturb them or surrounding vegetation. Look for insects resting high up with a clean, uncluttered background. This is important, as the wings of dragonflies and damselflies are transparent and their intricate veining will be lost against a messy backdrop. A greater working distance will help minimize the risk of disturbing subjects. A macro lens with a focal length of at least 100mm is best; alternatively, try using a 200mm or 300mm telephoto coupled with extension tubes (see page 20). When insects are resting, you may need to use a tripod, but position the legs carefully. Try to keep your camera parallel to the plane of the dragonfly, to capture as much as possible of the subject in focus. However, when it is impractical to do this, ensure your point of focus is on the insect's disproportionately large eyes – if they aren't sharp, the image will be ruined. Focus manually, as this will allow you to position your focal point more precisely; and regularly use your depth-of-field preview button – or LCD display – to check focus and background.

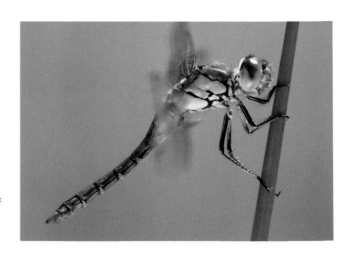

COMMON DARTER DRAGONFLY *(SYMPETRUM STRIOLATUM)*
Dragonflies are most commonly photographed from overhead, but avoid using the same viewpoint too often. A side angle, as shown here, will highlight the insect's shape and form, while adopting a closer approach will allow you to isolate specific body parts, like wings or eyes. Try to be innovative and keep your mind open to different angles or possibilities.
Nikon D200, 150mm, ISO 100, 1/250 sec. at f/4, tripod

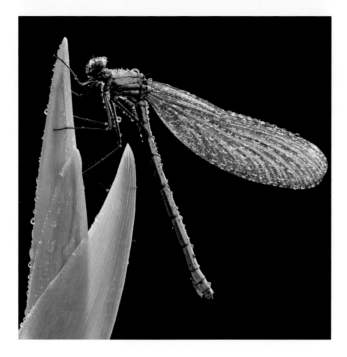

BANDED DEMOISELLE *(CALOPTERYX SPLENENS)*
After clear, cool summer nights, the wings and bodies of dragonflies and damselflies will be covered in tiny water droplets. The insects are generally inactive at this time so, with care, you can set up a tripod and move in close to the subjects with relative ease. The hard part is locating the insects in the first place – they will often hide away among grasses and can be difficult to spot.
Nikon D800, 150mm, ISO 100, 1/2 sec. at f/11, tripod

Dragonflies suit being photographed from directly overhead, as this reveals the intricate patterning of their wings. A side angle will highlight the insect's body shape, while a head-on view will emphasize their large eyes. The insect doesn't have to dominate the frame – shooting from further away, or using a wider focal length, will give your shots more context and scale. You don't have to include the entire insect either – if it will allow a close approach, employ a high magnification to isolate finer detail, such as wings, eyes, or their richly coloured bodies.

CAPTURING BEHAVIOUR

To enhance the impact of your shots, try to capture elements of the insects' behaviour. Shots of dragonflies or damselflies hatching, mating, laying eggs, or in flight are guaranteed to stand out and look less static. Larvae typically emerge in the morning, climbing out of the water and attaching themselves to a reed or grass near the water's edge, before hatching. They are highly vulnerable at this time, so take care not to knock or move them. Finding one emerging, which is also in a suitable position for photography, isn't easy – it may take many hours of searching. However, once located, it is possible to capture a sequence of images, at the various different stages, as the insect completes its metamorphosis.

During the heat of the day, large bodies of water will be alive with dragonflies and damselflies hunting, mating and laying eggs. Dragonflies will often mate on the wing, but paired damselflies will typically rest on vegetation near the water's edge. When male and female are in tandem, they form a 'wheel' or 'heart' shape. Keeping both insects acceptably sharp throughout will typically require an aperture of f/11 or f/16. When laying eggs, female dragonflies will often land on lily pads or weed and dip their tails beneath the water. Shoot from the water's edge, lying on the ground to achieve a low, natural viewpoint. Unless insects are very close to the water's edge, a macro lens will be of little use – instead, use a long telephoto in the region of 300–400mm. If you can, include the insect's reflection in the water to add further interest and a feeling of symmetry.

Dragonflies' aerial agility and quick reflexes make them a challenging subject in flight. Be prepared to take huge bursts of images, with a low success rate. Target larger species when attempting flight photography. Observe their range and place yourself close to the area they regularly patrol. The best opportunities will come when they hover, allowing a little extra time for you to achieve focus. Alternatively, try pre-focusing on a perch that a dragonfly regularly returns to and then fire a short burst of images – using the camera's continuous shooting mode – just before the insect arrives, or as it departs. It can take multiple attempts to capture an image that is both sharp and well composed, but the results can be fantastic. Prioritize a shutter speed of at least 1/1000 sec. for flight, while a teleconverter (see page 100) can be useful for increasing the pull of your lens.

SPIDERS

If you are an arachnophobe, you might be advised to flick to the next page! A fear of spiders is quite common, but arachnids are surprisingly photogenic. Spiders range greatly in size and appearance, with the largest having a legspan of nearly 12in (30cm). Some are brightly coloured and beautifully patterned. Nature photographers can highlight their primitive appearance by shooting in extreme close-up. However, remember to exercise caution – some countries are home to poisonous species, and some spider bites are potentially life-threatening.

PHOTOGRAPHING SPIDERS

Good spider images will come either as a result of opportunism – chancing upon subjects – or from careful research of specific species in order to learn about their habits and habitats. Typically, it is easiest to locate and photograph web-making spiders – webs reveal the whereabouts of their owners. When a spider is suspended in its web, it is often possible to capture two images, one from either side – capturing the markings on its back, and its underside and mouth parts. Spiders are sensitive to the tiniest vibration – knock the web, or the foliage it is suspended from, and it is easily disturbed.

Stealth and care is important when setting up. You should be able to use a tripod for photographing spiders in webs. Carefully position your set-up so that the sensor plane is parallel to the creature. Doing so will allow you to make the most of the available depth of field – if you don't, parts of its body or its legs are likely to drift out of focus. As ever, background detail is important. Try to keep the background clean and simple so that nothing competes with your subject for attention. When the sun is low in the sky in the morning and evening, you might be able to select an angle that allows you to silhouette (see page 66) the spider against the sky or sun – spiders suit this treatment, as their shape is so instantly recognizable.

Many species of spider don't create webs. Some live in tunnels, while others dwell in cracks in rocks, logs and tree trunks. Often, photo opportunities will arise by simply remaining close by and

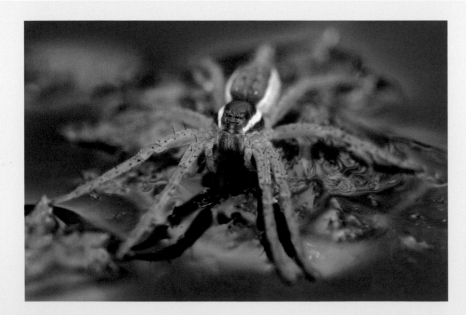

RAFT SPIDER *(DOLOMEDES FIMBRIATUS)*
When photographing spiders on the ground – or on water, like this raft spider – an eye-level viewpoint will often produce the most natural, intimate results. Overhead viewpoints can also be effective, as long as the spider is set against an interesting or contrasting backdrop.
Nikon D300, 150mm, ISO 400, 1/125 sec. at f/5, handheld

waiting. Other types of spider, like hunters, jumpers and weavers, are best shot from a low, ground-level viewpoint. A head-on angle will highlight the spider's impressive fangs and eyes and can create striking portraits. With this type of approach, it is not essential for all of the spider's body and legs to be recorded in sharp focus – as long as the eyes are pin-sharp, it shouldn't matter if the body and legs drift out of focus.

PRO TIP: Some spiders are most active at night. Spiders' eyes actually reflect light, much like those of mammals. This makes it easier to locate them – particularly larger species – by simply shining a torch around. Nocturnal species can be shot using flash.

SPIDERS' WEBS

The delicate structure and engaging shapes of spiders' webs make them incredibly photogenic. By isolating the web alone, you can create striking, abstract results. It is amazing just how varied each web can be and, together with different surroundings, light and weather, web photography offers many possibilities. The weather conditions are an important consideration, as webs are easily blown around in the wind. Ideally, opt for a still day – but if it is breezy, use an umbrella to help shelter from the elements. Look for a pristine web, and one that you can easily isolate from its background – grassy fields, tall grasses and small bushes are among the best places to search. Select your viewpoint carefully. A web can look completely different from one side to the other, so explore different viewpoints and choose the one where the light catches it best with an uncluttered background.

Normally, it's best to use a large aperture, in the region of f/2.8–f/8, to help keep background detail diffused and focus the attention on the subject. Depth of field will be shallow, so focus has to be very accurate. Use a tripod, taking care not to knock or damage the web. Using Live View (see page 126) can also aid precise focusing. After still, clear nights, webs will be glistening with dew, making them easier to find and more attractive. Rise early and shoot before the condensation evaporates. Crop in tight to emphasize the web's pattern and intricacy. The most interesting part of a web is usually its centre, so use this as your focal point or as a compositional tool.

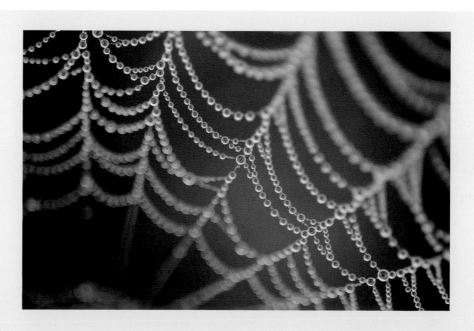

SPIDER'S WEB
Not all of the web needs to be in sharp focus. By intentionally positioning your camera at an angle to the web, and using a large aperture, you can highlight just a few strands, or keep only a small part of the web in focus, with everything else drifting pleasantly out of focus. In this instance, flowering heather created a colourful backdrop.
Nikon D300, 150mm, ISO 400, 1/30 sec. at f/2.8, tripod

AMPHIBIANS

Expect to get damp and dirty if you want to get close to frogs, toads, salamanders and newts – always wear good waterproof clothing and footwear when photographing amphibians. Also, you can anticipate working in poor lighting conditions as, generally speaking, they prefer moist, dark habitats. This shouldn't deter you, though. Frogs in particular are appealing and highly photogenic creatures; encounters can result in truly eye-catching images. As ever with wildlife photography, patience, technique and a slice of good fortune are key to achieving memorable images.

PHOTOGRAPHING AMPHIBIANS

The first challenge is to locate suitable subjects – amphibians are well camouflaged, nocturnal and live in swamps, under rocks and among thick foliage. Newts and salamanders present the greatest challenge, spending a large percentage of their lives underwater. The best images of newts, for example, are typically captured in captivity. This isn't something we encourage at our workshops and only experienced, careful nature photographers should attempt to collect species for photography. If you choose to do so, use a small, nylon net with a not too coarse grain. A standard-sized aquarium will suffice, or construct your own using thicker glass for the base and sides, and high-grade optical glass for the front of the tank in order to maximize image quality. Collect appropriate pond vegetation to create a natural-looking backdrop – it is also useful to use separating glass to restrict your subjects to the front of the tank. Water from a pond or river is not generally clear enough for photography. Collected rainwater is a good option – alternatively, tap water can be used, but only if boiled first and left to cool the day before. Water will quickly get warm and get de-oxygenated, so retain subjects for only short periods. Select an aperture of f/11 or f/16 to generate a generous depth of field and illuminate the subject from above using a single flashgun. If you do intend to photograph amphibians in captivity, do your research first and ensure any stress to the subject is kept to an absolute minimum. Always return subjects to the wild as quickly as possible, and put them back where you found them.

While newts and salamanders are difficult to photograph with any degree of control in the field, frogs and toads are a completely different proposition. They look just as natural and photogenic on land as underwater, so it is possible to capture images of them basking, mating or resting in the wild. Frogs and toads are easiest to locate and photograph in the breeding and egg-laying season, when they return to water. Visit suitable wetland habitats – small pools and garden ponds often provide the best accessibility for photographers. One technique is to simply kneel by the water's edge and wait for individuals, or mating pairs, to poke their heads above the water surface to breathe. Using a close-up attachment or macro lens, move slowly forward into position, lens pre-focused, and release the shutter at the point of sharpest focus. During the breeding season, ponds are alive with frog and toad activity, so opportunities should be plentiful. Include their reflections in the water when possible, as this will add an extra dimension to your images.

Out of the water, frogs and toads provide endless photo opportunities. Look to achieve simple, uncluttered compositions. If the subject stays still long enough, consider using a polarizing filter (see page 21) to reduce distracting glare from its reflective skin. Tree-frogs are particularly colourful, but, like most frog species, they are rarely found under good lighting conditions, preferring poorly lit habitats. While natural light is always preferable,

PRO TIP: When composing images, a low viewpoint normally works best. Shooting from a side angle is also popular, and a head-on viewpoint can create images with impact and enhanced eye contact. Keep the eyes off-centre to create stronger, more stimulating compositions.

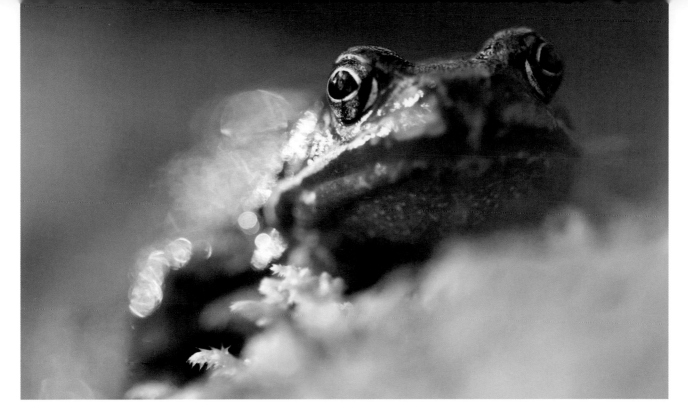

COMMON FROG *(RANA TEMPORARIA)*
A shallow depth of field, created by using a large aperture, will help create attractive, flattering backdrops when photographing amphibians. It will also help draw attention towards the subject's large, bright eyes. A longer focal length is preferable, creating a greater working distance from the subject.
Nikon D300, 150mm, ISO 400, 1/400 sec. at f/4, handheld

artificial light is often the only the way to achieve sharp, bright results. In rainforests, or among dense vegetation, for example, the light is dim and foliage can create unnaturally green colour casts.

In this type of situation, flash (see page 78) will help you to record vivid and accurate colours. Flash produces the correct amount of light you need to achieve the right exposure at any given aperture, so you are not restricted to using large apertures in order to generate workably fast shutter speeds – instead, you are able to select a small aperture, if you require a larger depth of field. Flash will also add a catchlight to the subject's eye. However, diffuse the flash burst – using a diffuser or soft box – to help avoid distracting hotspots forming on the subject's shiny skin.

FROG SPAWN
Don't overlook the various stages of an amphibian's life cycle. For example, the eggs or spawn of frogs can look fascinating in close-up. In this image, I photographed a clump of frog spawn back-lit on a lightbox before quickly returning it to the pond from where it was collected. Doing so created an abstract, high-key result.
Nikon D700, 150mm, ISO 200, 1/5 sec. at f/11, tripod

REPTILES

Although many people are wary, or even fearful, of reptiles, they occur in a wide variety of interesting shapes and startling colours and can be highly rewarding photographic subjects. Wide-angle views will reveal their environment, while a large magnification allows you to isolate detail, colour, scaling and unusual patterns. Some subjects – tortoises, lizards and other sun-worshippers – can be relatively easy to get close to, but the majority require patience, understanding and good fieldcraft.

PHOTOGRAPHING REPTILES

Reptiles vary hugely in size and shape. They are cold-blooded and their skin is covered in scales. The Komodo dragon can grow to over 10ft (3m) long, while the saltwater crocodile can be twice this size; in contrast, the smallest geckos and chameleons can be just a couple of inches in length. Your choice of lens type and approach will be greatly dictated by the size and type of subject you're photographing. Large or venomous reptiles should always be treated with caution. It is important to be able to identify species accurately so that potentially dangerous ones can be avoided. Only experienced naturalists – who take necessary measures to ensure their safety and the welfare of the subject – should ever attempt to photograph dangerous animals. The majority of reptiles are harmless, but they are shy and often difficult to approach, as they are highly sensitive to noise and movement. Many images of reptiles are shot by temporarily housing them in a vivarium, a tank designed for viewing and photography. However, we encourage our workshop participants to capture their images in the field whenever possible, using good, old-fashioned fieldcraft and technique.

Of all the reptiles, snakes are particularly photogenic. Their large, bright eyes, forked tongues, and markings look striking in close-up. A telephoto lens, of 300mm or more, will allow you to work from a good distance and minimize disturbance. Being cold-blooded, snakes and lizards will typically be at their least active early in the morning, as they bask in the sunshine. Therefore, this is the best time of day to visit suitable habitats. Research locations beforehand, visiting them regularly to identify spots where reptiles bask – this will help you work efficiently and enhance your chances of success. A low viewpoint often will create the most intimate-looking results. If you're using a long focal length, depth of field will already be shallow, but by shooting from ground level you will ensure foreground and background detail is quickly thrown out of focus, placing more emphasis on the subject itself. Nature photographers are often encouraged not to shoot subjects from an overhead angle, as shooting from human height is deemed to give subjects less importance. However, shooting from overhead can highlight the reptile's length, shape and form, particularly if it is resting on an attractive or contrasting backdrop such as sand or bark.

Many reptiles are timid, well camouflaged and will quickly scurry away if disturbed. They are often territorial, though, so will return again and again to the same rocks, clearing, sandy area or log pile. Try visiting places where you have seen them before. When photographing reptiles, you may need to shoot from awkward angles and you must be prepared to adapt to the subject's behaviour. Therefore, using a camera support is not often a practical option. When shooting handheld, image-stabilizing technology (see page 15) will be useful, together with a higher ISO sensitivity to enable faster shutter speeds.

You don't always need to shoot frame-filling portraits. A wider approach will reveal the subject's environment, while a closer approach, a single eye, for example, will produce more unusual results. Finally, remember to wait for the right moment – an image of a lizard devouring its prey will give you an image with much greater impact.

PRO TIP: Do not be tempted to handle reptiles, or temporarily place them in the fridge to make them less active – this is unethical behaviour, and potentially damaging to the subject. Great images should be the result of good technique and fieldcraft.

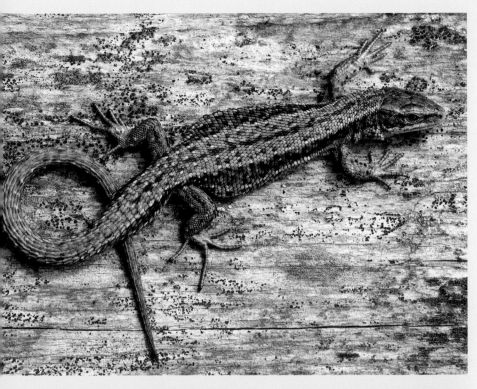

COMMON LIZARD *(LACERTA VIVIPARA)*
Many reptiles are shy and sensitive to noise and movement, making them challenging subjects. It is worthwhile visiting places where reptiles are more accustomed to human activity – along nature trails, and in parks and gardens, for example. Lizards will often bask on fence posts and will tolerate a much closer approach.
Nikon D70, 150mm, ISO 200, 1/200 sec. at f/11, handheld

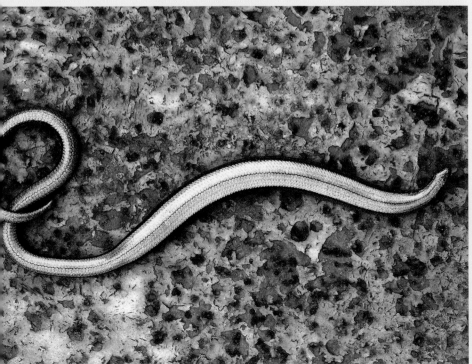

SLOW-WORM *(ANGUIS FRAGILIS)*
Because of their long, narrow shape, snakes and slow-worms don't often suit being photographed when they're stretched out, as too much empty space is created within the frame. They suit the traditional frame format best when coiled up and shot from ground level. However, don't be afraid to explore different viewpoints. In this instance, contrary to the general rule, an overhead angle created the most striking composition of this slow-worm basking on a rusty sheet.
Nikon D70, 105mm, ISO 400, 1/125 sec. at f/11, handheld

► CHAPTER SIX > **BIRDS**

Birds are among nature's most fascinating creatures. For the wildlife photographer, they are one of the hardest subjects to master, but as with all photographic difficulties, perseverance can bring great rewards. If you have ever witnessed the elaborate courtship display of the great crested grebe, watched a small passerine searching for material to line its nest, or seen an osprey plunge into icy water to snatch a fish, you quickly realize why birds are such popular subjects for photographers all around the world. Wherever you are, there is never a shortage of feathered subjects and there is a huge diversity of species, all with their various specializations. Many of them are easily accessible, even in a suburban environment, and some will permit a very close approach, so there are endless possibilities for capturing a stunning image.

IN THE BAG: WHAT IS REQUIRED?

Budget
- Telephoto zoom lens
 (for example, 75–300mm)
- Tripod
- Beanbag

Enthusiast
- Telephoto lens
 (ideally 400mm or longer)
- Carbon-fibre tripod
- Monopod
- Beanbag

Useful accessories
- Wimberley tripod head
- Teleconverter
- Bait
- Fully-charged spare camera battery
- Hide
- Camouflage netting

GREY HERON *(ARDEA CINEREA)*
I noticed this heron perched motionless on a mossy rock underneath a large waterfall, and immediately saw the potential for an environmental study. I managed to crawl to the water's edge without being seen, placed the camera on a tripod and used a slow shutter speed to blur the movement of the water, capturing the bird in its habitat.
Canon EOS-1D Mk IV, 100–400mm L IS, ISO 50, 1/8 sec. at f/16, tripod

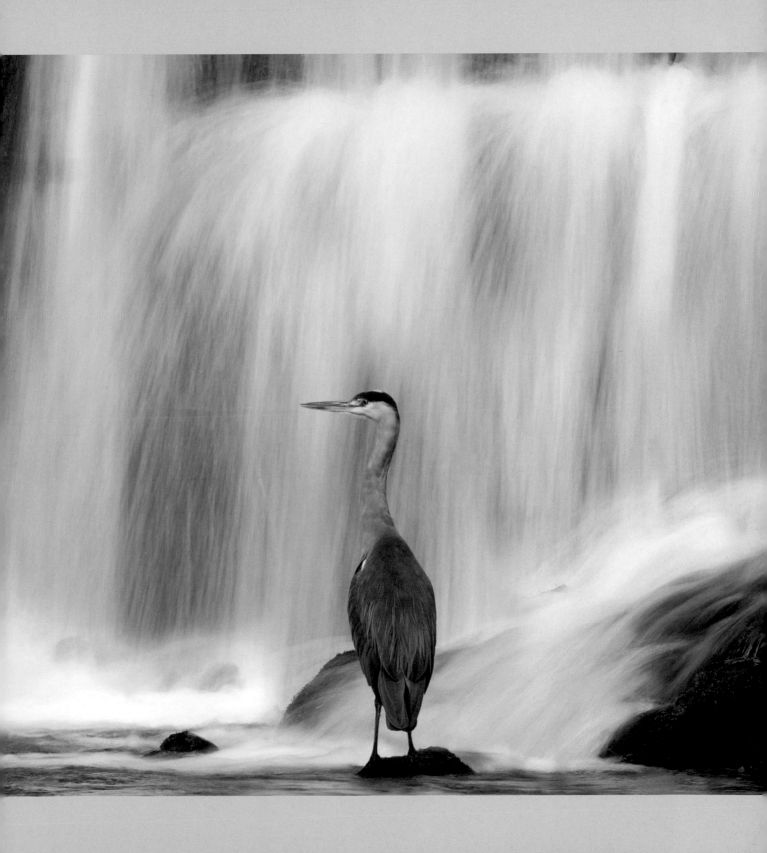

TECHNIQUE

Surprisingly, one of the most important aspects of successful bird photography lies not with the subject itself, but in its surroundings. Employing a wide aperture, such as f/5.6, will typically provide a very limited depth of field, especially when coupled with a long lens, helping to blur the background and eliminate unwanted distractions from the frame. Colour and compostion are two more key factors.

PHOTOGRAPHING BIRDS

For a close-up portrait image, simplicity is key. Look for a background that is not only clean and simple, but one that complements the subject. Colour plays a big part here, so look carefully at your surroundings and think about the best direction to shoot from, before approaching your subject. Colours can be complementary or contrasting (see page 54) – there are no hard-and-fast rules, and no absolute right or wrong, so experiment to find a combination that works for the subject you are shooting.

Areas of very deep shadow can be used to create a black background, creating a low-key effect, to add ambience. This can be further enhanced by adjusting your exposure compensation. Try –1 stop first, then check the histogram carefully and make further adjustments if necessary.

When photographing birds swimming, reflections in the water can make very effective backgrounds. In autumn, the wonderful browns and yellows of the surrounding trees can add a much-needed splash of colour and warmth, making the image more pleasing to the eye. Search for key elements of the landscape that can be included to give foreground interest. This could be foliage used as a natural frame, or water to help lead the eye into the image. Not only does this help to isolate the subject and produce a stronger composition, but it will also add depth, creating an almost three-dimensional effect that makes the subject 'pop' from the finished image.

When photographing birds on the ground or on water, try to get right down to their level. An eye-level perspective will make your images seem much more intimate, and will make the background

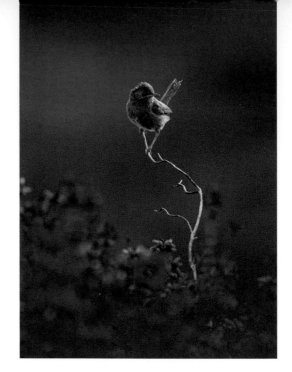

DARTFORD WARBLER *(SYLVIA UNDATA)*
I set the camera as low as possible for this image, to create a diffused foreground. The colour of the heather draws in the eye and the bird is set against a blurred background. This ensures good separation between the subject and its surroundings.
Canon EOS-1D Mk II, 500mm f/4 L IS, ISO 250, 1/800 sec. at f/5.6, tripod

recede into the distance. Generally, of course, birds rarely stay in one position for long, so you will need to be able to react very quickly when the perfect opportunity finally presents itself. Practise adjusting the ISO, aperture and focus settings until you can do it without taking your eye away from the viewfinder. This will help you to grab images in a split second. This is the key to all wildlife photography – anticipating action. Rather than settling for a stereotypical image of a bird perched on a branch, no matter how perfect the focus and exposure, try to anticipate what it might do next. An image depicting the bird's behaviour will reveal so much more and nearly always provide a more interesting shot.

When composing your image, leave space to one side of the frame for the subject to look into. This will almost always create a more pleasing photograph than one with the subject in the centre. The exception to this rule occurs when you have a degree of pleasing symmetry to your subject. A bird flying, or looking, straight into the camera will often look best when placed centrally.

ANDEAN CONDOR *(VULTUR GRYPHUS)*
I watched this Andean condor for some time as it circled the mountain ridges in Torres Del Paine National Park in Chile. In order to show the relationship between the bird and its spectacular habitat, I chose to shoot with a medium-length lens. The stormy sky adds menace to the image and highlights the wild landscape that is typical of this part of the Andes. By selecting a focusing spot in the top-right corner I was able to compose the shot as I wanted while keeping the bird in focus at all times.
Canon EOS-1D Mk II, 100–400mm L IS (at 250mm), ISO 400, 1/500 sec. at f/11, handheld

EIDER *(SOMATERIA MOLLISSIMA)*
To take this image of an eider duck swimming from the shore, I used a beanbag for support, which enabled me to adopt a very low shooting angle. The water-level view adds intimacy and creates a diffuse foreground, leading the viewer's eye into the picture and adding depth.
Canon EOS-1D Mk II, 500mm f/4 L IS, ISO 160, 1/1200 sec. at f/5.6, beanbag

AUTOFOCUS

Birds are fast movers, so in most cases autofocus (AF) is a crucial aid for ensuring really sharp shots. Recent major advances in lens and camera technology have resulted in autofocus systems that are incredibly complex and responsive, and all current digital SLRs feature at least two different autofocus modes, one designed for static subjects and one for moving subjects.

STATIC SUBJECTS

Canon calls its AF mode for shooting still subjects One Shot; Nikon uses the term Single Servo; and other brands commonly use Single Shot – but the function is essentially the same. In this mode, the autofocus system is activated by pressing the shutter button halfway; focus is 'locked' until the shutter is either released or the photograph has been taken. Most autofocus systems position the default focusing point in the centre of the viewfinder – which creates a problem with composition. In most circumstances, to create an aesthetically pleasing image, it is best to avoid placing the subject in the centre of the frame.

Fortunately, most modern digital SLRs offer several focusing points that can be selected by pressing a conveniently placed button with your thumb (which activates the focusing point), and then adjusting a dial to move the point to different areas of the viewfinder. The other way of achieving off-centre focus is to focus on the subject using the central focus point, keep the shutter button half-pressed to lock the focus, recompose the image with the subject off-centre and only then, when the desired composition has been achieved, fire the shutter. The clear disadvantage of using this method is that you will invariably have to keep re-composing your image after every shot – and that costs precious time. To be able to react quickly enough to your subject's movements, practise selecting different focusing points. With experience, you will be able to move the point to one side or corner of the frame in a split second, without taking your eye away from the viewfinder – helping you to capture the perfect composition at a moment's notice.

KINGFISHER (*ALCEDO ATTHIS*)
This kingfisher remained almost completely still for several minutes, allowing me to shoot in One Shot AF mode. With this function selected, focus is locked when the shutter is half-pressed and will only be released when the shot has been fired.
Canon EOS 10D, 100–400mm L IS (at 400mm), ISO 100, 1/60 sec. at f/5.6, tripod

MOVING SUBJECTS

For moving subjects, use the predictive focus mode on your camera. Keep the focusing point over the subject and pan with it as it moves, keeping the shutter half-pressed. The lens will track the subject and continually adjust its focus to keep the subject sharp. Good panning technique requires practice, so start with slow-moving subjects such as birds swimming on water. The tricky part is to keep the focusing point over the head of the bird as it moves; if the point shifts away from the subject, the focus will follow and you will end up with a sharp background, but a blurred subject.

Make full use of the technology that is offered to you by your camera. It isn't 'cheating' to shoot several shots per second, or to use automatic high-speed focusing and tracking, or auto exposure bracketing. When George Eastman introduced the Kodak camera, the very first to use roll film (which he also invented) back in 1888,

GOLDENEYE (*BUCEPHALA CLANGULA*)
As winter comes to an end, goldeneyes start to perform their elaborate courtship ritual. As part of their display they throw back their heads violently while kicking up a large spray of water with their feet, often emitting a loud, piercing call at the same time. I arrived early one morning and adopted a low viewpoint. To increase chances of success, I panned with the birds as they swam, firing a burst of frames every time they performed. The predictive focus setting allowed me to keep the birds in focus at all times.
Canon EOS-1Ds Mk III, 500mm f/4 L IS, ISO 200, 1/1600 sec. at f/5.6, beanbag

he coined the slogan, 'You press the button, we do the rest.' Consumers rushed to take advantage of what he offered – and photographers at all levels have continued to do so ever since.

Most autofocus lenses have a focus limiter, which can be used to limit the focus range. This is useful in situations when your subject is at a greater distance as it prevents the lens from hunting over a long range and helps it to lock onto your target at speed.

MAKING AND USING A HIDE

Due to the inherently shy nature of most wildlife, a hide – whether it is home-made or commercially sourced – should become an integral part of any wildlife photographer's kit. The most important consideration before attempting any photography from a hide is deciding on a suitable location for it. Simply erecting a hide at random in a field or woodland and hoping your preferred subject will wander into view is optimistic at best – and usually fruitless.

WHERE TO PUT YOUR HIDE

A hide is at its most productive when used at a feeding station (see page 98), adjacent to a pond or lake, at known roost sites and display grounds, or in another area that you are confident your subject will regularly return to. Used in this way it can be erected well in advance and left in place so that your intended quarry can become accustomed to it. Take extra care, though, if you are leaving a hide on public land, as it will almost inevitably attract unwanted attention and will most likely end up getting stolen! It can be better to use hides on private land, with the necessary permission, and leave it on-site with peace of mind. Farms attract a wealth of wildlife such as rabbits, badgers, hares, woodland birds, lapwings and curlew, all of which are excellent candidates for hide photography. When erecting your hide at a new location, avoid placing it out in the open. Instead, look for a suitable hedgerow or other convenient foliage that will help to break up its outline. It will then quickly become accepted as part of the landscape – and, if it is in a public place, it will be less conspicuous to passers-by.

There are numerous commercial hides on the market today. Most current dome hides use shock-corded poles to hold the fabric in place, and are similar in design to a tent. The most convenient type of hide is one that is designed with a pop-up construction. These can be erected in seconds and fold away into a flat, circular shape that resembles a giant reflector. They are fairly light and easy to carry and some even have integrated chairs. When purchasing a hide, make sure it is well made and roomy enough to afford some degree of comfort. This is vital if you are to be spending hours cooped up inside. You may fancy having a go at making your own hide out of locally sourced materials. The advantage, in addition to the cost saving, is that it will look more natural and should be accepted by most subjects almost immediately. Whether the hide is home-made or not, it is important that you can stretch and move around inside it without being detected, and a waterproof sheet is essential to keep the inside dry and comfortable.

USING YOUR VEHICLE AS A HIDE

Many creatures will happily venture close to roads. Kestrels like to hunt over roadside verges, raptors and corvids feed on roadkill and many animals use roads as corridors. Using your vehicle as a mobile hide is not only convenient, but can also be very effective. Most birds and mammals recognize the human shape and immediately perceive it as a threat (even if it is only a scarecrow), but will tolerate a much closer approach from a vehicle. Quiet country roads with raised banks are potential hotspots, and you can even keep yourself warm on chilly winter days. Although there are many supports on the market designed for use in a vehicle, a beanbag rested on the window ledge works well. This gives a solid support and allows much-needed freedom of movement if you need to change shooting position in an instant. Do be mindful of other motorists, though, and choose an appropriate and safe place to park.

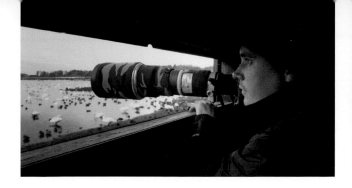
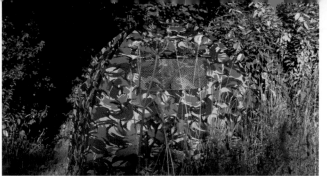

PUBLIC HIDE
A public hide where plenty of subjects come within shooting range, especially in winter, when hundreds of geese and swans congregate on the water.

DOME HIDE
This picture shows just how effective a dome hide can be when positioned in a suitable spot. Placing it among foliage will help to break up its outline and your subjects should soon accept it as part of the landscape.

Public hides are typically designed with birdwatchers in mind, rather than wildlife photographers. They are therefore likely to be too distant and too high to gain an eye-level view of your subject. However, there are a few public hides offering excellent potential for bird photography. If you have one near to you, the great advantage is that these hides are permanent and usually set up near well-established, large bodies of water that attract a wealth of birds. Public feeding stations also exist, where bait is put out at the same time each day to attract certain species of bird, allowing an almost guaranteed close-up view of your subject. The hides used are often designed with photographers in mind, and can offer fantastic opportunities.

FLOATING HIDES

A floating hide can be a very effective way of photographing water birds. It conceals your presence and helps you capture natural behaviour, and will also enable you to adopt a very low angle, adding intimacy to your shots. My own floating hide is home-made and very simple in design, consisting of three planks of wood that I screwed together in a U-shape. I then attached large polystyrene blocks to the underside of each plank to create enough buoyancy for the hide to float while supporting a large lens. The camouflage canopy is held up by plastic pipes that stretch from corner to corner, so the whole thing resembles a floating pop-up tent. Once under this contraption, I can wade into the water while remaining completely hidden from view. The hide is most effective in relatively shallow areas of water where I can manoeuvre myself into different positions while keeping my feet firmly on the bottom (this is very important!). The lens rests on a beanbag that sits on the frame of the hide. This way I can get my lens down low, almost at water level, and have a much

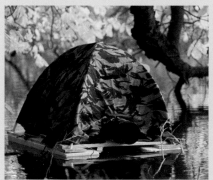

FLOATING HIDE
This image shows my floating hide in action. It provides an effective way of approaching birds on water, allowing a low shooting angle while remaining completely undetected.

better chance of capturing an attractive background. Due to the low position of the lens, an angle-finder is necessary in order to compose with accuracy and prevent water from lapping over the top of my waders. Note that it is important to always wear a lifejacket when using a floating hide, even in shallow water. As an extra note of caution, when I demonstrated my hide in action on a TV show, the presenter exhorted viewers 'not to try this at home'. You have been warned!

SETTING UP A GARDEN FEEDING STATION

Wildlife photography is so often about venturing into your subject's habitat as an observer that the idea of 'creating' habitat is often overlooked. You don't always need to travel miles from home to take great images. When looking for locations, your back garden is frequently the best place to start. Setting up a feeding station to photograph birds is easy, and you can use your own garden to create an environment that you can control. Once established, a well-planned feeding station will provide photographic opportunities all year round.

USING A FEEDING STATION

A feeding station can be as simple as you wish. For a basic set-up, a pole with one or two feeders attached to it is all you need. Different natural perches can be clamped to the pole at will, offering opportunities for a variety of compositions. Use a twig or small branch from a nearby tree or shrub to make a perch.

Think carefully about where you place your feeding station. Your first consideration should be the position of the sun as it rises and sets. My advice is to position the feeding station so that it is front-lit in the morning. This will enable you to take advantage of the 'golden hour' (see page 62) – and birds are also significantly more active at dawn. As the sun moves across the sky, you can experiment with different lighting conditions. As dusk approaches you could try back-lighting your subjects, which will create a halo of light around the bird (see page 60). Rim-lighting (see page 60) can be very effective, but take precautions to prevent flare.

Using a lens hood should eliminate the problem, but if the sun is very low in the sky, you may need to use a sheet of card to shade the front of the lens. Hold the card with the use of a Plamp. This useful device, made by Wimberley, consists of a flexible arm with a clamp at one end that can be fixed onto your tripod leg, and a clip on the other end to attach the card. The flexible arm can be threaded through the netting of a hide so that the card is held in place while leaving both hands free to shoot. I have used this device for multiple tasks and it now forms an essential part of my kit.

Your chosen background should be at least 33ft (10m) behind the feeders. By using an aperture of f/5.6 it will be rendered as solid, diffused colour, helping the birds to 'pop' out of the frame. Using a focal length of 300mm or more should enable you to get close enough to the action. If you are using a camera with a crop factor (see page 13) you will have even more reach, but depth of field can become a limiting factor. As a result you may need to stop down to f/8 to render the whole bird sharp. Always focus on the bird's eye – in almost all cases, this is the most important part of the picture.

When you have taken some decent portrait images, try some action shots by using the drive mode on your camera. By selecting manual focus, pre-focusing on a perch and firing a burst of images as the bird approaches, you will have a chance of capturing dynamic images of birds in flight, or alighting with wings outstretched. You will need a shutter speed of at least 1/1000 sec. to freeze a small bird in flight, so you will need to shoot in strong light. Even then you may need to increase your ISO setting to optimize exposure.

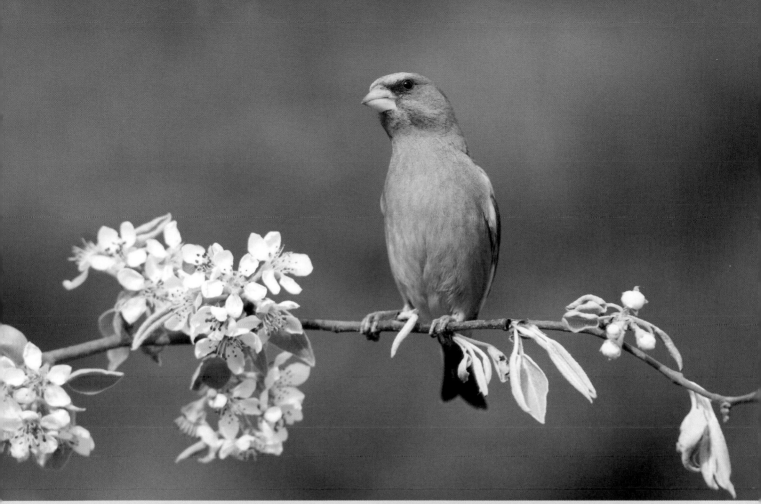

GREENFINCH *(CARDUELIS CHLORIS)*
When setting up your feeding station, look carefully at the background colour and how it will affect your images. Here, I chose a colour that would complement, rather than contrast, with the bird. The blossom has added to the image without overly dominating it.
Canon EOS 1D Mk II, 500mm F4 L IS, ISO 200, 1/320 sec. at f/5.6, hide and tripod

GARDEN FEEDING STATION
This image shows how simple it can be to use a garden feeding station. The clamp holds a perch in place, which is set a good distance away from the surrounding trees to ensure a diffused background. The hide allows me to shoot level with the perch, giving me an eye-level view of the subject.

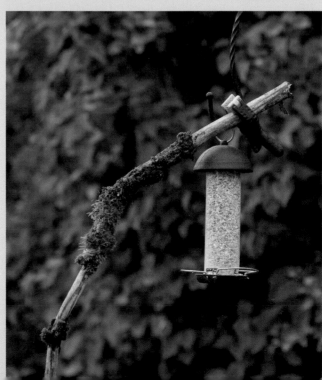

WETLAND AND COASTAL BIRDS

Large areas of wetland provide the perfect habitat for a wide variety of birds. Prehistoric people etched pictures of birds and wetlands onto cave walls and rocks, and they can be seen in the design of ancient artifacts. Today, many of these areas have been made into formal, protected nature reserves with permanent hides and feeding areas – excellent places to start honing your skills.

RESEARCH YOUR SUBJECT

Before attempting any photography, it is vital that you learn as much as you can about the behaviour of your subject. Simply venturing out with camera in hand when you have no idea what you are likely to see, or where, will inevitably be a fruitless endeavour. An Internet search is probably a good place to start, and visiting your locations and observing the birds in the wild will pay dividends. Birds use wetland habitats for breeding, nesting and rearing young, so the photographic opportunities are numerous.

Coastal areas can also be rewarding. In areas where there is an abundance of food, waders can be seen whizzing up and down the shoreline, hunting for tasty morsels in the sand. It is important when approaching any wild bird to keep as low a profile as possible. Look for rocks or other objects that you can use as cover, and approach slowly, keeping a close eye on your subject at all times to check for any sign of unease. If your subject looks like it may take flight, stop and wait for it to resume its business before attempting to get any closer. Adopting the low-level approach will not only help you get close to the birds, but will also enable you to blur the sand in the foreground, adding a degree of depth and intimacy.

A beanbag comes into its own in these types of environments, giving you a stable support but offering the freedom of movement that is vital when tracking small, fast-moving subjects.

When you're working on the shore or the marsh, it pays to keep a very close eye on the tide. It may be possible to find a suitable shooting position and wait for the tide to bring the birds closer to you. This is a good way of working as it keeps the birds at complete ease at all times. Often, especially during the winter months, waders congregate in dense flocks, either to roost or to feed. Experiment with slow shutter speeds to capture the movement of the birds and look for abstract patterns that occur when hundreds of birds are tightly packed together.

Another advantage of shooting in wild and open environments is the incredible quality of light that occurs around the hours of dawn and dusk. When shooting out to sea, there are no trees or other objects to block the light, so in the mornings and evenings, when cloud cover is low, the sky often becomes a mosaic of colour. This offers the perfect backdrop for birds in flight, on the water or on the shoreline. Care must be taken with exposure in these situations, however. Check your histogram regularly to ensure you are not losing important detail.

TELECONVERTERS

These are optical components placed between the camera and the lens. They are made in two strengths, 2x and 1.4x, and multiply the focal length of the lens by that factor, increasing versatility and range. Teleconverters are small and lightweight and enable you to shoot subjects from a greater distance but they do have drawbacks. Placing additional elements between the lens and the camera inevitably degrades image quality; often the effect is negligible, but it is advisable to buy the best-quality converter you can afford. Converters also absorb light: a 1.4x converter will incur a 1-stop loss; a 2x converter will result in a 2-stop loss. Therefore, attaching a 1.4x teleconverter to a telephoto lens with a maximum aperture of f/2.8 will effectively make f/4 the widest aperture available. TTL metering will automatically compensate for this, but be aware that shutter speeds will increase.

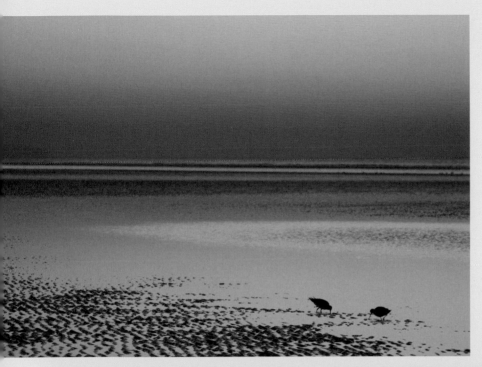

SNIPE (GALLINAGO GALLINAGO)

As the sun sinks out of sight and dusk draws near, two snipe start to forage for small invertebrates on the shoreline. I was initially drawn to this scene by the vivid colours of the sky reflected in the water. By taking a meter reading from the brightest part of the sky, I was able to silhouette the birds against the golden hues.

Canon EOS-1D Mk II, 100–400mm L IS (at 135mm), ISO 200, 1/40 sec at f/5.6, tripod

CURLEW (NUMENIUS ARQUATA)

I took this image while working on a commission to photograph coastal wildlife. As the afternoon wore on, a fierce storm erupted and started churning the sea into a frenzy. I noticed a flock of curlew flying in from the right, so quickly panned with the birds and fired off a sequence of images, capturing them as part of their coastal environment.

Canon EOS-1D Mk IV, 500mm L IS, ISO 320, 1/4000 sec. at f/6.3, handheld

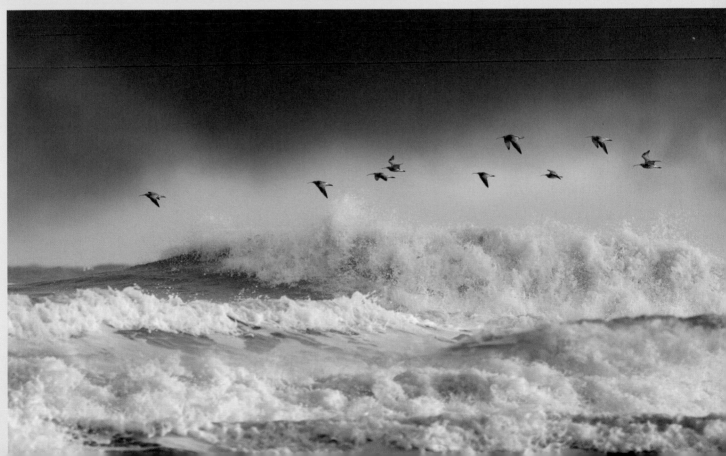

BIRDS OF PREY

Photographing a wild raptor at close quarters is sure to leave an impression on any nature-lover's memory. Unfortunately, birds of prey are solitary and elusive, and demand an incredible amount of time and patience. Your first consideration should be simply observing the birds and noting down when and where they can be seen. Buzzards, for instance, hunt over open fields. Their main prey are rabbits so it is possible to use roadkill as bait to tempt them down to within shooting distance.

PHOTOGRAPHING BIRDS OF PREY

A hide is essential for shooting birds of prey, preferably one that blends into the landscape. When baiting an area for raptors, it is important that bait is put out daily, and in exactly the same spot. Birds are creatures of habit and will return to the same place repeatedly when they are confident there is a regular food source. Owls are a little more predictable than most other birds of prey, and barn owls and short-eared owls often hunt during daylight hours. Knowledge of your subject is paramount, and time spent learning about the behaviour of your subject is time well spent. Owls regularly use the same areas to hunt, so by observing their hunting patterns you should be able to find a suitable position from which to shoot. Rather than attempting to stalk the bird, try remaining completely still and waiting for the owl to approach you. This is often the most productive method. Birds will usually fly into the wind, so waiting in a concealed position upwind is your best chance of success. When the bird flies past, use your camera's predictive focus setting and pan smoothly, firing a burst of frames. More often than not, one frame out of the sequence will stand out from the rest, either for compositional value, sharpness, or both.

CAPTIVE BIRDS

If you lack the time to dedicate to photographing wild birds of prey, captive birds are a good way to practise. There are many bird-of-prey centres, some of which offer in-flight displays, with opportunities for flight shots as well as portraits. All of the usual techniques apply to captive birds, but despite the obvious advantages, there will be one major drawback. To prevent the birds from flying away they will be either kept in aviaries, or tethered to a post. During flight displays, and while being handled by a falconer, the birds will be wearing jesses around their legs. All of these factors prevent your images from looking natural. However, it is possible when shooting a bird in an aviary to make the shot look more natural by paying careful attention to the background. Move position and try to find an area of foliage to shoot against, and keep your aperture wide open to diffuse the surroundings. On bright, sunny days – although not ideal for photography – you will often find areas of deep shadow. By shooting towards these dark patches, you can isolate the bird from its enclosure, helping to eliminate any obvious signs of captivity from your images. Aviaries will of course be surrounded by wire mesh, so you will need to get in as close as possible and use a wide aperture to blur the mesh to such a degree that it becomes invisible in the photograph. If the birds are out in the open and tethered to a stump, move in close and go for a tightly cropped head shot. This adds impact and eliminates any man-made objects from the frame.

GREAT GREY OWL (STRIX NEBULOSA)
This image was shot at a bird-of-prey centre. The owl was in an enclosure behind wire mesh, but by placing the lens so that it was almost touching the mesh, and using a wide aperture, I was able to blow the wire so far out of focus that it became invisible. I moved position so that I could shoot with a clean background to keep the image looking as natural as possible.
Canon EOS 10D, 100–400mm L IS (at 300mm), ISO 100, 1/125 sec. at f/5.6, tripod

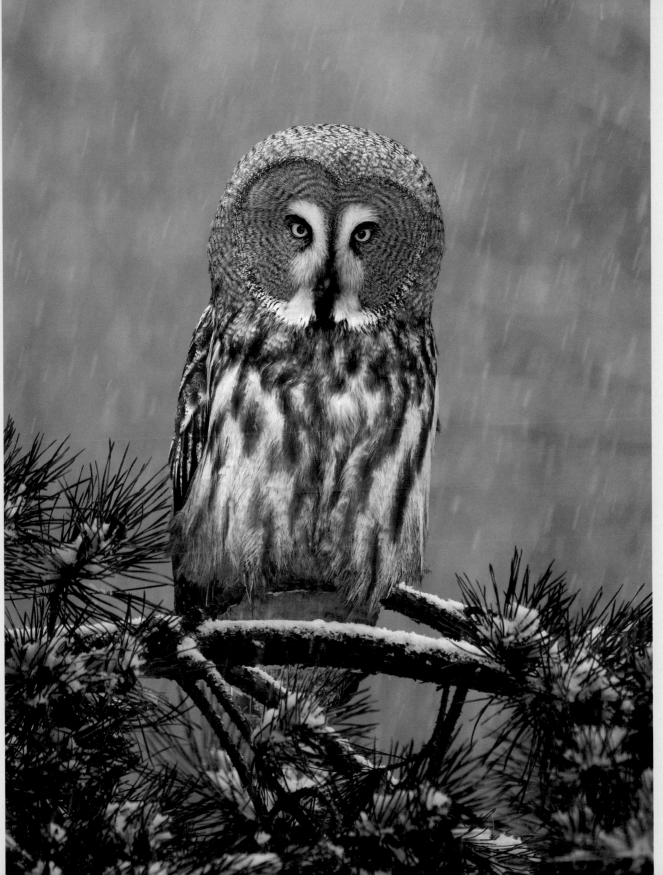

FLIGHT PHOTOGRAPHY

Photographing birds in flight demands both patience and perseverance. It is without doubt one of the most challenging areas of wildlife photography, but one that holds great rewards if you have the determination to succeed. To begin with, practise on larger subjects. Large birds, like swans, geese and herons, appear to fly more slowly than smaller birds, because of their more measured wingbeats, and therefore demand less precision.

FLIGHT PHOTOGRAPHY TECHNIQUE

A good panning technique is of paramount importance when attempting to photograph any moving subject. This can be done using a tripod, but will require a specific type of tripod head. A Gimbal head keeps the lens completely balanced while allowing you to pan smoothly from side to side and up and down. This takes all of the weight out of the camera and is always our recommended choice of support when panning with a long lens. When using shorter lenses (up to 300mm), handholding the camera gives complete freedom of movement. Providing the light level is sufficient, shutter speeds should be high enough to ensure sharp shots.

The ultimate key to successful panning is smoothness and anticipation. First, you will need the correct posture. Stand with your feet shoulder-width apart to provide a solid foundation. Tuck your elbows in to your side to create a stable support. As your subject passes, swivel the upper half of your body in one smooth movement. You will need to have both the continuous-shooting mode and predictive-focus function on your camera active, so that the lens will constantly readjust its focus as the subject moves. The most challenging part is to keep the focusing point directly over the head of your subject while panning as smoothly as possible. It is likely to take a few seconds for the focus tracking to lock onto the subject and predict the speed of its movement. As a result, the first few frames will often be soft, so it is important to fire a burst of at least six shots to give yourself the best possible chance of capturing a pin-sharp image.

When composing your flight images, place your subject off-centre, so that it has space in the frame to 'fly' into – this creates a more aesthetically pleasing image. Your choice of focusing point is critical, and depending on how big the subject is in the frame, you

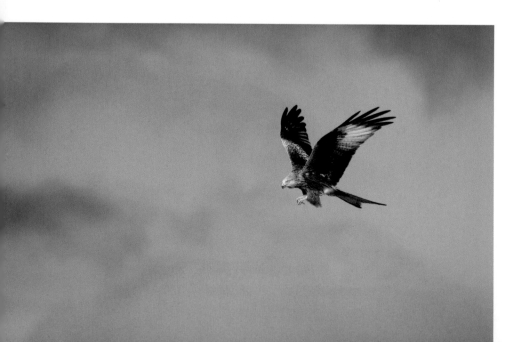

RED KITE (MILVUS MILVUS)
This image was taken at the end of a beautiful sunny day. As the sun started to sink, shades of pink appeared in the clouds, adding a splash of colour and contrast to the background. Had the bird been flying against a plain blue sky, the image would not have been so striking.
Canon EOS-1D Mk IV, 500mm f/4 L IS, ISO 320, 1/1250 sec. at f/5.6, tripod

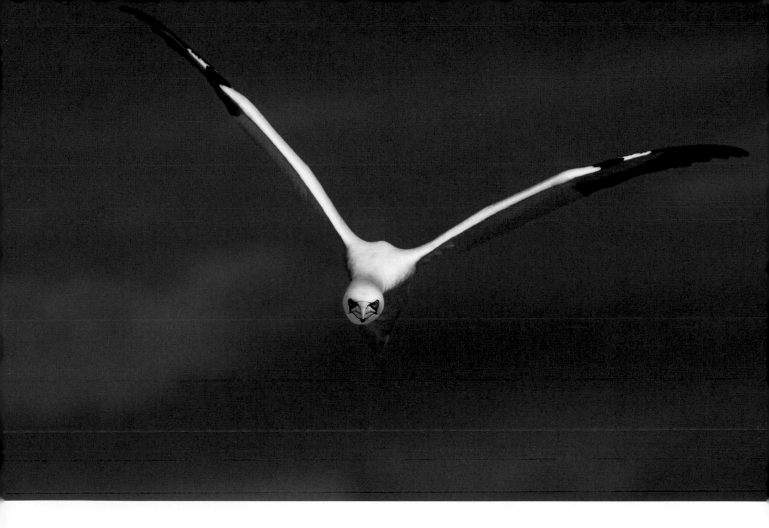

may need to select a point towards the edge of the viewfinder. The problem is that the outside focusing points are not as sensitive as the one in the centre, so only use these in strong light. If you find yourself shooting in low-contrast light, the centre focusing point will be the most accurate one to use. This tends to result in a centrally located subject, of course. To move the subject closer to the edge of the frame, you may have to resort to cropping the image slightly during the processing stage to achieve the most effective composition. Flight images work best when the sun is low in the sky, as it will light up the underside of the bird, helping to reveal detail. A bird flying against a plain blue sky can look a little uninspiring, so venture out when there are clouds present. A wonderful type of light for flight photography occurs when the sun lights the subject against a dark sky. This adds drama and impact and the results can be spectacular.

GANNET (*MORUS BASSANUS*)
I shot this image as the gannet was flying directly towards me: eye contact between the subject and the viewer adds impact. The bird was lit against a darkening sky – my favourite lighting conditions for flight photography.
Canon EOS-1D Mk II, 500mm f/4 L IS, ISO 200, 1/1600 sec. at f/8, tripod

▶ CHAPTER SEVEN > **MAMMALS**

Most wild mammals are highly secretive creatures. For much of the time they remain elusive and do their utmost to avoid any contact with humans. It is this character trait that makes them such difficult, and ultimately frustrating, targets for photographers. But there are advantages to their secretive behaviour. Let's imagine that you have put in the background research, donned your camouflage and employed the fieldcraft necessary to get close enough for a shot. You silently stalk the animal and manage to creep carefully inside its fear circle without being spotted. Finally, you raise the camera and squeeze the shutter button to take that winning shot. Now you finally realize what good wildlife photography is all about. There really is no feeling like it. This chapter will provide you with the necessary techniques to go out there and experience it for yourself.

IN THE BAG: WHAT IS REQUIRED?

Budget
- Tele-zoom lens (70–300mm)
- Tripod
- Beanbag

Enthusiast
- Telephoto lens
 (ideally 400mm or longer)
- Carbon-fibre tripod
- Monopod
- Beanbag

Useful accessories
- Ball and socket tripod head
- Teleconverter
- Fully charged spare camera battery
- Hide
- Camouflage netting

RED DEER STAGS *(CERVUS ELAPHUS)*
Each October I dedicate much of my time to photographing the red deer rut. For years I have longed for the perfect combination of a menacing sky and two adult stags fighting on the horizon. The opportunity finally arose one stormy autumn day. It had been raining heavily and as the sun started to sink, warm hues filtered through the air, providing a stark contrast to the black stormclouds. At just the right moment, two stags began to fight. I shot several frames and then stood back to watch the battle unfold as the clashing of their antlers echoed across the valley.
Canon EOS-1D Mk II, 500mm f/4 L IS, ISO 50, 1/1250 sec. at f/5.6, tripod

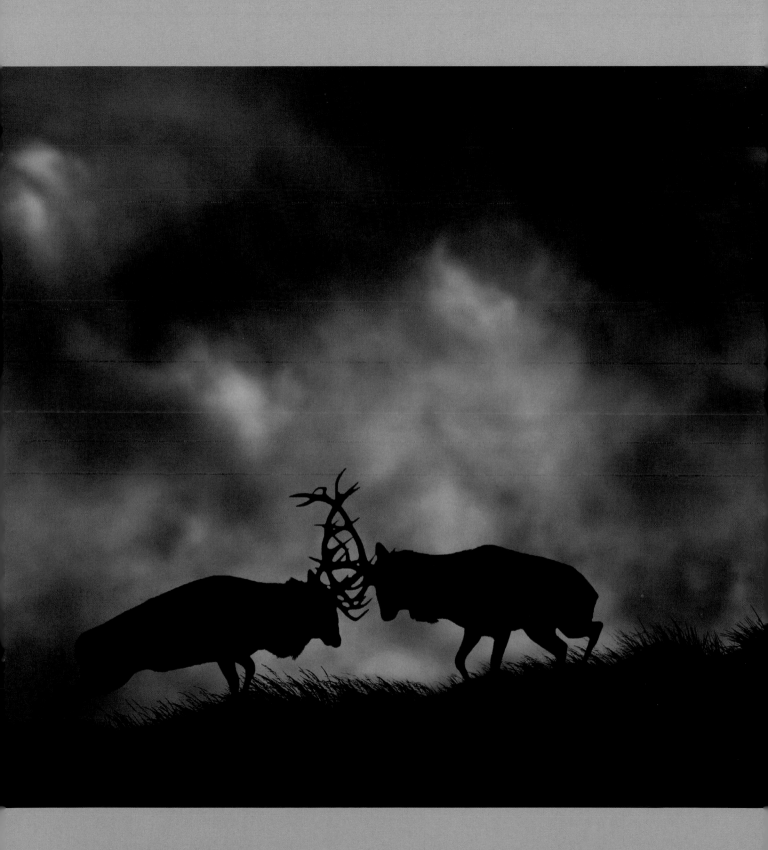

TECHNIQUE

EQUIPMENT

Much of what you have learned in the previous chapter on birds also applies to mammals. Most mammals are elusive, so therefore telephoto lenses are indispensable. Lenses in the region of 300–500mm are best for most mammal photography. Although fixed focal-length lenses offer the optimum in optical quality, current telephoto-zoom lenses are not far behind and remain the more flexible option. In most cases, zooms are lighter and easier to use, too. By allowing you to shoot from a distance, a long focal length will help to keep your subject relaxed and your images will look more natural as a result. One of our preferred lens choices for mammal photography is a prime 500mm, f/4. This focal length provides an excellent and practical working distance. Also, its fast maximum aperture of f/4 allows photographers to add a 1.4x teleconverter (see page 100) to gain some extra reach while retaining autofocus and image stabilization capabilities. For handheld photography, particularly of animals in motion, a medium-sized zoom such as a 70–200mm is ideal, especially one that offers image stabilization. In most situations, when using a telephoto lens of 400mm or greater, some sort of camera/lens support should be used. For smaller mammals such as rabbits and hares, try a beanbag. This makes it easy to compose images at speed, which is vital when photographing fast-moving subjects. When shooting larger mammals such as foxes, a 500mm lens can be mounted on a tripod.

CAPTURING CHARACTER

Whenever embarking on a new project, ask yourself the question: what distinguishing characteristics does the subject have, and how can I best represent these in an image? Just as in any good human portrait (look at Yousuf Karsh's 1941 photograph of Winston Churchill, for example), the essence and character of your subject should shine through. Rabbits, for instance, are highly inquisitive creatures. Perhaps you can capture one staring down the lens, its ears erect and nose twitching in typical fashion. Mountain hares are much the same, but they can also run at an incredible pace. By setting a slow shutter speed and panning with the hares as they run, you can capture this aspect of their character. The resulting images will depict a feeling of motion and energy.

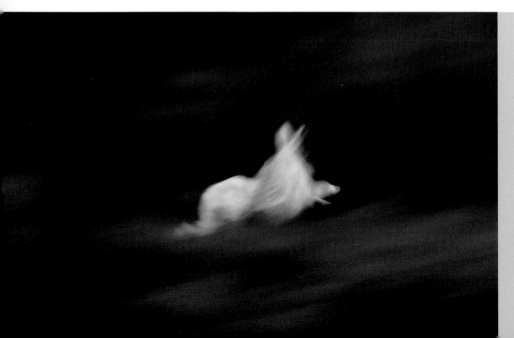

MOUNTAIN HARE (LEPUS TIMIDUS)
My aim for this image was to capture the spirit of the mountain hare in a single frame. They can run at an incredible pace, so I decided to use a slow shutter speed to represent this character trait. After spending roughly an hour stalking this individual on my stomach, I lay quietly in wait. I selected drive mode on my camera, and fired the shutter as the hare bolted from its resting place in the heather.
Canon EOS D60, 100–400mm L IS (at 300mm), ISO 50, 1/15 sec. at f/16, handheld

Many animals display aggressive tendencies, especially when guarding their territory or defending themselves against rival males. In such situations, make sure you have selected the continuous shooting mode, and fire as many shots as you can. There will always be a moment when the action peaks and you should try to secure a frame at just the right instant (see page 120).

COMPOSING ANIMAL PORTRAITS

When composing your images, look carefully at your surroundings. For most mammal photography you will be shooting from ground level. Your foreground and background are of utmost importance. Try to imagine the picture split into three separate planes – foreground, middle ground and background. The interaction of these three elements is important in supporting the main subject. Foregrounds can be used to add depth. They are likely to be part of the animals' environment – grass, foliage, leaves or even flowers – and should be rendered out of focus to retain emphasis on the subject. The lack of detail in blurred foregrounds also helps to contain the viewer's eye and prevent it from escaping the picture space. Always try to position yourself so that the foreground stretches for the whole length of the frame. The middle ground should be dominated by the subject, which should be instantly recognizable and appear almost as if floating in a sea of diffuse colour. Sometimes, rather than completely blurring the subject's surroundings, you may prefer to have certain elements of its environment rendered sharply, or at least recognizable. This can usually be achieved by simply raising your shooting angle slightly, and it gives the image a sense of the animal's habitat. Ultimately, though, it is up to you to interpret the image and decide how you would like each element in the image to appear.

When you have 'designed' the image in your mind, look carefully at your subject's face. Is it well lit? Depending on the angle of the sun, you may need to wait until the subject looks to one side for a catchlight to appear in the eye. Capturing sharp detail in the eye is imperative. In nearly all cases, it is the most important part of the subject's anatomy, and should be beautifully lit and pin-sharp. Look at other parts of the animal's body. A mammal's ears will twitch as it listens for any sign of danger. Catch them fanning forward and you capture the inquisitive nature of the animal. If you are photographing a deer, its antlers should be clearly visible. If necessary, wait until the animal turns its head to show clear separation between each antler branch. It is this level of detail that will help to raise your photography to the next level.

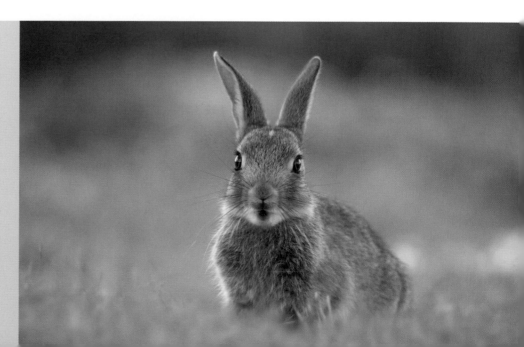

RABBIT *(ORYCTOLAGUS CUNICULUS)*
By shooting at ground level I was able to blur the foreground grass to add depth to the composition. I specifically wanted the rabbit looking directly into the lens to capture its inquisitive nature.
Canon EOS-1D Mk II, 100–400mm L IS (at 350mm), ISO 160, 1/200 sec. at f/5.6, beanbag

RESEARCH AND OBSERVE

Throughout this book we have stressed the importance of detailed subject knowledge. Sympathy and compassion for your subject should be a prerequisite for any wildlife photographer. Behavioural knowledge will not only help you to get close enough to your subject, but also enable you to understand the animal's movements.

FOXES

It is likely that a family of foxes lives less than 15 miles (24km) from your home. This may come as a surprise, but it applies whether you live in the UK, the USA, Africa or mainland Europe. They are highly adaptive animals and despite man's best efforts to eradicate them they have still managed to thrive, which pays testament to their hardy nature. They are beautiful animals, and thanks to their famous cunning, are the perfect subject on which to hone your skills. Foxes are primarily solitary animals and are very territorial.

Typically, their home range can span between 150 and 370 acres (60–150 hectares) and although many foxes have taken to an urban environment, they can be found pretty much anywhere! They use regular paths to patrol and guard their patch and spray pungent scent to mark the boundaries. The smell of a fox's scent marking is unmistakable – it is much like skunk odour. Imagine a mixture of rotten eggs, garlic and burnt rubber! Once you have found a fox's territory and its perimeters, you will need to spend time observing the animals and noting down their movements and the time of day. Before long you should start to see a correlation.

BADGERS AND RABBITS

This type of research and observation can be applied to any mammal. Being nocturnal, badgers are especially tricky subjects, but observing and gaining background knowledge will stand you

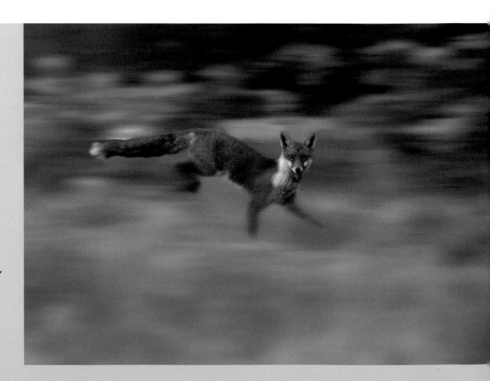

RED FOX *(VULPES VULPES)*
Foxes are incredibly shy mammals with an acute sense of smell, so fieldcraft skills played a large part in this picture. I stalked the fox by keeping my profile very low and used bushes and trees to hide my outline. It is important to be ready to shoot at all times, and as I got closer the fox caught my scent and bolted. By panning with the animal as it ran, I was able to keep the head sharp and portray the speed of the fox by rendering the background as a passing blur.
Canon EOS D60, 100–400mm L IS (at 400mm), ISO 100, 1/40 sec. at f/5.6, handheld

in good stead. It will take time, but to be successful you will need to gain their trust. A badger's favoured habitat is woodland, and their setts can usually be found close to a woodland edge. Just like foxes, they use regular paths in their search for food; the tell-tale sign is often an oval-shaped hole through areas of dense undergrowth. Finding diggings is another obvious sign of their presence, but you will need to learn to distinguish them from those created by other animals. Badgers' diggings are usually wider, as they dig with both paws at the same time. They are smart animals and have an incredibly powerful sense of smell.

Your best chance of success with badgers is by using food as bait. Peanuts work well and after time, the badgers will even start to associate your smell with feeding time. This may seem like a long-winded approach, but as with most wild mammals, these projects take time. Rush into it and you will fail to gain the trust of your subject, and your opportunities will be few and far between. If you are a little daunted by the time necessary for a project such as photographing badgers or foxes, or you simply don't have

the time to spare, why not start with a subject that's a little less sensitive? Rabbits are perhaps the most accessible subject of all and are relatively easy to locate. Find a nearby farm or area of open fields and you are likely to find rabbits. Once you have searched out a convenient and suitable location, visit during the hours of dawn and dusk and observe them, noting down when and where they appear. This should give you the opportunity to get into position before they emerge, and should increase your chances of success. Try lying flat on the floor close to a burrow entrance, covering yourself in camouflage netting to help you remain undetected. If a rabbit does catch your scent it will shoot down its burrow in a flash. Don't give up, though – after a few minutes they will often emerge again, allowing you to capture them sniffing the air tentatively, scouting for signs of potential danger. Whatever the subject you choose, there is no doubt that studying its behaviour and observing its movements will help you to gain a deeper understanding of its habits and open up a world of photographic opportunities.

RABBITS *(ORYCTOLAGUS CUNICULUS)*
A family of rabbits inhabits local farmland, and I was keen to capture some images of the youngsters. Shortly after dawn one morning, I covered myself in camouflage netting, positioned myself close to one of the burrow entrances and lay in wait. It wasn't long before two young rabbits emerged from the entrance. As they ventured out, they scanned the area for potential danger, providing me with the perfect opportunity.
Canon EOS D60, 100–400mm L IS (at 350mm), ISO 200, 1/250 sec. at f/8, beanbag

FIELDCRAFT

Most mammals are able to hear you, see you or smell you long before you catch a glimpse of them. The vast majority of mammals in the wild are extremely wary of humans – and rightly so, because it is imperative for their survival. To stand any chance of getting close enough for a successful shot, you will need to find a way of getting inside an animal's fear circle.

THE FEAR CIRCLE

Each animal's fear circle is different. Remain outside this invisible limit and your subject will carry on its business, unconcerned by your presence. The moment you approach the perimeter, however, you will see a marked change in behaviour. The animal will become agitated. It will look directly at you, and the next event you are likely to witness is its rear end disappearing rapidly into the nearest cover. The size of this safety margin depends on the species involved and the individual's tolerance – just like humans, every animal is different. There are very few wild mammals that can be photographed successfully from outside their fear circle, even with the longest telephoto lenses, so you will need to find a way to approach beyond this boundary without being detected.

STALKING

Stalking can be a lot of fun, but also very frustrating. Imagine crawling across a thorny forest floor on your stomach just to have your subject flee the moment you press the shutter. Believe me, it will happen, and has happened to me more times than I can remember. There are, however, certain rules that you should adopt that will greatly increase your chance of success.

Your first consideration should be what to wear. It should go without saying that you will need to be dressed in muted, subdued colours. Browns and greens should work, but for the most sensitive subjects I would recommend adorning yourself in full camouflage. The cheapest place to go for a camouflage jacket and trousers is an army surplus store, but there are certain considerations you should

make before making the purchase. How noisy is the fabric? You will need to remain completely silent when stalking, so avoid anything with Velcro or crinkly fabric. Make sure you choose a size that is loose enough to enable you to move around freely and under which you can add extra layers in winter. For most species, a camouflage jacket and trousers, or even loose clothing with muted colours is enough, but for highly sensitive subjects such as deer, badgers and foxes, a headnet and some camouflage gloves will further break up the human shape. You might think you look silly, but there is no doubting their effectiveness.

Before you begin stalking the animal, make a mental plan of your approach. Look carefully at your surroundings and note the direction of the wind. Animals such as deer have an incredibly acute sense of smell, and the first whiff of human scent will send them running for cover. With this in mind, it is also a good idea to avoid washing your stalking outfit. The dirtier and more worn it gets, the more effective it will become! Always approach your quarry from downwind, otherwise your stalk will be over before it has begun. Keep your profile below the horizon. Move as slowly as possible while approaching your subject and watch closely for any visible signs of unease. If the animal looks directly at you, freeze and don't move again until it looks away. Of course, by now it is often too late – the key is to try to stay undetected at all times. Look for natural cover to conceal yourself and stick to areas of dense foliage such as trees or hedgerows.

For camera support, opt for a beanbag or a monopod. A tripod is too cumbersome and could easily prevent you from firing a shot at the optimum moment. Beanbags are useful for small mammals such as rabbits and hares, but for larger subjects, a monopod will offer a good compromise between stability and ease of use.

The best time of day to go out stalking is at dawn, when most animals are preoccupied with feeding. In fact, the earlier the better. If you can be in position before the sun rises, you will stand a much better chance of success.

MOUNTAIN HARE *(LEPUS TIMIDUS)*
I came across this mountain hare after an entire day of stalking. The light was fading fast but by adopting a low angle I managed to frame the animal against the sky. The back-lighting created a lovely halo of light around the hare's body.
Canon EOS D60, 100–400mm L IS (at 300mm), ISO 100, 1/500 sec. at f/6.3, tripod

ROE DEER *(CAPREOLUS CAPREOLUS)*
Long lenses compress perspective, and when coupled with a large aperture, foregrounds and backgrounds become a sea of diffuse colour. I managed to stalk this roe deer buck by moving quietly and keeping my profile below the horizon. To attract its attention I fired the shutter and it popped its head over the heather and peered straight into the lens. To my amazement, he then carried on feeding, quite undeterred by my presence – very rare for a wild roe deer!
Canon EOS 1D Mk II, 100–400mm L IS (at 400mm), ISO 200, 1/40 sec. at f/5.6, tripod.

It is vital to travel as light as possible. You will often find yourself walking much further than anticipated, so arm yourself with just one lens and camera body. A zoom in the range of 100–400mm will work wonders in a stalking situation and you will be able to react more quickly with no heavy lens to weigh you down. I remember one winter's day clearly. I was out stalking mountain hares on the moors with just a 100–400mm lens and a beanbag. I spent nearly the entire day trying to get close enough for a shot, but every time they would get the better of me. It wasn't until dusk approached that I finally succeeded and managed to secure some frames of a hare silhouetted against the setting sun. I had been walking and stalking the whole day; my back was killing me and I was exhausted. If I had been carrying my 500mm lens that day, I am sure I would have missed the critical shot.

113

VISUALIZING BLACK AND WHITE

Colour photography allows us to capture the world with near-perfect accuracy. The vast array of digital SLRs available today are so advanced they are capable of providing a total colour depth of over 16,000 tones per pixel. This, of course, results in outstanding colour rendition. Sometimes though, we don't want the image to represent reality as we see it. If you always strive to capture total accuracy in tone and colour, your creativity will undoubtedly suffer. Eliminate colour completely, and the eye starts to see other characteristics in a picture. The colour is suddenly replaced by form, shape and texture. These are important attributes of any image and learning how to visualize them is key to effective black and white photography.

SEEING IN BLACK AND WHITE

Black and white is not a substitute for colour, but offers another way to interpret your subject. Our eyes do not give us the ability to see in black and white, so we all take colour for granted. By looking closely at a subject and learning to recognize the relationship between tone and colour, you can develop the ability to 'see' the world in monochrome. This skill is key to mastering black and white photography. Try taking a picture of your back garden, or indeed any familiar scene with plenty of differences in colour. First look carefully at the colour image, then convert it into monochrome and explore the tonal differences that exist between each colour.

RED DEER *(CERVUS ELAPHUS)*
As dusk approached, dark clouds loomed overhead and I was able to position these two red deer against a pale area of background, their silhouettes perfectly recognizable against the contrast of the sky.
Canon EOS-1D Mk IV, 500mm L IS, ISO 100, 1/500 sec. at f/5.6, tripod

You will notice, for instance, that red and green look very similar when converted to black and white and will provide little in the way of contrast. Interesting skies, however, with plenty of contrast, can look especially dramatic. A strong silhouette of an animal, set against a menacing sky, can look particularly effective when created in monochrome.

As with colour photography, one rule remains the same: your subject must be prominent in the frame. When shooting a silhouette with the intention of creating a black-and-white image, place the subject against a pale area of sky to provide a sufficient level of separation between the animal and the background. Depending on the weather conditions, this may not be possible, but often just moving a few feet from one side to the other can have a profound effect on the result. In the natural world, shape, texture and form can be found in abundance. Texture in particular is usually found

WILDCAT *(FELIS SILVESTRIS)*
With the complete absence of colour, this image of a captive wildcat becomes a study of texture and form. The dark surroundings draw the viewer's eye straight to its intense stare.
Nikon D300, 120–400mm (at 400mm), ISO 320, 1/160 sec. at f/5.6, tripod

in small details, and it is up to you to best interpret your subject. Perhaps by closing in on a small area of your subject's body, you can capture interesting patterns that highlight the delicate textures and shapes that would not be apparent in a colour image.

On sunny days, areas of light and shade can be used to great effect. As shadows are cast, the resulting contrast helps add depth and delicate form can suddenly be revealed. Nature photography in black and white is an exploration in itself. It is a fascinating and unique approach that can result in images with a timeless quality. The permutations are quite literally infinite.

ENVIRONMENTAL PORTRAITS

What image is conjured up in your mind when you hear the word 'fox'? Perhaps it is a 'chocolate box' portrait of a fox's head, or a character from a well-loved children's book. But when you hear the words 'urban fox' I'm confident you think of something very different. Perhaps this time it's an image of a rather mangy animal, skulking in a dimly lit alley, waiting to raid the refuse bags left behind a take-away restaurant for scraps. In your mind, you have placed the animal into an environment – and in doing so, you have created a more evocative image.

Think of a well-known wildlife artist – the late Sir Peter Scott, for example, famous conservationist and founder of the Wildfowl Trust. Sir Peter generally painted his much-loved wildfowl in their native habitat, often creating such strong images of marshland habitat that it is almost possible to hear the piping of a redshank and the baying of the pink-footed geese.

Since the very start of my career as a professional wildlife photographer, I have been a keen advocate of images that capture and portray the subject as part of its habitat. Frame-filling portraits of animals and birds can, of course, be beautiful works of art, but they have never interested me as much as a well-composed image of a creature in its natural environment. A photograph like this often tells a story about the subject. It shows the relationship between the animal and its environment, and will usually retain the viewer's interest much longer than a portrait shot ever could.

EQUIPMENT

One major advantage of shooting wildlife in the landscape is that it does not generally require big – and expensive – lenses. The best optic for this type of work is a mid-sized zoom such as a 70–200mm or 100–400mm. Having a flexible focal length allows you to refine the composition with ease. When shooting subjects that are easily approached, wide-angle lenses can be used to great effect and

interesting perspectives can be sought. Essentially, by getting up close and personal with your subject using a wide-angle lens, you can keep the subject large in the frame and include the surrounding landscape – impossible with a telephoto. When using a wide-angle, or even a mid-range zoom lens, a tripod is rarely needed; instead, rely on a steady hand (usually helped by image stabilization!) to ensure critical sharpness. The last thing you want to do is to spend valuable seconds setting up your camera on a tripod only for your subject to flee when you are finally ready to take that winning shot. There are some useful aids, though, which are quick to deploy. For example, depending on your point of view, a beanbag can often be utilized to good effect. This allows much more freedom of movement than a tripod, while still providing a very stable support.

LOCATIONS AND SUBJECTS

When deciding which subjects to tackle, there are two very important points to consider: how approachable is your intended quarry, and how photogenic is its habitat? Seabirds are a great subject to practise on. They inhabit often spectacular sea cliffs and usually allow a close approach. Large colonies of nesting birds in particular can look very impressive, especially when photographed with a wide angle of view. Their imposing surroundings can be included to create a feeling of isolation and add extra drama to the image. It is even possible to convey a sense of vertigo in such a scene, further adding to the feeling of connectedness between the viewer and the bird. Birds of prey that inhabit a mountainous environment can also look dramatic, especially when shot in flight against rolling hills or mountain peaks. Fortunately, however, it is not always necessary to venture far afield in your search for subjects. Even parks with relatively tame wildfowl can offer countless opportunities – a bird lit from behind by the rising sun, swimming across a lake shrouded in mist, perhaps.

COMPOSITION

Framing your subject within an expansive scene will require more forethought and 'vision' than a simple portrait. Frame-filling shots are often relatively simple to compose, as the background and foreground are usually rendered out of focus, leaving you with few alternatives. Despite the obvious differences, however, the subject should always be prominent in the frame. This can be achieved in a number of ways. First, the background directly behind the subject should not be distracting. Try to place the subject against an area of diffuse colour, or go even further and look for a patch of colour that contrasts to that of the subject. Maybe you can find an area of shadow so the subject rests against a dark part of the frame, increasing its impact on the scene. Try placing warm tones against cool tones – the blue hues of snow against the rising or setting sun, for example. Often, just by taking a few steps to one side or the other, you can dramatically change the image, so always keep moving and pay careful attention to background elements at all times.

When shooting back-lit subjects at dawn and dusk, the sun can be included to give an evocative feel and help to balance the composition. In frosty or snowy conditions, try to convey a sense of bleakness by keeping the subject small in the frame. Place it in one corner to emphasize the expansive surroundings and use its colour to help it stand out against the white of the snow.

When considering subject placement, the rule of thirds works well in most cases (see page 44). Placing the subject on one of the intersecting thirds instantly creates a feeling of balance and harmony. It is an old, oft-quoted and simple trick, but it works like magic. The term 'leading lines' is normally associated with landscape photography, but the same rule applies to environmental photography. In essence, you are creating a landscape image with the animal or bird as the main focal point. Leading lines can be found anywhere within the landscape – a row of wooden posts, leading the eye to the one on which the bird is perched; the line of a mountain ridge, drawing the eye through the frame, before it comes to rest on the raptor soaring amid the peaks. The key, as always, is to 'see'.

PATAGONIAN FOX (LYCALOPEX GRISEUS)
During a trip to Patagonia I spent several days in Torres Del Paine National Park in Chile. The landscape that makes up much of this region is incredibly dramatic, so I wanted to include as much of it as possible in my shots. When I came across this Patagonian fox, I switched to my wide-angle lens and shot at 30mm so that I could include the surrounding mountains and brooding sky.
Canon EOS 1D Mk II, 17–40mm L (at 30mm), ISO 100, 1/250 sec. at f/11, handheld

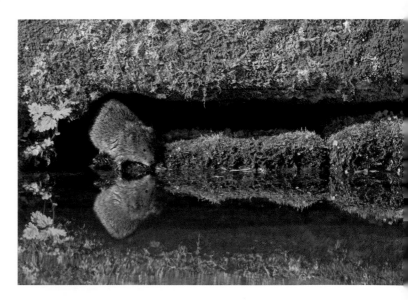

WATER VOLE (ARVICOLA AMPHIBIUS)
When I first noticed this water vole scurrying among the stones on the bank of a disused canal, I was drawn to the beautiful colour of the lichen. I placed the vole to the left of the frame and used the surrounding lichen-covered rocks to add a pleasing splash of colour.
Canon EOS-1D Mk II, 500mm f/44 L IS, ISO 160, 1/250 sec. at f/4.5, tripod

DEER PARKS

Deer are perhaps the most majestic and certainly one of the most photogenic mammals for the wildlife photographer. The mention of a deer almost always conjures up a vision of a majestic stag, with a wild and open hillside as a backdrop. However, this disguises the fact that, during the course of their long history, deer have been forced to adapt to a very different habitat. By nature and by choice, they are woodland dwellers, but the sad loss of much of their natural habitat has resulted in their enforced adaptation to moorland. However, this open ground is also found in the parklands that surround many stately houses – many of which have now become home to large herds of deer. Given the large numbers of visitors who flock to these attractions, it is hardly surprising that park deer are tamer and more accustomed to humans than their wild cousins. For those who do not have the time to photograph wild deer, these places offer a good alternative.

PHOTOGRAPHING DEER

October heralds the start of the annual red deer rut, and should mark an important time on any wildlife photographer's calendar. If you seek out red deer at this time of year, you will be rewarded with the evocative, haunting sounds of stags roaring their guttural threats, as they proclaim their presence and warn off rival males. To photograph this behaviour successfully, firstly, familiarize yourself with your location. Choose a park that is close by, and visit as many times as you can, each time noting the whereabouts of the deer and the position of the light. Despite their more tolerant nature, remember that most deer, even those in popular parklands, remain wary of people and possess three very acute senses to warn them of potential danger: their eyesight, smell and hearing far exceed ours.

It is not usually productive to stalk park deer. Since the deer are used to being around people, suddenly catching sight of someone crawling towards them on all fours will undoubtedly arouse suspicion! As we have already discussed, all animals remain within their own fear circle. Cross this boundary, and the deer will react by barking their alarm call and your photographic opportunity will come to a very abrupt end. The most effective way of getting close is to walk in very wide arcs, gradually moving closer to your quarry. The key is to avoid surprising the deer with your presence – patience, as always, is a virtue. Walk as slowly as possible, stopping and waiting at regular intervals. As the deer begin to gain your trust, they should soon become accustomed to you and should remain in a relaxed and natural state in your company.

Deer parks are often large areas and the deer can be very spread out, so you might find you need to cover a significant distance. With this in mind, you should travel light. Lugging huge telephoto lenses around is seldom the answer. It is much more important to get as close as you possibly can to your subject. It is best to take one camera body, one lens and a monopod. A good choice of lens for deer photography is a 100–400mm zoom. It gives the flexibility needed when composing shots, and is fairly light and easy to handle. In some deer parks, where the animals can be easily approached, even a shorter zoom such as a 70–200mm will be perfectly adequate for most needs. With careful composition, a lens like this, even when deployed within the confines of a park, can result in a photo evocative of 'the wild'.

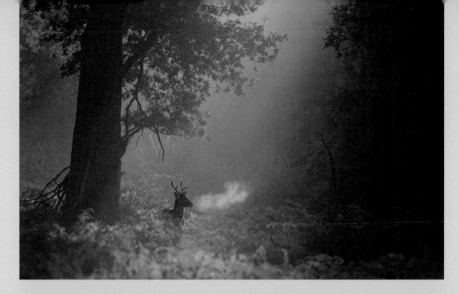

FALLOW DEER *(DAMA DAMA)*
One of my local deer parks offers great opportunities at dawn. Following a cold but clear night, mist often forms in the forests, allowing evocative images to be sought amid the ferns and trees. When composing this image I was keen to include the two trees on either side as a natural frame and draw the viewer's eye into the image.
Canon EOS 1D Mk II, 500mm F4 L IS, ISO 100, 1/250sec. at f/4.5, tripod

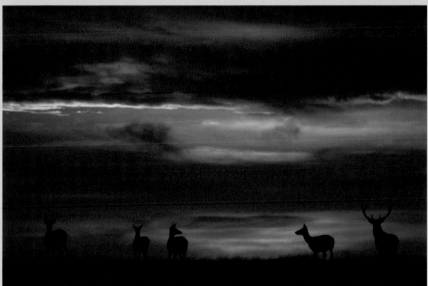

RED DEER GROUP *(CERVUS ELAPHUS)*
It pays to stay on the lookout for silhouettes, especially at dawn and dusk when the colours in the sky are at their most intense. I followed this group of deer for some time, until they headed up a rise and I was able to capture them against this stunning dusk sky.
Canon EOS D60, 100–400mm L IS (at 310mm), ISO 100, 1/350 sec. at f/5.6, tripod

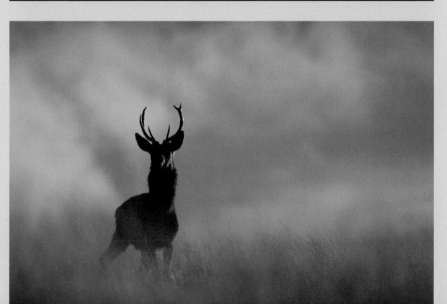

JUVENILE RED DEER *(CERVUS ELAPHUS)*
This image of a juvenile red deer stag was taken from a very low angle, to blur the foreground grasses. The lighting came from the side and lit up one side of the subject's face, adding drama and impact.
Canon EOS-1D Mk II, 500mm f/4 L IS, ISO 200, 1/1250 sec. at f/4.5, tripod

THE DECISIVE MOMENT

For an image to be successful, it should grab the viewer's attention instantly. It should excite and stir emotion, evoke a particular feeling and, ultimately, create a connection between the subject and the audience. At this point you might be wondering how you can possibly fit all of these attributes into one photograph. Unfortunately, there is no single secret ingredient, but rather a mixture of certain elements that should all come together at the optimum moment: the beauty of atmospheric light; capturing the subject in harsh weather conditions that demonstrate its hardy nature; positioning the subject in its environment to give the image a sense of place. Perhaps the most important ingredient, and the most difficult to capture, is the 'decisive moment' – the exact instant when something special occurs. Every moment in nature is unique, never to be repeated, and it is up to you as a photographer to preserve it.

THE RIGHT PLACE AT THE RIGHT TIME

It was the French photojournalist Henri Cartier-Bresson who coined the phrase 'the decisive moment'. He was captivated and inspired by a photograph of three African children running into a lake. He could not believe that the camera could capture such a spontaneous moment in time, and he set about forging his career by looking for these decisive moments everywhere he went. This was the 1930s and Cartier-Bresson used a small Leica 35mm roll-film camera with a 50mm lens. In fact, he almost always used only a 50mm 'standard' lens throughout his long and distinguished career. The equipment available today allows us to take multiple frames per second, capturing a string of digital files of incredible quality, using a plethora of lenses. But as advanced as current digital SLRs are, there is no substitute for being in the right place at the right time. It is the person that takes the picture, not the camera. As Cartier-Bresson once said, 'There is a creative fraction of a second when you are taking a picture. Your eye must see a composition or an expression

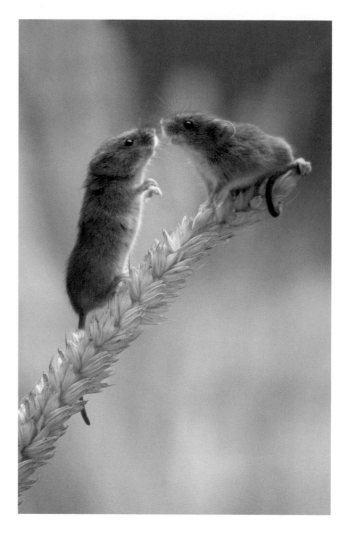

HARVEST MICE (*MICROMYS MINUTUS*)
I photographed these two harvest mice in captivity. They would constantly climb up and down the ears of wheat, usually passing each other on the way. On one occasion, they paused for a split second at the top of the wheat stem and tentatively touched noses, as if to give each other a kiss.
Canon EOS 10D, 100–400mm L IS (at 400mm), ISO 200, 1/320 sec. at f/5.6, tripod

that life itself offers you, and you must know with intuition when to click the camera. That is the moment the photographer is creative. Oop! The Moment! Once you miss it, it is gone forever.'

We have already discussed various ways of getting yourself into the best position. Stalking and using hides are perhaps the two most effective techniques. Once you are in position and poised for the shot, however, timing is crucial. The key is to watch your subject closely and note down patterns in its behaviour. This will help you to predict its next move and make it easier to capture its spontaneity. The decisive moment could be a moment of action – two red deer stage-battling for supremacy, perhaps. Or a pair of coots on a local pond, attempting to drown each other in a territorial battle. It could just as easily be a tender moment between a mother and her young, or a pair of birds performing an elaborate courtship display. I can recall vividly one spring dawn several years ago when I was chest-deep in freezing water. I was concealed in my floating hide in a local lake, hoping to photograph courting grebes and trying my best not to go too numb while waiting for the sun to rise. It was a magical morning. Plumes of mist rose from the water and as the sun crested the horizon, it lit two great crested grebes in beautiful golden light. Just at the right moment, one bird plucked a small white feather from the surface of the lake and offered it to its mate as part of their ritual. With a stroke of luck, I was already looking through the viewfinder, focused and ready to shoot. I fired off a burst of frames and managed to capture their tender moment forever. Ever since then, I have made a conscious effort to resist the temptation of looking through my images on the LCD display. If my subject is there, I try to keep focused, composed and ready to shoot at all times. You never quite know when the unexpected is going to happen.

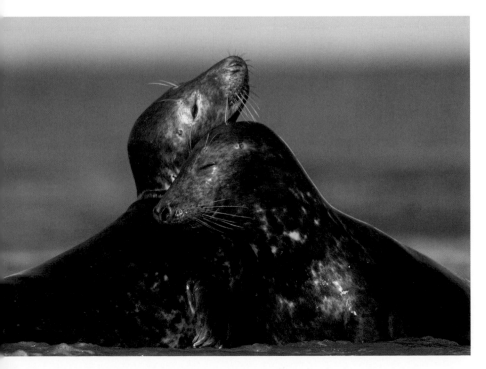

GREY SEALS (*HALICHOREUS GRYPUS*)
To capture the decisive moment, you need to be focused on your subject at all times, constantly composing images with your finger ready to fire. I took this shot of two seals as they seemed to embrace each other at the shoreline.
Canon EOS-1D Mk II, 500mm f/4 L IS, ISO 160, 1/800 sec. at f/5.6, tripod

▶ CHAPTER EIGHT > **PLANT LIFE**

Plant life is a hugely varied natural subject. Although it is largely static, highlighting a plant's beauty, form and design in a single frame is far from easy. In fact, it could be argued that the level of control plant photographers have over their results adds to the pressure to get things just right – both technically and aesthetically. Producing clean, striking images of plant life involves thought and care. Simplicity is often key, while background choice and lighting will help highlight the flow, colour, design and delicacy of plants – flowering or non-flowering. In all its many guises, plant life provides great subject matter for photography. It is time to hone your close-up skills and begin exploring the wonderful world of plants.

COMMON POPPY *(PAPAVER RHOEAS)*
Plant life has the advantage of being highly accessible – wherever you are, plants and flowers are always close by and only a relatively basic set-up is needed to capture great images.
Nikon D300, 70–200mm, 2x tele-converter, ISO 200, 1/800 sec. at f/5.6, tripod

IN THE BAG: WHAT IS REQUIRED?

Budget
- Wide-angle zoom (for example, 18–70mm)
- Telezoom (for example, 70–300mm)
- Close-up filters or extension tubes
- Tripod
- Live View

Enthusiast
- Macro lens – ideally 70mm or longer
- Wide-angle lens (in the region of 17–35mm)
- Right-angle finder
- Tripod
- Remote cord
- Mirror lock-up facility
- Geared tripod head

Useful accessories
- Polarizing filter
- Reflector
- Scissors
- Fully charged spare camera battery
- Wimberley Plamp
- Ground sheet
- Beanbag
- Spray bottle

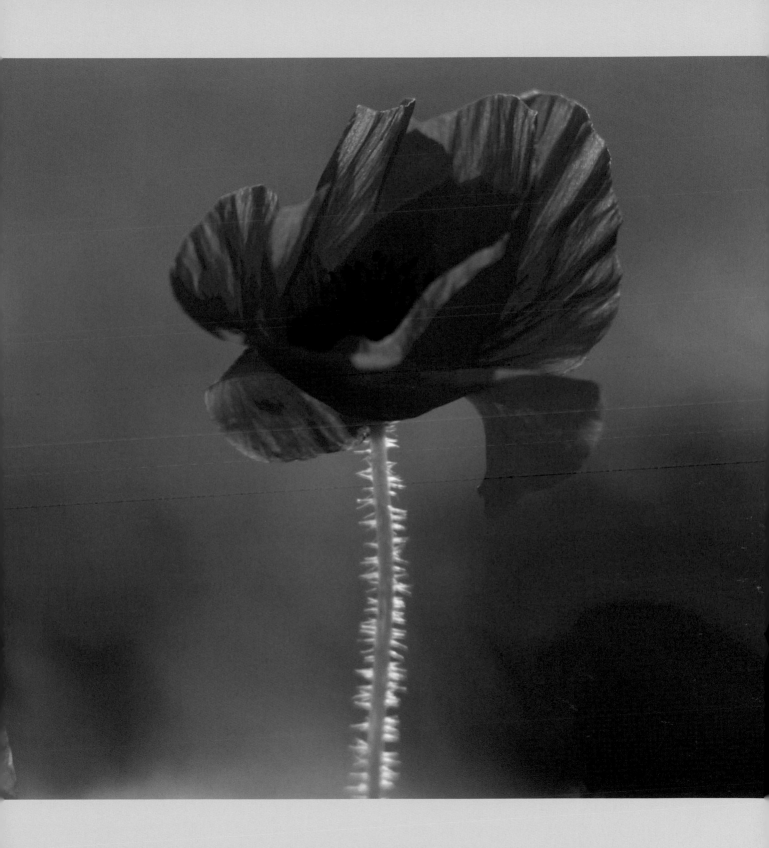

TECHNIQUE

There is never a risk of running out of inspiration when shooting plant life. Within the fascinating world of plants, there is a huge amount of diversity and seasonal variation. Due to the wide choice of subjects, it is difficult to generalize about technique. There isn't one procedure or technique that will work in all situations – instead, your approach must be dictated by the subject, its surroundings, and the weather, light and equipment at your disposal. That said, there are some general points and tips that will prove helpful in many shooting situations.

PLANNING AND THE WEATHER

Throughout this workshop, you'll notice a recurring message – when photographing nature, always do your homework first. Regardless of the subject you wish to shoot, planning and preparation are imperative – and plant life is no different. Flowers are ephemeral, so you need to plan your shoot carefully to photograph subjects in peak, pristine condition. Time your visit carefully, or you may have to wait until the following year for another opportunity. Study where and when your subject can be found flowering – for example, what habitats does it prefer, and when is its peak flowering period? If it's practical, visit likely sites regularly beforehand. This will allow you to monitor the plant and help ensure that, when you do visit with your camera, it will be at just the right time. Also, be aware that weather and seasonal variations can affect flowering time, potentially delaying it or bringing it forward.

You must also consider the weather when planning your shoot. Many plants are badly affected by wind movement. Tall flowers – poppies, for example – are particularly prone to being blown around in breezy weather, making it tricky for you to achieve focus or compose images. Plant photography is best attempted in still conditions, ideally with a wind speed below 10mph (16km/h). Check the weather forecast when planning your shoot.

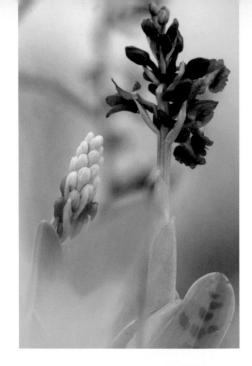

EARLY PURPLE ORCHID (*ORCHIS MASCULA*)
The difference between a gardened and non-gardened image can be striking. However, keep gardening to a minimum and be careful not to damage or remove surrounding plants or flowers.
Nikon D300, 100–300mm (at 300mm), ISO 200, 1/80 sec. at f/4, beanbag

GARDENING

When photographing close-ups of plant life, background is vital. While your choice of f-stop and viewpoint will greatly dictate the look of the subject's backdrop, when shooting static subjects like plants it may also be possible to selectively tidy up the image space. By carefully removing distracting grasses, twigs or light-coloured or dead vegetation, you can help ensure backgrounds remain free of clutter. This technique is known as 'gardening'. While it should always be kept to a minimum, and should always be achieved without damaging other flowers or plants growing nearby, it can help produce cleaner, stronger results. Most gardening can be done by hand, by removing bits of decaying leaf matter, small twigs, and so on. Distracting background grasses can be gently flattened by hand, or carefully removed using scissors. Normally it is best to compose your shot and select the aperture first. Having done this, depress your camera's depth-of-field preview button, or take a test shot, and carefully scrutinize the surroundings. If you identify any distracting elements, carefully remove them before re-shooting. You may need to repeat this process several times.

HEATHER *(CALLUNA VULGARIS)*
One of the key skills in plant photography is selecting the right subject. In close-up, the slightest flaw or damage will be magnified, so always opt for subjects that are in pristine condition and growing in a position where you can achieve a clean, flattering background.
Nikon D300, 70–200mm and Nikkor TC-20E III (at 320mm), ISO 200, 1/500sec. at f/5.6, tripod

Rarely will you photograph a wild plant without having to do some degree of tidying up first – ultimately, you are striving for an attractively clean and diffused background.

It is not always possible to work in ideal conditions. When you have no choice but to shoot in windy weather, look for subjects growing in sheltered areas, or use an umbrella or windbreak. It is possible to make your own windbreak using heavy, clear polythene held in position by aluminium rods. Alternatively, aids like the Lastolite Cubelite will help protect small subjects from the elements, while also diffusing harsh light. Another option is to use a Wimberley Plamp. Fasten one clasp to your tripod leg, while using the other end to hold your subject still. However, be careful not to damage plants if you're attaching the clamp to delicate flower stems.

MAXIMIZING IMAGE SHARPNESS

When photographing static subjects like plant life, there is no excuse for not producing razor-sharp results. While bird and mammal photographers have to rely heavily on the accuracy and speed of their camera's autofocusing (AF) system (see page 94), plant photographers have the luxury of time. When shooting flowers, you can switch to manual focus to position the point of focus with pinpoint accuracy. Nature photographers can also use Live View and trigger the shutter remotely to guarantee image sharpness. The message is simple: whenever the situation or subject allows, do everything in your power to maximize image sharpness.

FOCUSING AND LIVE VIEW

Despite the sophistication and accuracy of modern AF systems, it is normally best to switch to manual focus when shooting close-ups. At high magnifications in particular, autofocus has a tendency to 'hunt' for subjects and can struggle to 'lock on' to small or fine detail. If your eyesight allows, focus manually – doing so will allow you to select and place your point of focus with far greater accuracy.

For plants in particular, your camera's Live View facility can prove very beneficial. Effectively, this function allows you to use your camera's monitor as a viewfinder. In Live View mode, the camera continuously and directly projects the image onto the LCD, via the sensor. This allows you to preview the photograph you are about to take, providing a handy alternative to using the viewfinder. Live View typically provides 100% coverage, so 'what you see is what you get' – unlike many camera viewfinders, which have a slightly reduced coverage of around 94–97% of the image area. As a result, you can compose shots without the risk of unseen, unwanted bits of vegetation protruding into the edges of the frame. Live View is also useful when shooting at low or awkward angles – low-level plants and fungi, for instance – when it is impractical to peer through the viewfinder itself. However, arguably, it is most useful for aiding focusing. Having composed your shot, you can zoom into the photo to check critical sharpness and make fine adjustments to focus. On some models, you can use Live View in combination with your camera's depth-of-field preview button to achieve a 'live' preview of the zone of sharpness achieved at any given aperture. Focusing via Live View is perfectly suited to the challenges and precision of close-up photography – not necessarily just plants, but for static wildlife too.

MIRROR LOCK-UP

Why settle for anything less than pin-sharp results? Your subject, or focal point, should always be critically sharp, particularly if you intend to enlarge your images for printing or hope to have them published. But using a tripod alone won't guarantee sharpness. Physically depressing the shutter-release button can create a small amount of movement that can slightly soften the final image – particularly if the shutter speed is relatively slow. The effect can be minimal, but to eliminate any risk of camera movement, trigger the shutter remotely using a remote cord or infrared device (see page 20). If you don't have one, try using your camera's self-timer facility instead – this will allow you to trigger the shutter without touching the camera. In addition to this, employ your camera's Mirror Lock-up function, if it has one. This is designed to secure the reflex mirror prior to firing the shutter. Doing so will eliminate any internal vibrations that may be caused by the mirror swinging up, and out of the light's path, just prior to the shutter opening. The internal vibrations generated by 'mirror slap' can degrade the sharpness of fine

PRO TIP: When photographing wide-angle, environmental views of plants, you will normally want to select a small f-stop to generate front-to-back sharpness. However, avoid using a lens's smallest apertures, like f/22 or f/32, as they are most prone to lens diffraction. This effect is caused by light striking the edges of the aperture blades and becoming dispersed. This softens overall image quality.

COWSLIPS *(PRIMULA VERIS)*
When shooting plants, you have the time to ensure nothing is left to chance regarding image quality. To consistently capture bitingly sharp results, use a tripod, focus carefully using the added precision of Live View, and trigger the shutter remotely using a remote device.
Nikon D300, 100–200mm (at 200mm), ISO 200, 1/100 sec. at f/4, tripod

HERB ROBERT *(GERANIUM ROBERTIANUM)*
When focusing on fine, tiny detail, the most precise focusing method available to you is to use Live View. With Live View activated, zoom in to the projected image and manually fine-tune focus to ensure your subject or focal point is perfectly sharp.
Nikon D300, 150, ISO 200, 1/8 sec. at f/7.1, tripod

detail, so it is always good practice to lock up the mirror first and then wait briefly for any vibrations to fade before finally releasing the shutter. When using Mirror Lock-up, you have to press the button twice to take the picture – the first press locks up the mirror; the second takes the shot. Bear in mind that when the mirror is in the locked-up position, the subject will no longer be visible through the viewfinder. On many digital SLRs, Live View effectively performs the same function as Mirror Lock-up, because when Live View is activated the mirror is in the 'up' position.

WILD FLOWERS

There are many different ways to photograph wild flowers. You could simply opt for a documentary style, in which you record subjects accurately and in their entirety. However, while this type of shot might be popular among botanists, we encourage a more imaginative approach. Using selective focusing and creative technique, it is possible to capture eye-catching and unique images.

SELECTIVE FOCUSING

Selective focus is the art of using very shallow depth of field in order to contrast your subject against an artfully blurred background. By using a large aperture, in the region of f/2.8 or f/4, surrounding detail will be diffused and the eye will be directed toward your focal point. This approach is particularly effective when photographing flowers and blossom, but there is more to the technique than simply choosing a wide, maximum aperture to create a narrow zone of sharpness. Lens choice is also important. Longer focal lengths have a more restricted depth of field, so will exaggerate the effect. A telephoto lens, in the region of 300mm, coupled with an extension tube to reduce its minimum focusing distance, is ideal for selective focusing. Together with a large aperture, depth of field will be wafer-thin, allowing you to isolate just a single flower. A similar effect is achieved at high magnifications, so use a macro lens for smaller subjects. A low shooting angle can be helpful, placing more distance between the subject and its background. Focusing needs to be very accurate, so use a tripod. By using Live View (see page 126), you can position your focal point more precisely.

A CREATIVE APPROACH

Images of flowers don't always have to be sharp, or realistic. The key to capturing original images of nature that really stand out is often creativity. For example, subject or camera motion (see page 50) can transform an otherwise ordinary photo. If you wish to add a dreamlike quality to your wild-flower images, try shooting a double exposure. By capturing one sharp image and combining

WOOD ANEMONE (*ANEMONE NEMOROSA*)
When using the selective focusing technique, your main focal point should be sharp, while everything else drifts attractively out of focus. Careful framing and focusing are required.
Nikon D300, 150mm, ISO 200, 1/180 sec. at f/2.8, tripod

it with a second, out-of-focus frame, it is possible to produce ethereal-looking results. The effect particularly suits images of back-lit flowers. Both images have to be identically composed, so the camera needs to be in a fixed position. Many digital SLRs have the facility to create a double exposure in-camera – the camera takes the two shots and combines them into one file. To do this, select the camera's multiple exposure setting, choose a total of two frames, and then take the shots – one sharply focused and the other blurry. The amount by which you defocus the lens will alter the look of the final result. However, overlaying images in-camera gives you limited control, and not all cameras have a multiple-exposure facility. Arguably, a better option is to blend the images during processing – combining them using Layers. This allows you to adjust each frame individually with more control. It is even possible to mimic the effect using just a single, sharply focused image: create a copy of the photograph and add Gaussian blur before combining it with the original, sharp frame.

FOCUS STACKING

Focus stacking is a technique designed to artificially extend depth of field. It is a blending technique, in which a number of images, each captured at a different focal depth, are combined using software. In principle, it is not dissimilar to High Dynamic Range (HDR) photography, except that it is aimed primarily at extending back-to-front sharpness. It is useful for shooting close-ups of flowers, when depth of field is insufficient to keep the subject sharp throughout. However, subjects need to be perfectly still in order to 'stack', so it is better suited to the studio than shooting in the field. Using a tripod, take a series of images captured at very slightly different focal depths. In other words, with each image, manually alter the point of focus so that a different part of the subject is sharply focused. While none of the individual shots will capture the subject entirely in focus, the sequence should contain all the data to generate an image in which the subject will be sharp throughout. The images are then aligned and blended in post-processing. This can be done in the latest versions of Photoshop, using the Auto Blend Layers command; there are several third-party programs that do the same job.

SNOWDROP (*GALANTHUS NIVALIS*)
Many digital SLRs enable you to create a multiple exposure in-camera. You can select the number of frames to be overlayed, and then the results can even be saved as a Raw file. In this example, a double exposure has added an ethereal quality to this close-up of a single, back-lit snowdrop.
Nikon D300, 70–200mm and Nikkor TC-20E III (at 320mm), ISO 200, 1/400 sec. at f/5.6, beanbag

PLANTS WITHIN THE LANDSCAPE

Capturing plant life in frame-filling close-up images will not always guarantee the strongest, most captivating results. While it is possible to highlight the beauty and detail of individual flowers using a macro or telephoto lens, you can't convey a true feeling of scale or context when isolating such a small area. Environmental portraits of wildlife and plants – showing them in relationship to their surroundings and habitat – can reveal far more about the subject. Therefore, when the situation allows, switch to a wide-angle lens (see page 17) and capture nature images of plants within the landscape.

WIDE-ANGLE PLANT PHOTOGRAPHY

Large swathes of wild plants – for example, thrift, poppies or alpine flowers – are an impressive and colourful sight. Only a wide-angle view will do justice to this type of natural spectacle. A focal length in the region of 17–35mm will normally prove a good choice, although for more extreme, distorted views, consider using a fisheye. The major appeal of using wide-angles for nature photography is their wide, stretched perspective, naturally large depth of field, and impressive close-focusing ability. The majority of wide-angles can

focus to within 12in (30cm) and boast a magnification of around 1:4. As a result, photographers are able to get very near to subjects and exaggerate their size – capturing them looming large in the frame, but still in context with their background. Alternatively, flowers can create interesting or colourful foreground matter in environmental images, proving a useful device for directing or leading the eye into the frame. Photographs of plants captured in context with their surroundings will often convey far more information about the subject's typical habitat and their characteristic shape and growth.

When capturing plants together with a sweeping, distant view, a higher viewpoint often works well. However, for more intimate or distorted results, a low shooting angle is better. The more extreme the wide-angle, the greater the level of distortion. Don't be afraid to get very close to your subject in order to exaggerate the effect. We normally recommend prioritizing a small aperture, in the region of f/16, when shooting this style of image. Together with careful focusing, a small f-stop will help provide front-to-back sharpness. In breezy conditions, don't be afraid to make subject motion (see page 50) a feature of your views – it will help your shots look less static.

OXEYE DAISY (*LEUCANTHEMUM VULGARE*)
Use wide-angle lenses to capture a distorted and unusual perspective – the results can be eye-catching and surreal. For the most pronounced effects, try using a circular fisheye. This allows you to take pictures from just a few centimetres away from the subject – in this instance, the front element of the lens was practically touching the nearest daisy.
Nikon D300, 8mm, ISO 200, 1/180 sec. at f/16, handheld

THRIFT *(ARMERIA MARITIMA)*
I was drawn to this area of colourful thrift, carpeting the clifftop. Had I opted to photograph it in close-up using a long lens, the result would have looked generic. Instead, a wider view created a more original result, placing the flower in context with its coastal environment.
Nikon D300, 17–35mm (at 19mm), ISO 200, 10 sec. at f/13, tripod

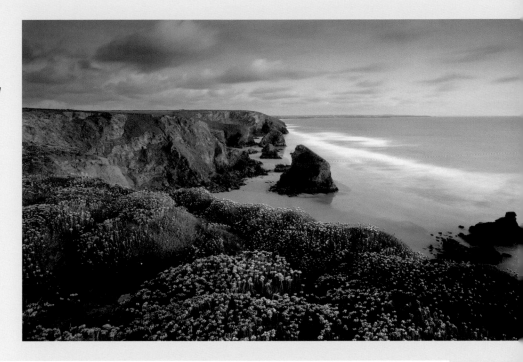

HYPERFOCAL DISTANCE

When photographing environmental views of plant life, focus carefully to ensure everything within the frame – from front to back – is rendered sharply. Typically, depth of field extends roughly one-third in front of the point of focus and two-thirds beyond it. Therefore, if you inadvertently focus too near or far into the frame, you risk wasting valuable depth of field. To help ensure you maximize front-to-back sharpness, focus on the hyperfocal distance. This is a technique commonly used by scenic photographers, but it is just as useful when shooting environmental views of plants and flowers. The hyperfocal distance is the point at which you can maximize depth of field for any given aperture and focal-length combination. When a lens is focused on the hyperfocal distance, depth of field will extend from half this distance to infinity. When using prime focal lengths, with good distance and depth of field scales marked on the lens barrel, it is relatively easy to select the hyperfocal point – simply align the infinity mark against the selected aperture.

However, most modern lenses are not designed with adequate markings, so photographers have to calculate the distance themselves. There are a variety of depth of field calculators and hyperfocal charts available to download online, which are designed to make this simple and straightforward (see page 172). You can even get hyperfocal-distance apps for your smartphone – simply enter the f-number and focal length, and it will calculate the distance for you. Frustratingly, having calculated the hyperfocal distance, it can still be difficult to focus your lens to the exact, specified distance. This is due to the fact that many lenses have rather perfunctory distance scales, with only a handful of distances marked on them. As a result, photographers often have to employ a degree of guesswork when adjusting focus. However, most people are able to judge distance fairly accurately within such a short range. Adjust focus manually and, if in doubt, allow margin for error by focusing slightly beyond the calculated distance.

SHAPE AND FORM

When shooting nature, you don't have to photograph your subject in its entirety. One of the most appealing aspects of close-up photography is the ability to isolate and reveal exquisite detail and beauty. We always encourage our workshop participants to look at subjects closely and with a fresh and creative eye. Try to avoid obvious viewpoints and compositions – often the most striking, memorable images will be those that are less conventional. Working at high magnifications allows us to highlight shapes, lines, curves, texture and patterns that otherwise lie beyond our range of vision. Abstract results are possible by identifying and photographing shape and form.

PRO TIP: Eliminate anything from the frame that isn't essential or beneficial to the final image – this will guarantee that the viewer's attention stays focused on the subject's shape and form. Filling the frame with your subject will disguise a subject's scale, remove it from its context and create a sense of intrigue.

varying light. Shape and detail is best isolated – the emphasis should be on the subject's form, not its surroundings. A dedicated macro or close-up attachment (see page 17) will normally be the best tool for the job, allowing you to highlight miniature detail, or focus on just a small part of the subject.

Composition is all about arranging the elements in a visually pleasing and stimulating way. When shooting shape and form, simplicity is the golden rule. Filling the frame with the subject will often create the most striking result, excluding conflicting or distracting background detail that might otherwise dilute the subject's impact. Lines, cutting through the image, are a powerful compositional tool. However, when placed horizontally, lines may appear to bisect the image, or lead the eye out of the image. When shooting abstract images of nature, lines – the veins of a leaf, for example – are often best positioned diagonally, as this will create less static results.

The direction of the light (see page 60) also plays an important role. Light without shadows is well suited to images of shape and form, helping you to record fine detail, while back-lighting will highlight a subject's shape, particularly if it is contrasted against a dark background.

When shooting shape and form, the 'right' composition is usually far less obvious than with more traditional nature images. Developing an eye for abstracts can take time. Compositions often evolve over a number of frames, so take your time and fine-tune your shots until you achieve the look and result you want.

CREATIVE VISIONS OF NATURE

Photogenic form, texture and pattern exists everywhere in nature, and particularly in the world of plants – the spiral formed by an uncurling fern, the sharp lines and sweeping curves of a succulent, or the striking, intricate pattern of a leaf's veins, to name just three. Abstraction disguises scale and context and emphasizes colour, shape and form.

Familiar geometric shapes, lines and repeating patterns are pleasing to the eye and highly photogenic, but such detail is rarely obvious at first glance. Therefore, the most important skill you need to develop when shooting shape and form is the ability to 'see', or identify the type of detail that will successfully translate into a still image. Look for contrast, colour, unusual detail and symmetry. Study subjects closely and carefully and from different viewpoints and in

HART'S-TONGUE FERN
(PHYLLITIS SCOLOPENRIUM)
Back-lighting defines a subject's shape and highlights fine detail, such as the tiny hairs growing on a flower's stem. By isolating this small fern from all the others growing around it, I emphasized its spiral shape as it began to unfurl.
Nikon D300, 150mm, ISO 200, 1/15 sec. at f/16, tripod

AGAVE PLANT *(AGAVE UTAHENSIS)*
Look for patterns, symmetry or intriguing detail within a subject that will make a strong photograph.
Nikon D300, 150mm, ISO 200, 1/40 sec. at f/11, tripod

FUNGI

Fungi might not be the most attractive or glamorous subject, particularly when compared to colourful flowering plants. However, don't overlook the potential of mushrooms and toadstools – they are surprisingly photogenic. They've existed for millions of years, evolving into an extraordinary variety of types, which range hugely in shape, size, colour and form, from waxcaps, stinkhorns, puffballs, and death caps to fly agaric – the 'fairytale' mushroom. Generally speaking, autumn is the best time of year to find and shoot fungi.

FINDING FUNGI

A huge variety of fungi is found all over the world. While their preferred growing conditions and habitats vary greatly, many favour moist environments and ancient woodland. The older the ground or woodland, the more mycelium (roots) will occur, increasing the likelihood of finding a good range of subjects. Fungi can be found throughout the year, but autumn is the best time for photography. Visit woodland and look for subjects growing on decaying stumps and among rotting tree matter, fallen branches and dense leaf deposits. Some are large, grow in clumps, and will be quite easy to find; others will be small, hidden and well camouflaged. Look up as well as down – you will find fungi growing above you on overhanging branches, but still within the range of a telephoto lens. Fungi can emerge suddenly, without warning, and disappear again just as quickly. Therefore, it is worthwhile visiting the same locations regularly. Places to avoid looking are rocky, dry and badly overgrown regions.

PHOTOGRAPHING FUNGI

Any focal length can prove useful when photographing fungi – a wide-angle, in particular, is useful for capturing environmental images of larger species,

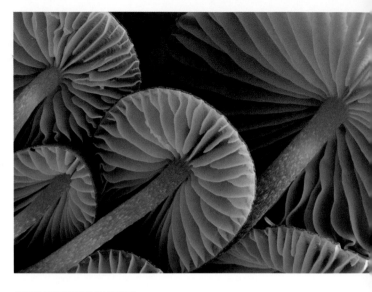

GILLS (*SPECIES UNKNOWN*)
A low shooting angle, looking up at your subject, can sometimes prove awkward to achieve when photographing fungi, but it will reveal the intricate texture and detail of a mushroom's gills. Filling the frame with your subject will not only create striking compositions, but ensure any distracting background clutter is excluded from the frame.
Nikon D70, 105mm, ISO 200, 4 sec. at f/22, tripod

like bracket fungus. However, many mushrooms are small, and a dedicated macro is the best choice. This will provide a practical working distance, and the large maximum aperture will help provide a brighter viewfinder image, aiding focusing and composing images in dark woodland.

In terms of general technique and viewpoint, you can approach fungi in much the same way as you would any other plant. However, lighting can prove more problematic, as the majority of species prefer dark, damp environments, so natural light is often restricted. Inevitably, a mushroom's gills and stem receive less light than its cap, so fill flash or reflected light is often a necessity. When photographing fungi, we suggest using a reflector (see page 70). The advantage of bounced light over flash is that

PRO TIP: Look for subjects in pristine condition. Fungi will quickly pass its best, as it is prone to weather damage and being nibbled by slugs. Fungi often grows through decaying wood and leaf matter so, using a blower brush, remove tiny, distracting specks of dirt and vegetation before taking photos. Doing so will save you the time and effort of having to tidy up the image in Photoshop later, using the Clone Tool or Healing Brush.

you can regulate its effects easily – quickly changing the angle, or intensity, of the light as required. A sheet of white card, mirror, or aluminium foil can also be used to reflect light onto the subject.

Unlike many other plants, fungi are rarely affected by wind movement, as they are sturdy and often grow in sheltered positions. Therefore, assuming you are using a tripod, the shutter speed doesn't really matter – even if it reaches several seconds long, don't worry. However, push the feet of your tripod firmly into the ground to ensure complete stability.

Many types of fungi are strangely or awkwardly shaped, which can complicate the depth of field required. For example, a mushroom's cap will extend closer to the sensor plane than its stalk. To keep both acceptably sharp, a smaller aperture than normal is needed. The exact f-stop required depends on the subject size and type, the reproduction ratio and the effect you desire. However, f/11 or f/16 will normally provide a practical level of sharpness. Review depth of field at the time of taking the photograph – either by depressing the depth-of-field preview button (if your camera has one), or reviewing images on the camera's LCD and scrutinizing sharpness.

Fungi often grows in the most unaccommodating, awkward places and the woodland floor will usually be damp and dirty during autumn. Therefore, it is advisable to use a ground sheet when photographing fungi – it will help keep your clothing and kit clean and dry. A right-angle finder, or digital SLR with a vari-angle LCD, is useful for low-level work, greatly assisting focusing and framing. Woodland can be a messy, chaotic environment, so study your subject's surroundings carefully and 'garden' backgrounds to keep them clean and uncluttered. Keep compositions simple. Don't overcomplicate matters by trying to include too much in the frame – isolating just one or two mushrooms will often have more impact than photographing a large, spread-out group. One of the most photogenic aspects of mushrooms is the texture and detail of their gills. Therefore, when possible, opt for a low shooting angle and make this a feature of your fungi images.

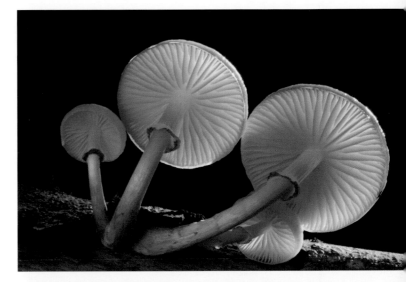

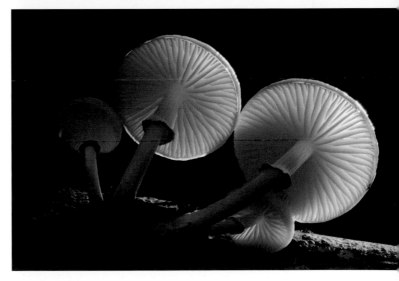

PORCELAIN FUNGUS (*OUDEMANSIELLA MUCIDA*)
A small, foldaway reflector is a useful lighting aid when photographing fungi. It is the simplest and most natural-looking way to relieve ugly shadows. It is easy to regulate the look of bounced light, as you can see its effects instantly, and adjust the angle and intensity of the light quickly. Top image taken with reflector, bottom image without.
Nikon D300, 150mm, ISO 200, 1/8 sec. at f/16, tripod

SEASONAL CHANGES

Seasonal changes present photographers with fresh subjects and new opportunities. During spring, vibrant growth is everywhere, particularly in woodlands and hedgerows. In summer, meadowland, clifftops and heathland are awash with colour. During autumn, leaves and foliage turn golden brown, while natural fruits, nuts and fungi abound. In the winter months, plants and dead vegetation glisten, encrusted with frost. Regardless of the time of year, you should never be short of inspiration, or plant life to photograph.

SPRING

Spring is the best time of the year for plant photography. New growth is everywhere. In woodland, look for emerging leaves, uncurling ferns and dense, photogenic carpets of wild flowers – bluebells, for example. Lush, green vegetation is everywhere and the long spring days mean you have longer to work. Cloudy days are best for woodland photography, producing flattering, shadowless light. However, some flowers will only open fully in sunlight. In the mornings, after clear, still nights, flowers and plants will be heavy with dew. Tiny water droplets add sparkle, scale and interest to your close-up images. Rise early and take photographs before the dew evaporates. Alternatively, add your own photogenic water droplets by spraying plants using a gardener's spray or atomizer.

SUMMER

Although summer light can be harsh and foliage can begin to look less lush and colourful, many wild flowers peak in the summer months, so it's a great time of year for flower photography. Orchids are typically at their best at this time. They range greatly in size, colour and appearance and are popular, photogenic subjects. Highlight details of individual flowers by using a macro lens or close-up attachment. Large summer flowers, like willowherb and foxgloves, will stand tall along banks and hedgerows, and look most attractive back-lit in the hazy, evening light. Heath and moorland will be carpeted with flowering heather, which can photograph well in close-up or in context with its surroundings.

MALE FERN (DRYOPTERIS FILIX-MAS)
During spring, woodland is home to vibrant, fresh growth and an array of colourful woodland flowers. During early morning and late evening, the light will be warm, soft and dappled.
Nikon D700, 70–200mm (at 200mm), ISO 200, 1/4 sec. at f/4, tripod

MARSH HELLEBORINE (EPIPACTIS PALUSTRIS)
In summer, there is a colourful array of flowers to photograph. Orchids are a popular subject and most abundant at this time. Don't be afraid to crop in tight to your subject and isolate just a small area of colour or detail.
Nikon D300, 150mm, ISO 200, 1/50 sec. at f/4, tripod

AUTUMN

There are fewer flowering plants in autumn, so turn your attention to autumnal foliage and fungi (see page 134) instead. The cooler temperatures and shorter days of autumn cause the chlorophyll (colour pigment) in the leaves to change, turning them yellow, orange or red. Colourful leaves look particularly photogenic back-lit, with the light highlighting their translucency and intricate veining. Isolate a single colourful leaf against a backdrop of colour by using a telephoto and selective focus. A polarizing filter will help restore natural colour saturation when shooting reflective foliage. Autumn is also the best time of year to photograph fungi, so return to woodland and search carefully among decaying branches and leaf matter.

MAPLE LEAVES (ACER JAPONICUM)
Your shooting position will have a marked effect on the appearance of your subject's background. Position yourself carefully to create colourful, flattering and pleasantly diffused autumnal backdrops.
Nikon D300, 150mm, ISO 200, 1/50 sec. at f/2.8, handheld

WINTER

During winter, most wild plants are dormant. However, while there may be fewer subjects around, wintry weather can create a whole host of opportunities. The appearance of seed heads, rushes, grasses and catkins are transformed by a frost. Set your alarm early and wrap up warm. A close approach is normally best, allowing you to isolate plant detail encrusted in frost – so attach a macro or close-up lens. Towards the end of winter a late dusting of snow may coincide with the emergence of early plants, such as snowdrops, crocuses and alpines. Photographs of flowers or plants poking up through clean, white snow can look very striking. A low shooting angle will normally work best. Snow can fool TTL metering systems into underexposure, so positive (+) exposure compensation may be required.

SNOWDROP (GALANTHUS NIVALIS)
Although many plants are dormant during winter, some – such as snowdrops – flower early and make excellent photographic subjects when poking up through snow, or covered with frost.
Nikon D300, 150mm, ISO 200, 1/30 sec. at f/4, beanbag

► CHAPTER NINE > **POST-PROCESSING**

Post-processing is an essential part of digital photography. To obtain the best possible results from your camera, learning how to process and manage your digital images correctly is vital. Contrary to popular opinion, post-processing is not cheating – it is a necessary part of the image-making process. Indeed, in some cases, it is the only way to achieve an accurate representation of the original scene. However, it cannot be stressed enough the importance of achieving the most accurate exposure, composition and sharpness in-camera. Skill behind the camera should always be paramount. As the famous idiom goes, 'You can't make a silk purse out of a sow's ear', so, in general, the more you alter an image in the processing stage, the more its quality suffers. This chapter is designed to help you to acquire the essential techniques you will need to realize the full potential of your camera, and help you to get the best possible results from your wildlife photography.

IN THE BAG: WHAT IS REQUIRED?

Budget
• Computer
• Raw processing software
• Adobe Photoshop Elements

Enthusiast
• Computer
• Third-party Raw processing software
• Adobe Photoshop (full version)
• Several external hard drives
• Fully calibrated monitor

RED GROUSE *(LAGOPUS LAGOPUS SCOTICA)*
In this photograph, there was a significant difference in contrast between the foreground and the sky. At the processing stage I made a selective adjustment and darkened the sky to prevent it from looking too pale in the final photograph. This has created a much more accurate representation of the scene at the time of shooting.
Canon EOS-1D Mk IV, 17–40mm L, ISO 400, 1/50 sec. f/8, tripod

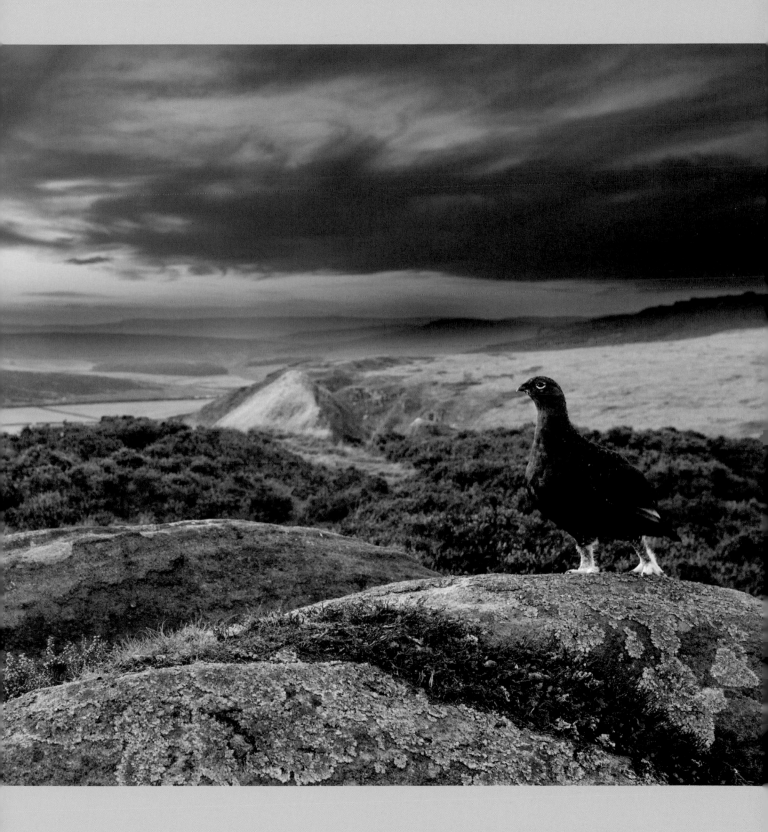

FILE TYPES

Most photographers would rather spend time out in the field taking pictures than devote long periods to sitting at a computer processing them, so it is important that you have an organized workflow to minimize frustrating hours sitting in the office. Workflow begins with your choice of file format. Most current digital SLRs offer two formats, Raw and JPEG, though there are others. We strongly recommend shooting in Raw, as it will provide the ultimate in image quality. Here we will examine the most common file types.

JPEG (JOINT PHOTOGRAPHIC EXPERTS GROUP)

JPEG is a compressed file format, with a small file size. This, of course, has the benefit that images saved as JPEGs take up less space on your hard drive. The downside of JPEG is that the compression process discards some of the original image data, which results in a loss of quality. The greater the level of compression, the more the quality suffers. Compression can be made both in-camera – by selecting low, medium or high quality – or subsequently, when you save the image. If you choose a lower-quality setting, the file size will be reduced but 'artifacts' such as poor edge definition, colour banding and sometimes even posterization may be introduced. JPEG is a 'lossy' file type, which means that the quality deteriorates every time you re-save the file.

RAW

Unlike a JPEG file, a Raw image retains 100% of the original image data, allowing a wider range of colours and tones to be captured. It will also show a greater dynamic range and is more forgiving when it comes to exposure. Put simply, a Raw file will give you the highest quality image that your camera is capable of producing. When shooting Raw for the first time, you may notice that the images look flat and a little lifeless. Unlike a JPEG, no in-camera processing takes place on a Raw file, which means the files are not normally useable straight from camera – they require processing, either using the software that came with your camera, or using a third-party program such as Adobe Lightroom or Phase One.

TIFF (TAGGED IMAGE FILE FORMAT)

We recommend converting a Raw file to a TIFF at the processing stage. TIFFs are not normally compressed like a JPEG, so the file will ultimately be of a higher quality. As a TIFF file is a 'lossless' format, you can re-save an image as many times as you like without seeing a reduction in definition. Some cameras allow you to capture images in TIFF format, but large file sizes and relatively long writing speeds prevent this from being a viable option. It is also possible to create 8-bit, 16-bit and 32-bit TIFF files. If further adjustments are going to be made to the image after the initial Raw conversion, save it at least as a 16-bit file, as the adjustments will have less impact on image quality.

WORKFLOW

Shooting in Raw and converting your images is much more time-consuming than shooting JPEGs in-camera, but the results will be well worth the extra effort. Image quality will be superior and you will have much more flexibility when it comes to exposure. A Raw file will often allow you to recover important highlight detail if you make the mistake of overexposing the image, and shadow detail can also be enhanced. If you have taken several images in the same sequence, it is possible to apply your adjustments to all the files simultaneously. This is known as 'batch processing' and can speed up the process substantially. Every photographer has a different way of processing images and ultimately it is up to you to find a workflow system that suits you. There is no definitive right or wrong way of doing things. We have, however, made some suggestions over the next few pages, which should help you on your way.

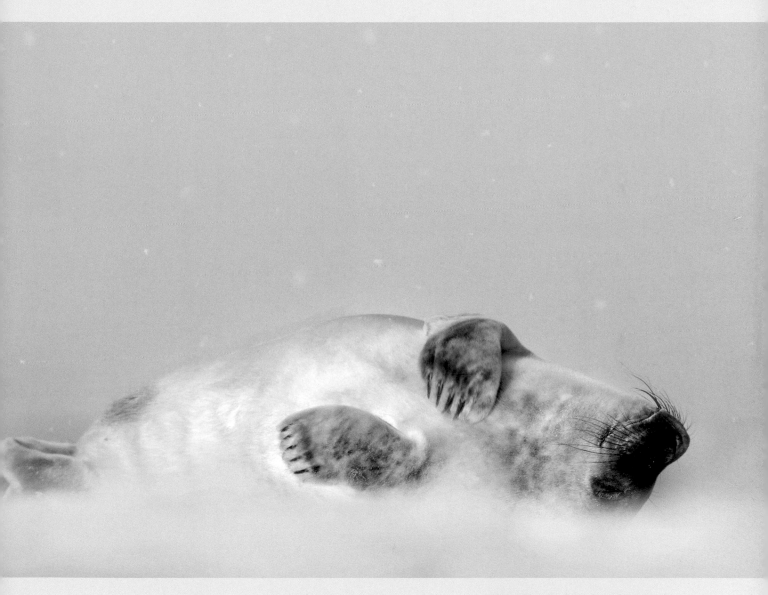

GREY SEAL *(HALICHOERUS GRYPUS)*
Raw files enable you to correct some
exposure errors. It is often possible to
recover important highlight detail that
would have been lost forever if the image
had been captured as a JPEG.
Canon EOS-1D Mk II, 500mm f/4 L IS, ISO 50,
1/250 sec. at f/7.1, beanbag

141

PROCESSING A RAW FILE

To process a Raw file, you will need some software. Each camera manufacturer has its own program, which is usually supplied with the camera. While these programs will convert images and produce a good-quality result, they lack the features of many third-party programs and tend to be slightly awkward to use. For this reason, we recommend investing in a good third-party Raw converter.

THIRD-PARTY RAW CONVERTERS

The market is full of Raw conversion software, but we recommend looking at three options in particular: Adobe Photoshop Lightroom, Apple Aperture and Phase One Capture One. Both Lightroom and Aperture combine a Raw file converter with Digital Asset Management (DAM) features, which allow you to organize your images into collections and assign keywords to each file to help search for particular images. The Raw converter also provides you with options beyond the basics of white balance, exposure and colour correction, enabling you to correct lens distortion as well as make local adjustments to colour, contrast, exposure and sharpness. Adobe Photoshop and Photoshop Elements both include a Camera Raw plug-in, which includes all of the same conversion tools as those found in Lightroom but does not include the DAM capabilities. Apple Aperture is only available for Mac users but has proved very popular. Capture One is also popular and is known for its excellent quality. It includes an array of batch-processing features and for this reason is widely used by portrait and wedding photographers.

Whichever Raw converter you decide to buy, it is worth purchasing a detailed manual for the program too, which should provide you with a full description of all the features. Although each software package differs slightly, the basic tools that you will be using will remain the same. We suggest basing your workflow on the following pattern:

IMPORTING AND EDITING IMAGES

The first step is to import your images into the Raw converter. There are various ways of doing this and your chosen software will dictate the method you use. Next, you will need to edit your pictures. Look through each image and pick out the ones that you would like to work on. Most programs have a star-rating or flag system so you can easily distinguish the best images from the rest. When your images are safely saved onto the computer, you should back them up carefully onto a separate hard drive, before formatting your card ready for your next shoot.

CROPPING

You should always try to compose your images as best you can in-camera, but there will always be times when some cropping is required. Perhaps there is a distracting element you wish to eliminate, or the subject isn't quite in the desired position within the frame. When cropping images, it's often best to retain the 3:2 ratio that most digital SLRs use as standard. There are times, however, when a square crop or a panoramic crop will look better. Most Raw converters allow you to 'lock' a particular ratio, or you may, of course, want to disable this function and crop with an alternative ratio that better suits the individual image.

WHITE BALANCE

Before making any other adjustments to your images, you should set the white balance. Most programs include the original default settings, such as Daylight and Cloudy, but for more precise control you can use the colour temperature slider to make the image appear warmer or cooler. You can also increase or decrease the amount of green and magenta in the image with the tint slider. Another option is to select the eyedropper tool and click on an area of neutral colour, although this method can be difficult to predict.

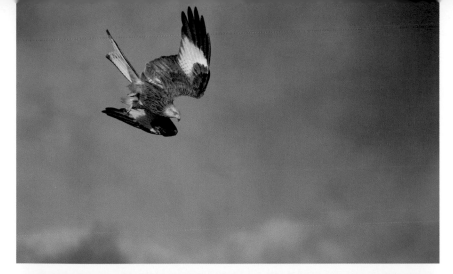

RED KITE (*MILVUS MILVUS*)
After exposure adjustments have been made, an image such as this should show a full range of tones. Setting the black point correctly here was important as it has darkened the clouds and added impact. Notice how the low angle of the sun has illuminated the underside of the bird, revealing important feather detail.
Canon EOS-1D Mk IV, 500mm f/4 L IS, ISO 100, 1/800 sec. at f/6.3, handheld

ADJUSTING CONTRAST
This image shows the editing screen in Adobe Lightroom. To set the white point, drag the Exposure slider to the right – this affects the highlights. Do the same with the Blacks slider to set the black point. For greater accuracy, hold down the Alt key and you will see the screen go black (the screen turns white when setting the black point). As you drag the sliders, stop when you see the first bit of colour appearing.

SETTING CONTRAST

Correcting the contrast in your images is done by setting the white and black points. This ensures that the tones in the image are spread across the full range of the histogram, and should prevent your images from looking 'muddy' or flat. The histogram will be displayed next to the image in your Raw converter, giving you a clear indication of the range of tones in your image. Just below the histogram you will see three sliders. The pointer on the far right represents white (255); the pointer to the far left, black (0); and the middle pointer represents the mid-tone (128). To set the black point, move the black-point slider to the right until it just touches the beginning of the histogram. You will see the shadow areas grow darker. To set the white point, drag the white-point slider

to the left until it almost touches the histogram. You will notice the highlight areas become lighter, but is important not to go too far or you will risk 'clipping' the highlights and losing detail. You can now adjust the overall brightness of the image by moving the middle slider. Drag it to the left and the mid-tones will darken; slide it to the right and they will become lighter. As each image is unique, it is up to you to decide how you would like the tones to appear in the final image. If you have a high-key image, you may wish to push the tones as far to the right as you can so the image appears as light as possible. A low-key image with predominantly dark tones may look more effective when the sliders are dragged to the left.

USING CURVES TO FINE-TUNE CONTRAST LEVELS

If your image fails to meet your expectations after your initial tonal adjustments, you may need to adjust the contrast further using Curves. Curves offers a much greater control over the tones in the image than the simple contrast slider. The Curves graph represents the tones in the image, much like the histogram. You will see a diagonal line running from the bottom left to the top right. This line represents the tones from pure black at the bottom to pure white at the top. You can click anywhere on this line and drag it up or down to alter the tones. To increase overall contrast, add an S-shaped curve by dragging the line down at the bottom quarter, and then pushing it up at the top quarter. To decrease contrast, reverse this by pushing the bottom quarter upwards and pulling the top quarter down. You are not limited to making adjustments only at the quarter points; it is possible to alter the line at any point from top to bottom, giving you complete control over all the tones in the image.

CURVES
This image shows a typical Curves graph. Create an S-shape to increase the overall contrast in your image.

BOOSTING COLOUR

Because no in-camera processing is performed on a Raw file, the colours in the initial image can often appear dull and a little lifeless. Your exposure adjustments will usually remedy this, but you may wish to boost the colour a little more. This is where the Saturation and Vibrance controls are especially useful. Not all Raw converters have both, some only have Saturation, but there is a distinct difference between the two. Saturation boosts all the colours by an equal amount, while Vibrance only affects the less saturated colours. For this reason we generally find that Vibrance produces a more natural-looking result, but neither control should be overused. It is up to you to judge how much is needed, but do try to use it sparingly. Apply too much of either and in addition to your image looking unnatural you run the risk of introducing unwanted noise.

LOCAL COLOUR ADJUSTMENTS

Some Raw converters allow you to adjust the saturation and hue of certain colours individually. This is usually done either with a colour wheel or colour picker, or a targeted adjustment tool. It is very easy to end up with fake-looking colours when adjusting them individually, so again, take care not to overdo it.

CLEANING UP DUST SPOTS

All digital SLRs are prone to attracting dust spots on the sensor, even those with automatic cleaning systems. Since most wildlife images are taken with wide apertures and long lenses, the depth of field is so narrow that dust spots are not usually visible. There are always occasions, however, when they will show up – usually against skies or when a smaller aperture has been used. Most recent Raw converters feature a cloning tool that can be used to remove dust spots, though you may find it easier to do this in Photoshop.

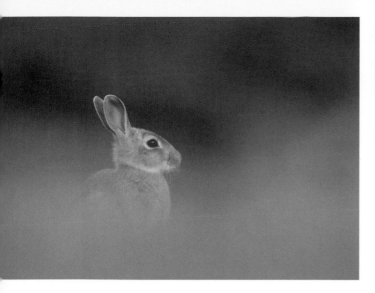

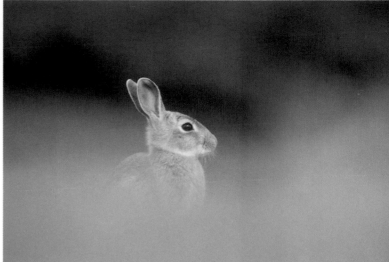

SHARPENING

Most Raw images from a digital SLR have an inherent degree of softness. This is introduced in-camera by the anti-aliasing filters used to reduce artifacts. Most digital SLRs offer various adjustment parameters, one of which enables you to add sharpening in-camera, but we recommend keeping the setting on standard and adding sharpness at the Raw conversion stage. The amount of sharpening required depends on the image, and the camera and lens used, but the program's default setting is a good place to start. As with Saturation and Vibrance, it is important not to over-sharpen, as you may introduce artifacts such as noise. We will discuss selective sharpening in more detail on pages 146–7.

NOISE REDUCTION

All digital images contain a degree of noise; the amount is dependent on a number of factors. Wildlife images are more susceptible than most, since noise is most evident in out-of-focus areas, especially those that consist of dark colours. Lightening an image that is underexposed also introduces noise – another reason why you should do everything possible to ensure a perfect exposure in-camera. Removing noise at the conversion stage should be done with care as it can destroy important detail. Luminance noise is more acceptable to the eye and can even suit certain images. Colour noise is generally very ugly and can ruin an otherwise perfect shot.

BEFORE AND AFTER
Straight from the camera, most Raw files look flat, with muted colours (left). Making suitable contrast adjustments with a little Saturation and/or Vibrance can make a world of difference (right).
Canon EOS-1D Mk IV, 500mm f/4 L IS, ISO 250, 1/500 sec. at f/5.6, beanbag

CONVERTING YOUR IMAGE FOR EDITING AND OUTPUT

When all your adjustments have been made, you are ready to convert your image to your chosen file format. We recommend converting to TIFF as this will give you the best quality, especially if you intend to make any further adjustments in Photoshop. During the conversion stage you will typically have various options offered to you. Saving your TIFFs at 16-bit preserves maximum image quality. You can convert the image to 8-bit to save space after further adjustments have been made in Photoshop. Set your size at 300 pixels per inch. This is the industry standard and is perfectly acceptable for printing. It is also the resolution required by photo libraries and for general publication. Additionally, you will need to select the colour space. There are usually three options: sRGB, Adobe RGB and ProPhoto RGB. sRGB is best used only for web publication. It is the smallest colour space and therefore offers less than the optimum quality. ProPhoto RGB is the largest and should be used if you are planning to print your images with an inkjet printer. For all other purposes, Adobe RGB is the best option. It is the industry standard and is the colour space that is required by photo libraries and publications.

SHARPENING

Files from your digital camera, especially those in Raw format, often lack critical sharpness. If you want to print your own images, you will need to apply some sharpening. This should be the last stage of the process, after all other adjustments have been made. Most wildlife images contain areas of diffuse colour. These out-of-focus areas should not be sharpened, or you run the risk of introducing undesirable artifacts such as noise. Therefore, only sharpen your subject. There are various ways in which selective sharpening can be achieved. This example demonstrates a method that is both simple to use and very effective.

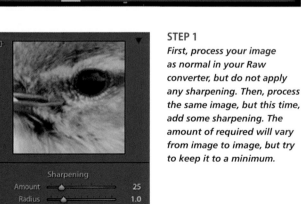

STEP 1

First, process your image as normal in your Raw converter, but do not apply any sharpening. Then, process the same image, but this time, add some sharpening. The amount of required will vary from image to image, but try to keep it to a minimum.

STEP 2

Open up both images in Photoshop. With the first image selected (the one with no sharpening), go to Image > Select all. Then go to Edit > Cut. Select the second image (with sharpening) by clicking anywhere on the image and go to Edit > Paste. The first image will now be added as a second layer on top of the sharpened image.

STEP 3

Select the Eraser tool from the Tools palette and use the brush to selectively erase the top layer, revealing the sharpened image beneath. The key here is to erase only the parts of the image that you would like to appear sharpened. In most cases this will be the subject only. The background and areas of diffused colour will not be affected, keeping them clean and free from anything unwanted. Take care when erasing not to go over the edges.

Canon EOS-1D Mk IV, 500mm f/4 L IS, ISO 400, 1/800 sec. at f/4.5, tripod

STEP 4

When you have finished this process and your sharpened subject has been revealed, you will need to flatten the layers. To do this, go to Layer > Flatten image. You will now have selectively sharpened the subject without risking the appearance of any unwanted artifacts in the out-of-focus areas.

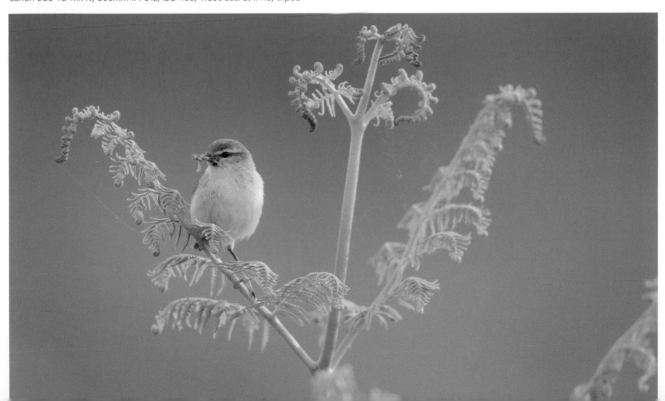

EXPOSURE BLENDING

The rich, golden light that occurs at dawn and dusk can help you create wonderful wildlife images. Colours are adorned with warm hues, texture is amplified and contrast is reduced. However, there will inevitably be times when you find yourself shooting in high-contrast situations. Photographing birds with both black and white plumage in harsh sunlight is the worst-case scenario. If you process the image to reveal detail in the whites, the blacks will be grossly underexposed. If you make your adjustments based on the blacks, the whites will 'burn out'. Thankfully, there is a way to rectify this problem using some fairly simple post-processing techniques. Here we look at a process that involves blending two exposures together, giving you detail across the whole range of tones.

STEP 2

Go back to your Raw converter and revert back to the same image before any alterations were made. Now process the same image again but only take into account the white areas. You may need to use the Highlight recovery slider to reveal detail in the whites. When you have finished, convert the image again, but make sure you give it a different file name to prevent it from replacing the first image.

STEP 1

Open the image that you would like to work on in your Raw converter. Make your usual adjustments to the colour and contrast but ignore the whites. The white areas are likely to burn out, but don't worry about this for now. When your alterations have been made, convert the image as normal.

STEP 3

Open up both images in Photoshop. Make sure you have selected the first image, and go to Select > Select all. Then go to Edit > Cut. Click anywhere on the second image to select it and go to Edit > Paste. The first image will now be placed on top of the second as a separate layer.

STEP 4

Zoom into the image and use the Eraser tool to carefully brush over the white areas to reveal the image beneath. Reducing the opacity and flow slightly will help when going around the edges.

STEP 5

When the blending process is finished you will need to flatten the two layers. Go to Layers > Flatten Image. Now that the image has been flattened, you can make very small adjustments to the contrast of the image as a whole if you need to, using Levels and/or Curves.

Canon EOS-1D Mk II, 500mm f/4 L IS, ISO 100, 1/400 sec. at f/5, tripod

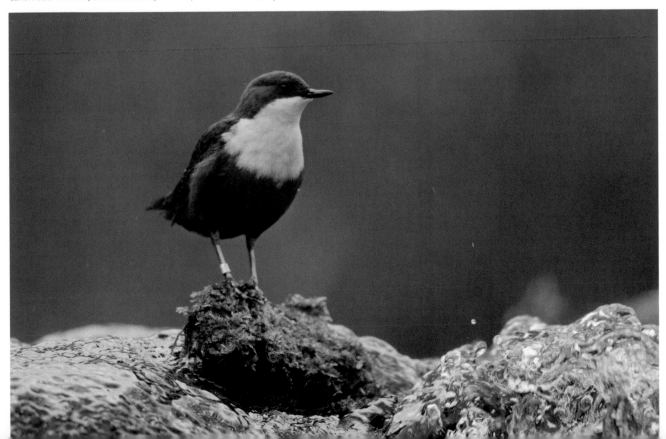

NOISE REDUCTION

Animals and birds very rarely present themselves under ideal lighting conditions, and photographing wildlife often requires the use of high ISO settings. Noise is an unwanted by-product of shooting at such settings. It is the digital era's equivalent of film grain and it has the potential to ruin an otherwise excellent shot. Digital sensor design has come a long way in recent years and most top-end digital SLRs boast excellent low-noise performance, but there will always be occasions when your image will show high levels of noise. Apart from shooting at high ISO settings, there are other factors that create noise: underexposing an image, for example, and having to lighten it during the post-processing stage will often result in a noisy image. Here we will look at ways in which you can reduce the amount of noise in your images using your Raw converter.

TYPES OF NOISE

There are two main types of noise: colour noise and luminance noise. Colour noise is more obvious and generally consists of ugly patches of red, green and blue dots. Luminance noise is more reminiscent of film grain and is much more pleasing to the eye. In some cases, a certain amount of luminance noise might even be desirable, and can be used to create a certain mood.

Each Raw converter has slightly different noise-reduction controls. For this example we will use Adobe Lightroom, but the techniques described will work with all Raw converters.

STEP 1
Start by opening up your image and zooming in to 1:1 (100%).
You should always judge sharpness and noise at this magnification as it will give you a much clearer picture of the effects that each slider has on your image. Click the 'before and after' view and you will see the same image displayed twice. The adjustments you make will now only affect the image on the right, so you can compare it to the original at all times.

STEP 2

Move the cursor until you can see an area of the image that shows both detail and diffuse colour. Move the Colour noise reduction slider to the right. This slider only affects the red, green and blue speckles, so if your image has high levels of colour noise you should see it start to disappear. The key is to only apply enough noise reduction to affect the unwanted noise without losing detail, so you will need to keep a close eye on your 'before' image to compare the level of detail.

STEP 3

At this stage, carefully consider whether you need to apply any luminance noise reduction. For most images, the Colour noise slider is sufficient, but it is worth experimenting while you can see the effect that the slider has when compared to the original image. The Luminance noise reduction slider applies a type of Gaussian blur to your image to eliminate noise. This can lead to severe loss of detail. Remember, luminance noise is not necessarily detrimental to your image, so this should be applied with great care.

STEP 4

In addition to the two noise-reduction sliders, Lightroom has another slider called Detail. When this is moved to the right you will see some additional edge definition being introduced. The trick is not to go too far. Keep it to a minimum or you may risk reintroducing noise back into your image.

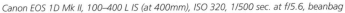

Canon EOS 1D Mk II, 100–400 L IS (at 400mm), ISO 320, 1/500 sec. at f/5.6, beanbag

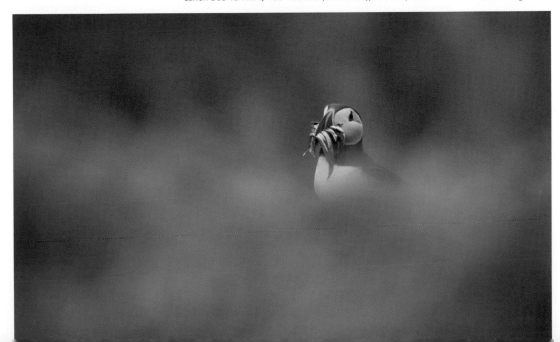

ARCHIVING

The term 'archive' is used to describe any file that has been put away in permanent storage and safely backed up. The importance of archiving your images should never be underestimated. If you fail to take the necessary steps to organize and manage your pictures, you will find it difficult to locate a particular image months, years or even decades down the line. We will now look at some simple steps that you can take to organize and safeguard your work.

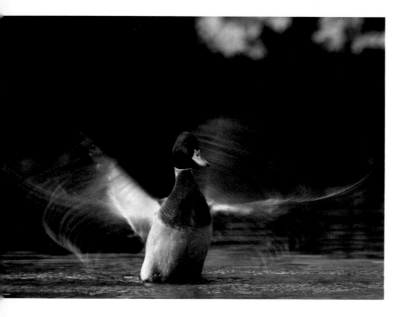

MALLARD *(ANAS PLATYRHYNCHOS)*
I photographed this mallard using a slow shutter speed to reveal the movement in its wings, the result would be impossible to replicate exactly, so it is imperative that you are vigilant with your back ups. External hard drives provide a convenient and relatively inexpensive way of backing up your work, with the added advantage of being portable.
Canon EOS 1D Mark II, 100–400 L IS ISO 160, 1/25sec. at f/10, beanbag

FILE NAMING AND FOLDER STRUCTURE

Your first consideration should be how to name your files. Every photographer has a different method. It can be useful to include your initials in the image title, as well as the species name and the date the image was captured. So, a typical file name could be BH_Robin_150311_0001. If searching for a certain species, you can then search under the name of that species and easily locate all relevant images. Of course, you can choose any method of file naming that works for you, but you should always include some convenient and recognizable text such as a species name to help locate your images when performing a search.

Once you have made your adjustments to an image in your Raw converter you will need a destination folder in which to store the converted image. It is best to keep things simple and uncluttered with very few folders named in fairly general terms – Birds, Mammals, Insects, Flowers, Landscapes, and so on.

BATCH NAMING
This screenshot shows the batch renaming feature in Adobe Bridge. It is easy to use and you can rename multiple images at once, saving precious time.

ADDING CAPTIONS AND KEYWORDS

After each batch of images has been named, converted and placed in the relevant folder, it is a good idea to assign keywords to them, which will help when searching for particular images. Some Raw converters such as Adobe Lightroom offer a keyword facility. I prefer to use Adobe Bridge, but the process is broadly similar in most applications.

Open Adobe Bridge (or your Raw converter) and select the file to which you would like to add the keywords. If you haven't entered them already, you'll need to create new keywords. Click the New Keyword button (+) or choose New Keyword from the panel menu. Type your keyword and press Enter (Windows) or Return (Mac). It is also possible to add sub-keywords and place them under a parent keyword to help categorize them.

STORAGE AND BACK-UP

Even the most expensive hard drives can fail, so it is vital that you back up your work as soon as possible after processing. For peace of mind, you should make at least two back-ups of all your work. We recommend external hard drives for your main back-ups. They have made great progress in recent years, as memory has increased and prices have dropped dramatically. Just in case your home or office is burgled or disaster strikes by way of a fire or flood, you should also make at least one off-site back-up. You could store your back-ups at a relative's house, or even in a safety deposit box at a bank. There are also now many options for storing images online, but it's a good idea to keep a 'physical' copy too. In addition to backing up your processed images, you should also make a back-up of your Raw files, just in case you would like to revert back to your original file at any time in the future.

ADDING KEYWORDS
This image shows the keyword panel in Adobe Bridge. Keywording is a laborious task but if it is done at the time of processing it shouldn't take too long and it will help when performing searches. Photo libraries also require keywords.

► CHAPTER TEN >
CREATIVE ASSIGNMENTS

Attending a workshop with a professional photographer is an excellent way to expand your knowledge and improve your technique. A successful workshop should inspire you to take your photography to the next level and motivate you to head outdoors in search of your own wildlife subjects. After the workshop has finished and the excitement is over, however, it is inevitable that you will forget some of the techniques that you learned on the day, especially if you're not able to venture out with your camera very often. In this chapter we have outlined six creative projects to encourage you to get started and to put into practice the techniques that we have outlined for you throughout this book. We have offered key pointers for each assignment but have purposely kept instruction to a minimum to encourage you to think for yourself. Most importantly of all, be creative. It's time to get your camera. Best of luck!

CHILEAN FLAMINGOS *(PHOENICOPTERUS CHILENSIS)*
Following an arduous dawn trek into the Patagonian Andes searching for puma, I saw a group of flamingos feeding on a dried lake bed in the distance. Equipped with a 100–400mm lens, I made my way towards them. After several failed attempts at getting close, part of the group took to the air and circled me. I fired off a sequence of images in an attempt to show the relationship between the birds and the wild, hostile environment. This shot is my favourite. For me, it shows the beauty of the birds and the incredible, dramatic landscape and tells a story about the relationship between them. Of course, you don't have to travel to far-flung destinations to take great images of wildlife!
Canon EOS-1D Mk II, 100–400mm L IS (at 400mm), ISO 160, 1/2000 sec. at f/5.6, handheld

TECHNIQUE TIPS

Forcing yourself to think 'outside the box' when it comes to composition can be difficult, but here are some ideas to help you:

■ One of the most commonly used compositional rules is to leave space in front of your subject for it to look – or 'move' – into. Try placing your subject at the opposite end of the frame so that it appears to be 'exiting' the picture.

■ Place your subject in the centre of the frame. This is usually considered compositional suicide! But, for images that depict symmetry, it can work surprisingly well.

■ In most cases we would consider an image that contains more background than foreground to be the more effective composition. Try moving your camera to a lower position so that the foreground dominates the image, and place your subject towards the top of the frame.

■ One of the 'rules' of wildlife photography is that the subject must not be looking away from the camera. Try to capture your subject within the landscape. In some circumstances, if it is facing away from the camera it may appear as though it is surveying the scene in front of it.

■ Usually we try to get the whole subject in the frame, and chopping off a bird's wingtips is perhaps the biggest sin of all. But images showing action, such as a bird flapping its wings, can be very effective when cropped tightly. Ignoring the wings and concentrating on the face of the bird can also add impact.

EQUIPMENT CHECKLIST

You should be trying to vary your approach to composition, so you will need to carry an assortment of lenses.

LENS: A zoom lens is invaluable when trying out different compositions as it will allow you to experiment with various framing options without needing to move position (and maybe revealing yourself to your subject).

ACCESSORIES: A tripod with a head that allows easy fine-tuning adjustments is essential. If shooting from ground level, a beanbag will allow even greater freedom of movement while providing a solid support to ensure a crisp image.

CREATIVE ASSIGNMENT 1: BREAK THE RULES

There are a number of rules associated with composition, but rules can sometimes be overly restrictive. Every photographic opportunity is unique, and if you always adhere to the established guidelines without taking into account your subject, its surroundings and your own personal vision, your creativity will undoubtedly suffer. Some of the very best images are those that break the accepted rules. The key is to learn when to abide by them and when to ignore them.

THE ASSIGNMENT

The purpose of this assignment is to explore the art of composition and its accepted rules, deepening your understanding of them. Look carefully and study every aspect of your image in the viewfinder before firing the shutter. Your most important consideration here should be to ignore the rules and explore other interesting ways of designing your pictures. Will moving position slightly help to balance the subject and its surroundings? Perhaps a central composition will work, or placing the subject so that it is exiting the frame – both contrary to the accepted rules. You may be very surprised – and perhaps delighted – by the results.

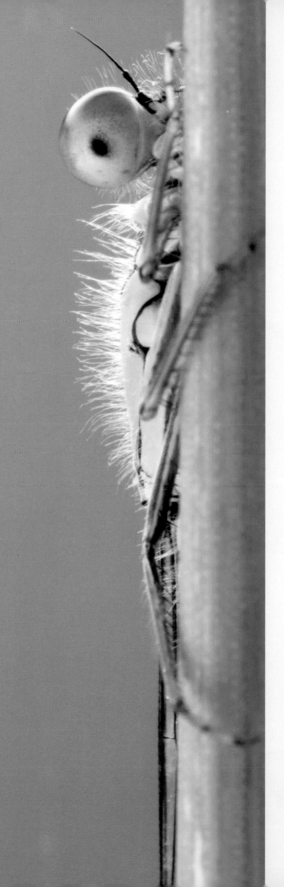

BLUE-TAILED DAMSELFLY
(ISCHNURA ELEGANS)
Ordinarily, you would avoid placing your subject so far to the right of the frame, or leaving such a large area of empty wasted space. However, the unusual composition and quirky nature of the shot has resulted in a striking portrait. Don't be afraid to break the rules.
Nikon D300, 150mm, ISO 200, 1/2sec. at f/13, tripod

TECHNIQUE TIPS

▪ Develop a smooth panning technique. Follow the guidelines on page 95 to practise your panning. Aim to pan as smoothly as possible while keeping your focusing point over the head of your subject.

▪ Varying your shutter speed will markedly affect your results. Try using speeds between 1/15 and 1/60 sec. but don't be afraid to use an even longer exposure for a more abstract representation of your subject.

▪ Look for motion in the landscape. When you have flowing water in your shot and a stationary subject, a slow shutter speed will render movement in the water. Your subject must, of course, remain completely still throughout the exposure or it will not appear sharp. (What a pity it is that water-loving animals and birds fail to understand this!)

▪ Following a wash, most wildfowl will rise up out of the water and shake the excess water from their wings. Experiment with shutter speeds until you are able to keep the body and head sharp but capture movement in the wings. This will give your images a really dynamic edge.

▪ Pay close attention to colour. An abstract image showing motion will lack crisp detail, so colour suddenly becomes a major factor in its success. Target particularly colourful subjects for the most effective results.

EQUIPMENT CHECKLIST

LENS: Shorter lenses are easier to handle. When panning, a medium zoom such as a 70–200mm is ideal.
ACCESSORY: When panning with long telephoto lenses, a Gimbal tripod head is invaluable. It takes all of the weight out of the lens but still allows complete freedom of movement.

CREATIVE ASSIGNMENT 2: CONVEY MOTION

Images conveying a sense of motion can be an effective way of capturing the spirit and character of your subject. Given the appropriate lighting conditions, images of birds in flight work especially well, but mammals running can also make striking pictures. You will need to employ a panning technique. The motion effect created when the camera is moved during a slow exposure creates a painterly effect and can give your images the appearance of an abstract painting.

THE ASSIGNMENT

To begin with, find a suitable subject, preferably one that is easily accessible and slow-flying. Swans or geese at your local park will be a good place to start. Once you have perfected your panning technique, dial in a slow shutter speed – this can be done by selecting a smaller aperture if you are shooting in aperture priority. You may find it easier, however, to use shutter priority and set the shutter speed manually; the camera will then choose the matching aperture automatically. Depending on the speed of your subject, shutter speeds between 1/15 sec. and 1/60 sec. often yield the most effective results. The key is to experiment as much as possible and take as many images as you can – the results will vary wildly!

DIPPER *(CINCLUS CINCLUS)*
*During early summer,
I made numerous visits
to a woodland stream to
photograph dippers with
their young. After spending
several days observing
one family, I began to
learn where their favourite
perches were, and was
soon able to predict their
movements. This individual
would sometimes pause
on a waterfall in the midst
of the cascading water,
so I decided to use a slow
shutter speed to capture the
movement and texture of
the flowing water. Luckily
the dipper remained in the
same spot for some time.
I kept firing away until it
took off. Out of a total of
17 frames, there was just
one in which the bird was
rendered completely sharp.*
*Canon EOS-1D Mk II,
100–400mm L IS (at 275mm),
ISO 50, 1/2 sec. at f/29, tripod*

TECHNIQUE TIPS

■ Try different foods to attract a variety of species. Peanuts and sunflower seeds are great for members of the tit family, but adding niger seeds may attract goldfinches, often in small flocks for winter security. Robins and dunnocks can be enticed with meal worms from a local pet shop. Apples on the lawn will tempt thrushes, blackbirds and perhaps even the occasional fieldfare or redwing.

■ When attaching perches to the feeding station (see page 160) select only the most photogenic branches – gnarled twigs covered in lichen, or a sprig of blossom to add a splash of colour.

■ Set your camera to the high-speed drive mode and fire a burst of frames at a time. Small birds are fast movers so you will need quick reactions to capture them.

■ Try pre-focusing on the perch, setting your lens to manual focus, and firing a sequence of shots as the birds land or take off. You will need strong light to freeze their movements and you may also need to increase your ISO setting in order to achieve a fast enough shutter speed.

■ Take advantage of variations in the light. Experiment with 'back-lighting' when the sun is low in the sky. Aim for a rim-lighting effect that can add both mood and drama.

EQUIPMENT CHECKLIST

LENS: A focal length of 300mm or greater is ideal for small birds. Faster lenses are an advantage due to their quick movements.
ACCESSORIES: Feeder and pole, bird food, hide, clamps for attaching natural perches to pole.

CREATIVE ASSIGNMENT 3: BUILD YOUR OWN FEEDING STATION

Setting up a feeding station is a great way of attracting subjects. If you have a suitable garden this is an ideal location as you can keep an eye on it at all times to see which species of birds you are attracting. If you do not have a garden, an alternative would be to find some privately owned land such as a farm and ask permission to use a small area in return for some prints. The feeding station can be as simple as a pole with a single feeder attached. The beauty of this set-up is that you have complete control over both the position of the subject and the background.

THE ASSIGNMENT

Set yourself the task of building your own feeding station and photographing as many species of birds as you can. You will need to think carefully about the position of your feeder. Make sure that it is a considerable distance from the background and think about the colours in the background. Why not have a go at building your own hide? You can move its position to take advantage of different backgrounds and lighting situations. A home-made hide doesn't need to be complicated. Four upright stakes with two pieces of wood attached to the top, running from corner to corner, provides you with the frame. Then simply drape camouflage netting over the top.

LONG-TAILED TITS
(AEGITHALOS CAUDATUS)
**During a spell of particularly
harsh winter weather, the
action at my feeding station
was almost non-stop.
Groups of long-tailed tits
were literally fighting over
the feeders, and many were
forced to wait their turn on
nearby branches. The snow
was falling heavily when
this pair both landed on
this pine branch, seemingly
creating the perfect
composition.**
*Canon EOS 1D Mk II,
100-400mm L IS (at 260mm),
ISO 200, 1/500 sec. at f/5.6,
tripod*

TECHNIQUE TIPS

■ Use bait to entice your subjects into the best position. Birds and animals found in urban places are often opportunistic and will readily accept bait. Use this to your advantage to coax them into a suitable spot.

■ Think of imaginative ways to frame your subject and try to include an element of the urban environment – a close-up of a pigeon with a tower block dominating the background, for instance.

■ Town lakes are great places to explore. Look for vantage points that allow you to capture birds swimming on the water with people walking in the background. Choose an aperture that allows you to throw the background sufficiently out of focus but still hints at the urban habitat.

EQUIPMENT CHECKLIST

LENS: As most urban wildlife will often allow a closer approach than similar species found in the countryside, a wide-angle zoom may be the most useful lens. This will allow you to get in close and incorporate the environment into your shots.
ACCESSORIES: You will often find yourself shooting from ground level when tackling urban wildlife, so a beanbag is invaluable. Using a cable release will allow you to trigger the camera from a distance. This may come in handy in situations where you are using bait to entice a subject into a particular spot.

CREATIVE ASSIGNMENT 4: EXPLORE URBAN WILDLIFE

At first sight, cities and towns may not seem to be the ideal places for wildlife photography, but with the ever-increasing pressure on the countryside, urban areas are fast becoming important havens for wildlife. Urban parks, wastelands and gardens offer myriad creatures places to shelter, feed, nest and breed. A visit to any of these places can offer a wide array of subject matter with fascinating potential. There is, of course, one huge advantage to photographing wildlife in and around towns and cities. Because of man's proximity, animals and birds have learned to tolerate the presence of humans and are usually far more approachable than wildlife in rural areas. Even inner city environments, far from nature's green fingers, harbour birds and animals. Who would consider visiting a skyscraper to photograph a peregrine falcon, for example? Yet even these enterprising raptors can be found in such locations. For a falcon, a tall building with a suitable ledge closely resembles a cliff face – its more usual habitat. As long as there is food to be found, such a bird may actually be safer in the city than in the countryside, where, sadly, even in the recent past, it has been persecuted by man.

THE ASSIGNMENT

Subjects can often be found in the most unusual places. Even urban wasteland can harbour some fascinating plants and insects. Thistles, nettles and brambles can be magnets for local birdlife. Your assignment is to go out and explore and see what unexpected subjects you can find. A good place to start would be your local park. Swans and other wildfowl can be photographed with relative ease, so look for creative ways of framing them, perhaps even including elements of the urban environment to hint at their habitat.

PEREGRINE FALCON
(FALCO PEREGRINUS)
I was commissioned to photograph a pair of peregrines that were nesting in a city-centre site. I gained permission to shoot from a nearby hotel rooftop and spent many hours observing the nest. One afternoon, one of the parent birds landed on the corner of the roof I was shooting from. With adrenaline flowing, I managed to creep along the roofline under the careful watch of the peregrine, who amazingly didn't seem at all perturbed by my presence. I spent a good minute photographing this amazing raptor and tried a variety of compositions. My favourite were the tight shots, showing the intensity of its stare. (Note that peregrines are a Schedule One species and depending on your proximity to the nest, you may need to obtain a licence to photograph them.)
Canon EOS-1D Mk IV, 500mm f/4 L IS, ISO 400, 1/250 sec. at f/8, tripod

163

TECHNIQUE TIPS

■ Observe! Spend as much time as you can just watching your subject. Note down patterns in its behaviour.

■ The longer you spend with your chosen subject, the easier it will become to predict its movements. Try to capture the decisive moment by guessing its next move. Shoot on high-speed drive mode to give you a better chance of success.

■ Experiment with different focal lengths to give you more framing options and therefore more variety in your images.

■ Take advantage of different lighting situations. The rich, warm light at dawn and dusk is almost always favourable, but don't dismiss overcast days. On cloudy days the light is soft, which helps to reveal detail in your subject and will give your images a completely different feel.

■ Always pay close attention to the background to make sure nothing distracting is ruining your shots.

■ Look for opportunities to silhouette your subject at dawn and dusk. Change position to find an area of bright sky to place behind your subject and take an exposure reading from the brightest part of the image.

EQUIPMENT CHECKLIST

The equipment needed for this assignment will depend on your chosen subject.

LENS: The key to this assignment is variety, so a zoom lens that will allow an array of framing options will be particularly useful.

CREATIVE ASSIGNMENT 5: CONCENTRATE ON ONE SPECIES

Rather than taking a few pictures of a subject and then moving on, concentrate on capturing as much variety as possible. Aim to photograph different aspects of the subject's behaviour. Shoot close-up portraits and environmental studies. Capture images of it interacting with its offspring, or battling with rivals over territory. Immersing yourself in a project like this will invariably mean spending more time with your chosen subject. This can only be a good thing. The more time you spend observing your subject, the easier it will be for you to predict its movements and behaviour. This in itself will open up a world of opportunity.

THE ASSIGNMENT

Your first job will be to select the subject you would like to tackle. Pick a creature that is easily accessible and close to home. Perhaps you have a local park where the same creature can be found on every visit. Depending on your chosen subject, behavioural patterns may change throughout the year, so take advantage of the different seasons and the opportunities that they present. At the end of this project you should have built up a library of pictures that tells a story about your subject and gives a real insight into its life cycle.

GREAT CRESTED GREBES
(PODICEPS CRISTATUS)
Several years ago I started to cover great crested grebes in depth. I returned to the same location, at different times of the year and managed to capture images showing a variety of behaviour. I still regard this as one of the best bird pictures I have ever taken. I shot it on a very cold February morning. I was concealed in my floating hide, and as the sun rose above the horizon, the back-lighting highlighted the birds' beautiful breeding plumage. As they started to perform their elaborate courtship ritual, the male's haunting bird call resonated across the lake, and its plume of breath became momentarily visible against the dark background.
Canon EOS 10D, 100–400mm L IS (at 400mm), ISO 200, 1/800 sec. at f/5.6, beanbag, floating hide

TECHNIQUE TIPS

- Don't be afraid to venture out in bad weather conditions. (There's really no such thing as bad weather for the wildlife photographer – just the wrong sort of clothes!) Falling snow or even rain can add atmosphere to your shots and show an important aspect of the creature's environment.
- Experiment with composition and don't be afraid to break the conventional rules.
- When shooting in snow, increase your exposure to compensate for the additional light and check your histogram regularly to make sure you are holding sufficient detail in both the highlights and the shadows.
- Don't forget to consider black-and-white conversion at the time of shooting. Animals in silhouette against a huge sky work well in black and white and can look dramatic and depict a sense of space.
- Look for elements in the landscape that you can use as a natural frame.

EQUIPMENT CHECKLIST

LENS: A wide-angle lens is useful for subjects that are easily approached. For more wary creatures, a telephoto zoom will offer more freedom when it comes to composition. This is essential when trying to incorporate the landscape into your photograph.

ACCESSORIES: A waterproof cover for your camera is essential when shooting in heavy rain. There are several commercial products available to help protect your precious equipment from the elements. Warm and dry clothing is also important. The more comfortable you are, the longer you are likely to stick around!

CREATIVE ASSIGNMENT 6: STUDY THE ENVIRONMENT

Capturing a successful image of a creature in the context of its environment can be a challenge, but the results can be both visually striking and conceptual. Images that incorporate the animal's habitat help to tell a story and often hold far more interest than a close-up portrait.

THE ASSIGNMENT

For this project you will need to think carefully about composition. When filling the frame with your subject, you have few options, but when taking a wider view you will have more clutter to contend with. Subject placement is critical. If the creature takes up only a small part of the frame, the rule of thirds can work particularly well, but try not to let these guidelines dictate your picture-taking. Instead, be creative and experiment as much as possible. You may be able to use elements of the landscape as a natural frame. Leading lines can be a strong compositional tool and can be used to lead the viewer's eye towards the subject. It is imperative that the subject is clearly visible. Look at the background directly behind and make sure that it is not distracting. When looking for suitable subjects, don't ignore tiny creatures. Photographing insects such as butterflies and dragonflies with a wide-angle lens can produce spectacular results.

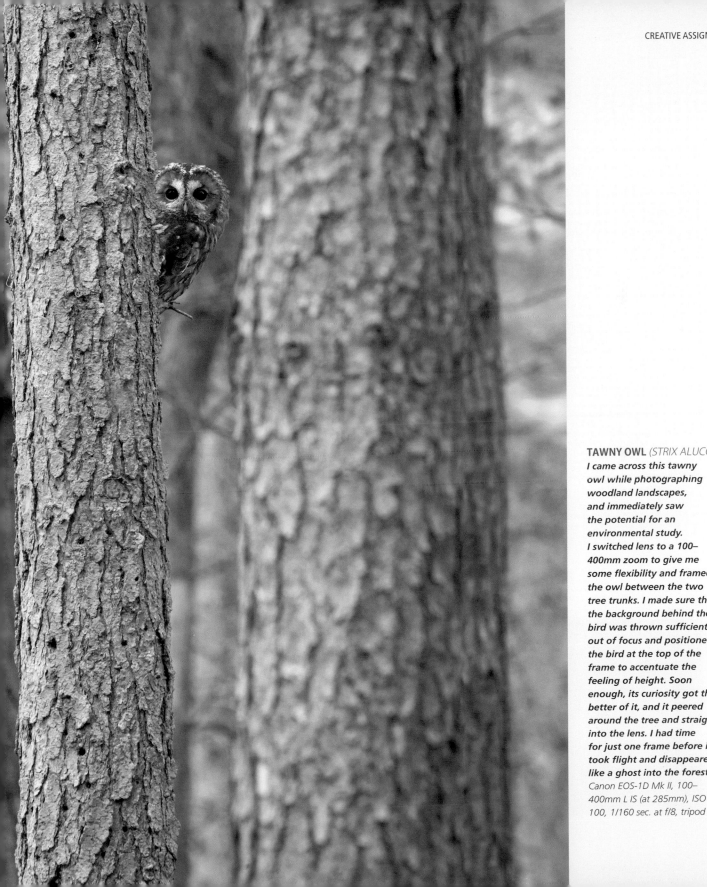

TAWNY OWL *(STRIX ALUCO)*
I came across this tawny owl while photographing woodland landscapes, and immediately saw the potential for an environmental study. I switched lens to a 100–400mm zoom to give me some flexibility and framed the owl between the two tree trunks. I made sure that the background behind the bird was thrown sufficiently out of focus and positioned the bird at the top of the frame to accentuate the feeling of height. Soon enough, its curiosity got the better of it, and it peered around the tree and straight into the lens. I had time for just one frame before it took flight and disappeared like a ghost into the forest.
Canon EOS-1D Mk II, 100–400mm L IS (at 285mm), ISO 100, 1/160 sec. at f/8, tripod

FREQUENTLY ASKED QUESTIONS

We have tried to cram as much information into this workshop-in-a-book as possible. However, wildlife photography is such a huge, varied topic that inevitably we won't have answered all your questions. Unlike an on-location workshop, we don't have the opportunity to invite you to ask your own unique questions. However, by answering a handful of questions that are frequently asked at our workshops, we hope to be able to replicate a typical workshop Q&A.

Q) What is the highest ISO setting I can use without seeing image quality suffer?

A) A fast shutter speed is often a priority when shooting wildlife. Digital photographers have the luxury of being able to vary the ISO sensitivity depending on the light and situation. Increasing ISO will help generate a fast enough shutter speed to freeze subject motion. However, this is at the cost of increased signal noise. That said, the latest digital SLRs boast impressively high ISO performance, making it possible for photographers to capture usable images of action and behaviour even in low light – something previously not possible without the use of flash. Just how high you can push your ISO setting without seeing a significant drop in image quality greatly depends on your camera. Only a few years ago we would recommend always keeping ISO below 800, but today – with certain models, particularly Nikon's range of FX digital SLRs – you can still capture usable results at values of up to a staggeringly high 25,600, thanks to the advancements in sensor technology. Even at such extreme ISOs, there is relatively little grain and natural colour saturation remains good, allowing nature photographers to do things never possible before. Its usefulness in fading light is obvious, but a high ISO is useful even in good light, if you need to generate an exceptionally fast shutter speed in order to capture very rapid movement. Therefore, if you do own a modern camera, our advice is don't be afraid to shoot at high ISOs of 3,200, 6,400 or above. It is better to capture a pin-sharp result with increased noise than a noise-free image that is ruined due to subject blur. Noise-reduction software is excellent. However, it goes without saying that it is still logical to always select the lowest practical ISO for the subject or situation.

Q) When photographing small animals – frogs or butterflies, for example – is it ethical to physically move them in order to place them in a more photogenic setting?

A) Ideally, you should avoid moving subjects for photography, but it isn't uncommon for photographers to do this when appropriate. The advantage of moving a subject is that you have greater control over the look of its environment – for example, placing them somewhere where there is a cleaner, clutter-free background. However, you should only consider moving subjects if you are experienced at handling wildlife – particularly reptiles, which can thrash about wildly, shed their tail or bite if handled incorrectly. Handle any creature with extreme care; insects' wings and legs are particularly fragile and easily damaged if dropped or poorly handled.

BARN OWL *(TYTO ALBA)*

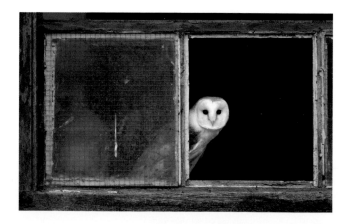

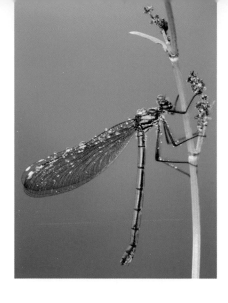

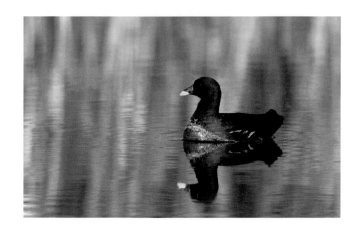

MOORHEN
*(GALLINULA
CHLOROPUS)*

**BANDED
DEMOISELLE**
*(CALOPTERYX
SPLENDENS)*

Consider using a fine, soft, artist's paintbrush when moving insects such as resting damselflies, carefully placing the tip of the brush next to the insect's legs for it to climb onto. Always return subjects to the place where you found them – or to a similar safe, sheltered place – when you have finished taking photos, and do not consider moving a subject if doing so will place it at risk. Do not refrigerate subjects to make them less active.

Q) Due to work and family commitments, I just don't have the time to wait for days in a hide. What are the best subjects to shoot when you only have limited time?

A) Despite what we're often led to believe, not all great wildlife images are the result of days of waiting and stealth. Obviously, the more time you can spend behind the camera, the better the chances of capturing great shots. However, when time is limited, visit parks, wetlands and reserves where subjects are usually easier to locate and get close to. This will allow you to be more productive with your time, enabling you to start taking photos almost immediately and concentrate on composition and creativity. Also, plant life and creepy-crawlies typically require less time to find and photograph, so consider targeting smaller subjects like those. Don't overlook the wildlife on your doorstep. Even small gardens are home to potentially good subjects, like snails, spiders and ladybirds; most are visited by small birds that can be enticed

to a predefined spot using feeders, and photographed from a nearby window or shed. In summer, there's plenty of daylight, so there may be the opportunity to get up at dawn, shoot for a couple of hours, and still be home ready to go to work or to get breakfast ready for the kids.

Q) Can you explain what EXIF data is and its purpose?

A) Exchangeable Image File Format – or EXIF – data is recorded by the camera every time you take a digital photo. Quite simply, it is shooting information that the camera embeds into the image file – lens focal length, aperture, shutter speed, metering pattern, white balance, exposure compensation, time and date, and so on. This information is useful for a variety of reasons. It allows you to review and study your settings, which is helpful when you want to work out why an image was or wasn't successful. The EXIF data gives a valuable insight into how certain settings affect and alter key photographic characteristics, for example, subject motion and depth of field. It is also useful when you are required to provide technical details, including the subject and its scientific name, when captioning images.

EXIF data can be read in-camera, or in applications that support the relevant image file formats, such as Raw converters. One of the most popular ways to view EXIF data is using Photoshop – simply click File > File info.

GLOSSARY

Aberration: An imperfection in the image caused by the optics of a lens.

Angle of view: The area of a scene that a lens takes in, measured in degrees.

Aperture: The opening in a camera lens through which light passes to expose the image sensor. The relative size of the aperture is denoted by f-numbers.

Autofocus (AF): A through-the-lens focusing system allowing accurate focus without the user manually focusing the lens.

Bait: Food or water used to entice a subject to a predefined point.

Bracketing: Taking a series of identical compositions, changing only the exposure value, usually in 1/2 or one f-stop (+/–) increments.

Buffer: The in-camera memory of a digital camera.

Burst rate: The maximum number of frames that a camera can shoot before its buffer is full.

Camera shake: Movement of the camera during exposure that, particularly at slow shutter speeds, can lead to blurred images. Often caused by an unsteady hold or support.

CCD (Charged-Coupled Device): One of the most common types of image sensor incorporated into digital cameras.

CMOS (Complementary Metal-Oxide Semiconductor): A microchip consisting of a grid of millions of light-sensitive cells – the more sensors, the greater the number of pixels and the higher the resolution of the final image.

Colour temperature: The colour of a light source expressed in degrees Kelvin (K).

Compression: The process by which digital files are reduced in size.

Contrast: The range between the highlight and shadow areas of an image, or a marked difference in illumination between colours or adjacent areas.

Depth of field (DOF): The amount of an image that appears acceptably sharp. This is controlled by the aperture – the smaller the aperture, the greater the depth of field.

Distortion: Typically, when straight lines are not rendered perfectly straight in a photograph. Barrel and pin-cushion distortion are examples of types of lens distortion.

dpi (dots per inch): Measure of the resolution of a printer or a scanner. The more dots per inch, the higher the resolution.

Dynamic range: The ability of the camera's sensor to capture a full range of shadows and highlights.

Elements: The individual pieces of glass that form the overall optical construction of a lens.

Evaluative metering: A metering system whereby light reflected from several subject areas is calculated based on algorithms.

Exposure: The amount of light allowed to strike and expose the image sensor, controlled by aperture, shutter speed and ISO sensitivity. Also the act of taking a photograph, as in 'making an exposure'.

Exposure compensation: A control that allows you to increase or decrease exposure.

Fieldcraft: The skills, such as stealth and camouflage, required to get close to a wild animal.

Filter: A piece of coloured, or coated, glass or plastic placed in front of the lens for creative or corrective use.

Focal length: The distance, usually in millimetres, from the optical centre point of a lens element to its focal point, which signifies its power.

fps (frames per second): The ability of a digital camera to process one image and be ready to shoot the next.

F-stop/number: Number assigned to a particular lens aperture. Wide apertures are denoted by small numbers such as f/2.8; small apertures by large numbers such as f/22.

Hide: Camouflaged barrier used by wildlife photographers to disguise their whereabouts from the subject.

Histogram: A graph used to represent the distribution of tones in an image.

Hotspot: A light area with a loss of detail in the highlights. This is a common problem in flash photography.

ISO (International Standards Organization): The sensitivity of the image sensor measured in terms equivalent to the ISO rating of a film.

JPEG (Joint Photographic Experts Group): A popular image file type, compressed to reduce file size.

LCD (liquid crystal display): The flat screen on the back of a digital camera that allows the user to play back and review digital images and shooting information.

Lens: The 'eye' of the camera. The lens projects the image it sees onto the camera's imaging sensor. The size of the lens is measured and indicated as focal length.

Macro: A term used to describe close focusing and the close-focusing ability of a lens.

Manual focus: This is when focusing is achieved by manual rotation of the lens's focusing ring.

Megapixel: One million pixels equals one megapixel.

Memory card: A removable storage device for digital cameras.

Metering: Using a camera or handheld light meter to determine the amount of light coming from the subject and calculate the required exposure.

Metering pattern: The system used by the camera to calculate the exposure.

Mirror lock-up: Allows the reflex mirror of an SLR to be raised and held in the 'up' position, before the exposure is made.

Monochrome: Image compromised only of grey tones, from black to white.

Multiplication factor: The amount the focal length of a lens will be magnified when attached to a camera with a cropped-type sensor (smaller than 35mm).

Noise: Coloured image interference caused by stray electrical signals.

Overexposure: When too much light reaches the sensor. Detail is lost in the highlights.

Perspective: In the context of visual perception, this is the way in which the subject appears to the eye depending on its spatial attributes, or its dimensions and the position of the eye relative to it.

Photoshop: A photo-editing program developed and published by Adobe Systems Incorporated. It is considered the industry standard for editing and processing photographs.

Pixel: Abbreviation of 'picture element'. Pixels are the smallest bits of information that combine to form a digital image.

Post-processing: The use of software to make adjustments to a digital file on a computer.

Predictive autofocus: An autofocus system that can continuously track a moving subject.

Prime: A fixed focal length – a lens that isn't a zoom.

Raw: A versatile and widely used digital file format in which the shooting parameters are attached to the file, not applied to it.

Remote release: A device used to trigger the shutter of a tripod-mounted camera to avoid camera shake.

Resolution: The number of pixels used to either capture an image or display it, usually expressed in ppi (pixels per inch). The higher the resolution, the finer the detail.

RGB (red, green, blue): Computers and other digital devices understand colour information as shades of red, green and blue.

Rule of thirds: A compositional device that places the key elements of a picture at points along imagined lines that divide the frame into thirds.

Saturation: The intensity of the colours in an image.

Shadow areas: The darkest areas of the exposure.

Shutter: The mechanism that controls the amount of light reaching the sensor by opening and closing when the shutter release is activated.

Shutter speed: The shutter speed determines the duration of exposure.

SLR (single lens reflex): A camera type that allows the user to view the scene through the lens, using a reflex mirror.

Spot metering: A metering system that places importance on the intensity of light reflected by a very small percentage of the frame.

Stalking: To track or observe a subject stealthily.

Standard lens: A focal length similar to the vision of the human eye – typically, 50mm is considered a standard lens.

Telephoto lens: A lens with a large focal length and a narrow angle of view.

TIFF (Tagged Image File Format): A universal file format supported by virtually all image-editing applications. TIFFS are uncompressed digital files.

TTL (through-the-lens) metering: A metering system built into the camera that measures light passing through the lens at the time of shooting.

Underexposure: A condition in which too little light reaches the sensor. There is too much detail lost in the shadow areas of the exposure.

USB (universal serial bus): A data transfer standard.

Viewfinder: An optical system used for composing and sometimes focusing the subject.

White balance: A function that allows the correct colour balance to be recorded for any given lighting situation.

Wide-angle lens: A lens with a short focal length.

Workshop: A brief, intensive course, seminar or a series of meetings emphasizing interaction and exchange of information.

Zoom: A lens that has a focal length that can be adjusted to any length within its focal range.

USEFUL WEBSITES AND DOWNLOADS

CALIBRATION:

ColorEyes Display:

www.integrated-color.com

ColorVision: www.colorvision.com

Xrite: www.xrite.com

CAMERA CARE:

Visible Dust: www.visibledust.com

CONSERVATION PROJECTS:

2020VISION: www.2020v.org

DEPTH-OF-FIELD CALCULATOR:

DOFMaster: www.dofmaster.com

OUTDOOR EQUIPMENT AND CLOTHING:

SatMap: www.satmap.com

Paramo: www.paramo.co.uk

Wildlife Watching Supplies:

www.wildlifewatchingsupplies.co.uk

PHOTOGRAPHERS:

Ben Hall: www.benhallphoto.com

Ross Hoddinott: www.rosshoddinott.co.uk

PHOTOGRAPHIC EQUIPMENT:

Canon: www.canon.com

f-stop gear: www.fstopgear.com

Giottos: www.giottos.com

Gitzo: www.gitzo.com

Lexar: www.lexar.com

Manfrotto: www.manfrotto.com

Nikon: www.nikon.com

Olympus: www.olympus.com

Peli: www.peli.com

Pentax: www.pentaximaging.com

Sigma: www.sigma-photo.com

Sony: www.sony.com

Tamron: www.tamron.com

Wimberley: www.tripodhead.com

PRINTING:

Epson: www.epson.com

Hahnemühle: www.hahnemuehle.de

Harman: www.harman-inkjet.com

HP: www.hp.com

Lyson: www.lyson.com

Permajet: www.permajet.com

PUBLISHER:

Ammonite Press:

www.ammonitepress.com

SOFTWARE:

Adobe: www.adobe.com

Apple: www.apple.com/aperture

Combine ZM: www.hadleyweb.pwp. blueyonder.co.uk/CZM/News.htm

Corel: www.corel.com

DxO: www.dxo.com

Phase One: www.phaseone.com

Photomatix Pro: www.hdrsoft.com

SUNRISE AND SUNSET DIRECTION:

The Photographer's Ephemeris:

www.photoephemeris.com

USEFUL READING:

Digital Photography Review:

www.dpreview.com

Digital SLR Photography magazine:

www.digitalslrphoto.com

Discover Wildlife:

www.discoverwildlife.com

PhotoPlus magazine:

www.photoplusmag.com

WILDLIFE PHOTOGRAPHY COMPETITIONS:

British Wildlife Photographer of the Year: www.bwpawards.org

Wildlife Photographer of the Year: www.nhm.ac.uk/wildphoto

Windland Smith Rice Awards: www.naturesbestphotography.com

ABOUT THE AUTHORS

ROSS HODDINOTT

Ross Hoddinott is one of the UK's leading professional outdoor photographers and writers. His intimate and creative photography is published worldwide and he will be familiar to readers of many photographic publications, including *Outdoor Photography* and *Digital SLR Photography*. Ross's images are represented by NaturePL. In 2009, Ross was named British Wildlife Photographer of the Year and he is also a multiple award-winner in the international Wildlife Photographer of the Year competition. Ross is a member of the 2020VISION photo team – the most ambitious nature photography project ever staged in the UK.

Ross is a close-up specialist, best known for his intimate portraits of insects and plant life. *The Wildlife Photography Workshop* is Ross's eighth photography book. Previous titles include *The Landscape Photography Workshop* and *Digital Exposure Handbook*. Ross co-runs Dawn 2 Dusk Photography, specializing in photographic workshops in the southwest of England. He also runs tutorial days giving personal tuition on close-up photography. Find out more about Ross at **www.rosshoddinott.co.uk**.

BEN HALL

Ben Hall is one of Britain's foremost professional wildlife photographers. His personal approach to nature photography lies in the creative art of 'seeing'. He uses his pictures to communicate his personal vision, generate an emotional response and to excite the viewer's aesthetic sensitivity. He is described by *Living Edge* magazine as 'a passionate and experienced wildlife photographer, with a perfectionist's eye for detail'. Ben's work is represented by Getty Images, RSPB Images and NaturePL and is sold worldwide.

Ben specializes in bird and mammal photography and has won numerous international awards including category wins in the British Wildlife Photography Awards and the Windland Smith Rice International Awards. In 2009 he was named 'Geographical' Photographer of the Year. He is a regular contributor to clients as diverse as *BBC Wildlife*, *PhotoPlus magazine*, *Digital SLR User*, *Photography Monthly* and many more. He has appeared on numerous radio and television programmes and is also a member of the 2020VISION photo team.

Ben runs his own nature photography workshops all over the UK and further afield, using his personal coaching style to inspire others. Find out more about Ben at **www.benhallphoto.com**.

AUTHORS' ACKNOWLEDGEMENTS
Thank you to Gerrie Purcell and Jonathan Bailey for commissioning this title and also to Virginia Brehaut, Tom Mugridge, Simon Goggin, Emma Foster and everyone at Ammonite Press for helping make our book idea a reality. Thanks also to Kevin Keatley at Wildlife Watching Supplies for his help and images. Unsurprisingly, the biggest thank you has to be reserved for our long-suffering partners, parents and children – Ben's wife Milena, daughter Lissy and son Charlie; and Ross's wife Fliss and daughters Evie and Maya. Photographers are hard to live with. The hours are long, unsociable and unpredictable. Despite this, your support, encouragement, patience and belief is never-ending. Thank you!

INDEX

To place an order, or request a catalogue, contact:
Ammonite Press
AE Publications Ltd, 166 High Street, Lewes, East Sussex, BN7 1XU, United Kingdom
Tel: +44 (0)1273 488006 **www.ammonitepress.com**